Design Secrets:
Packaging

50 Real-Life Projects Uncovered

GLOUCESTER MASSACHUSETTS

ROCKPORT PUBLISHERS

Catharine Fishel

First published in the United States of America by
Rockport Publishers, Inc.
33 Commercial Street
Gloucester, Massachusetts 01930-5089
Telephone: (978) 282-9590
Fax: (978) 283-2742
www.rockpub.com

Library of Congress Cataloging-in-Publication Data

Fishel, Catharine M.
 Design secrets: packaging: 50 real-life projects uncovered/
Catharine Fishel
 p. cm.
 ISBN 1-59253-006-0
 1. Graphic arts—Technique. 2. Packaging. I. Title.
NC1000.F57 2003
741.6—dc21 2003009404
 CIP

ISBN 1-59253-006-0

10 9 8 7 6 5 4 3 2 1

Layout & Production: *tabula rasa* graphic design
Cover Design: Madison Design & Advertising, Inc.
Project Manager/Copy Editor: Stacey Ann Follin
Proofreader: Karen C. Comerford

Printed in China
Printed in Hong Kong
Printed in Singapore

Many, many, many thanks to Kristin Ellison, the most patient, most gracious, most forgiving editor and friend a hapless writer could hope for, and additional thanks to the hundreds of designers who generously shared their time, work, and ideas in order to help transform a folder full of odd notes into the book you hold in your hands now.

contents

S.A.C.S) Bottles: Oils/Vinegars.

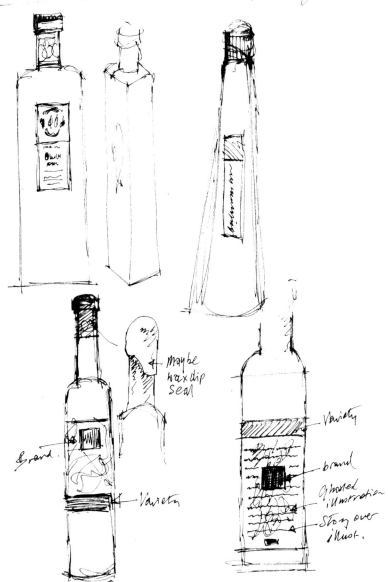

maybe
wax dip
seal

Brand.

Variety

Variety

brand

ghosted
illustration

story over
illust.

Chase Design Group has been working for **Kama Sutra**— not surprisingly, **a purveyor of sex products**—for eight years; although the company has been in existence **since 1965.**

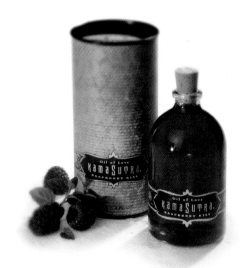

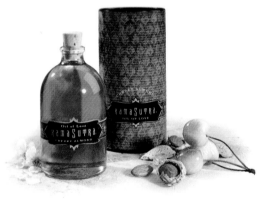

Chase Design Group was inspired by the challenge to tie together, through packaging design, an almost 40-year-old brand of sex aid products. The new packaging for Kama Sutra was so lush and beautiful that it successfully maneuvered its way into more mainstream retail venues. Previously, it was only sold in sex and head shops.

"Registering the Kama Sutra name internationally was the smartest thing he ever did," says agency executive creative director Margo Chase of her client, Joe Bolstad. "As a result, there are no other competitors in the market with that name. He has competitors in the sex aid market, but none have been able to cross over into the mainstream gift market as successfully."

A great deal of that success is attributable to Chase and her designers, who have taken the products—through gorgeous packaging designs—from items that might be bought furtively at sex or head shops to a line of products that are beautiful enough to sell in all levels of gift and specialty stores. Even more significantly, they look artful enough to leave out on the counter or bedside table at home.

The client had two sets of packaging designs before the work Chase Design Group created. The original packaging was created in 1965. It used brown ribbed paper with a circular logo. These designs were rather dingy looking, but the line also contained a few special packages that used Indian-style illustrations, which Chase thought had potential.

In the 1980s the entire line of packaging was redesigned. All the new containers were matte black with red type and gray stone texture. Chase describes the look as "not very sexy." Part of the redesigned suite included some phallic-looking bottles that—unfortunately—leaked. The client was not happy with the new look, so he let some of the original designs stay on the market. The result was a disjointed brand image.

To make the next step in expanding his line into larger gift and department stores, the client needed packaging that was more palatable to mainstream consumers. Originally, Chase recalls, Bolstad wanted to simply go back to and update the original brown packaging. Chase didn't want to abandon the core of this idea, but felt that bringing in Indian art and more color would give his products more appeal and visual diversity.

This was the genesis of the green ribbed paper that is used throughout Chase's redesign. "The paper is actually just the brown shipping paper they use in Europe. We scanned it and shifted the color to create a rich, jewel-toned green," she explains. On top of the green, the designers added a gold metallic leaf overprint together with a new brand identity. It was important to maintain some elements from the original design, Chase adds, so that long-time customers wouldn't feel as if they had been abandoned.

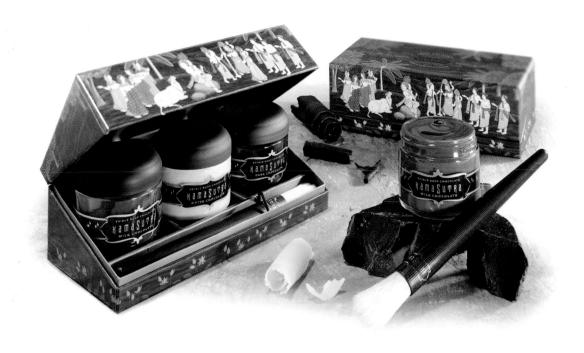

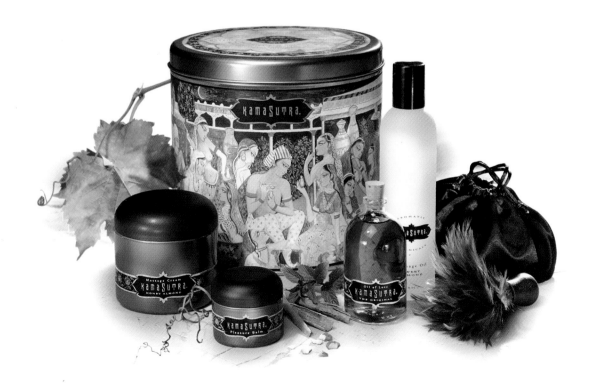

The team also explored Indian artwork, frescos, and textiles for inspiration. From these sources, rich, detailed artwork was developed for use on canisters and bottle bellybands. Two different looks were built from the green paper and floral illustrations: The core product line—which includes Oil of Love, Pleasure Balm, and Honey Dust—is wrapped in the green ribbed paper. Each flavor has a different bellyband design to distinguish it and tie it into the second look, which was used on the gift product line. This line is decorated with similarly colored illustrations based on the art of the original Kama Sutra.

"We felt that color was an important aspect that was missing in the old packaging. The Oil of Love is manufactured in various beautiful colors, but they were hidden inside brown or black tubes, which are necessary to keep the glass bottles from breaking. We decided to bring the color to the outside of the containers," Chase says. She notes that the consistent green paper theme gave the client a single, ownable color on store shelves and helped him carve out an identifiable space. "But we wanted to break that up with floral patterns and illustrations to keep everything interesting, inviting, and friendly."

The art served another, more subliminal purpose. Many people are uncomfortable buying sex products. "We hope that the beautiful art would help people feel like they were buying a gift or a piece of art rather than a sex aid. That's one big reason for Kama Sutra's success: It still does a huge amount of business in sex shops because its products are the only ones that look tasteful, and he has been able to break into the mainstream gift market for the same reason," Chase says.

Today, the Kama Sutra product line is found in high-end gift stores all over the world, as well as at mainstream retailers. Its business has grown dramatically every year since Chase Design Group began its work; in 2002 alone, sales doubled.

Chase doesn't claim that the new packaging is the only reason for such impressive improvement, but both she and the client like to think it has had a huge impact. She also credits client Joe Bolstad—the only client she has ever had who graduated from Art Center with a degree in design—with being incredibly receptive to their ideas.

"We often make comps in several versions. He takes them away and sits with them until he's sure which one is right. He'll have thought everything through and offer great input, often making the designs even better than they were," she says.

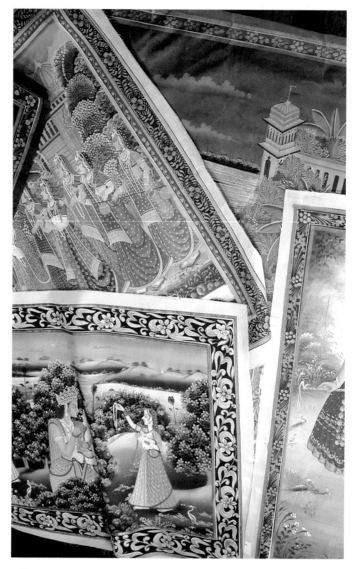

Rich fabrics from India were one of the visual resources that Margo Chase and her designers studied for guidance on color and illustration.

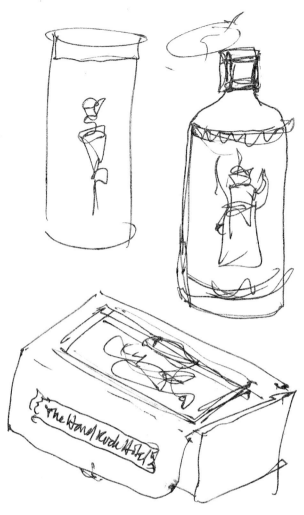

P.O.P. — booklet container
— more substantial —
holds booklets
& collection oils as tester

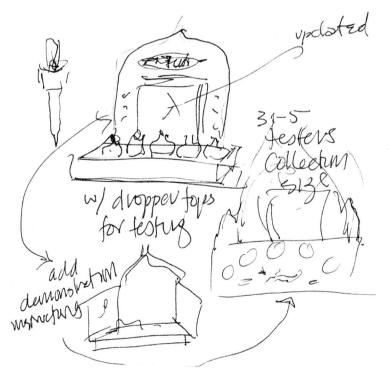

updated

w/ dropper tops
for testing

31-5
testers
collection
size

add
demonstration
instructing

gift sets:

2 bath gels
treasures
sponge + shell

1. bath kit:

2. Herbal bath set (all 3 same flavor)
1 mini herbal bath
1 mini bath gel mini massage oil
1 candle
 Marcia to make box + foil clear
 tray.

3.] love kit
honey dust
oil & love
balm
candle

IN BOX tray w/
clear slide

In clear or
box w/ clear
slide

 A range of sketches completed during early discussions with the client.

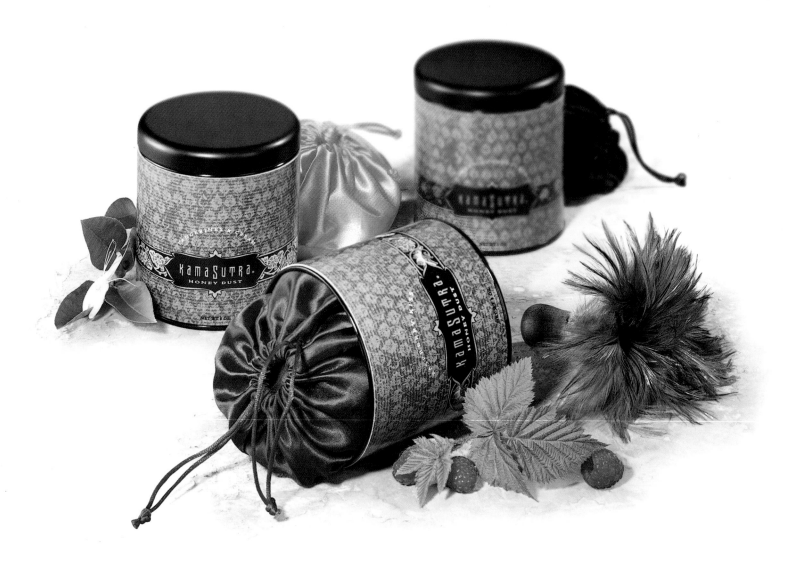

◇ Kama Sutra's original packaging was wrapped
◇ in brown ribbed paper, and the client had ex-
pressed a desire to return to that look, fol-
lowing an unsuccessful redesign attempt by
another design firm in the 1980s and years
of a disjointed identity. Chase delivered his
wish, with a lovely twist: She used a ribbed
paper (actually, a brown shipping paper com-
monly used in Europe), electronically gave it
a rich green color, and added a leaf pattern
colored with gold leaf on top. An illustrated
bellyband added color. This core design was
one of two looks the designers created for
their client.

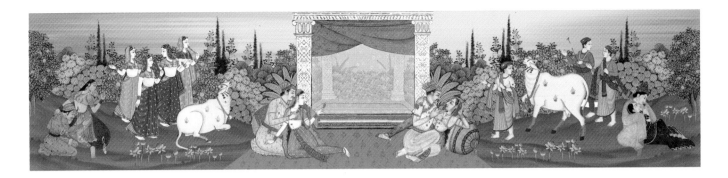

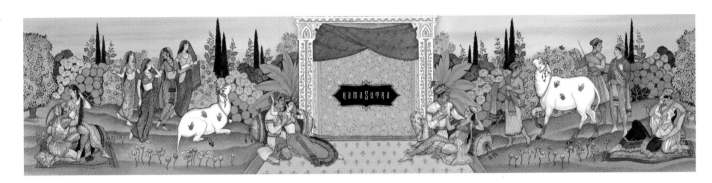

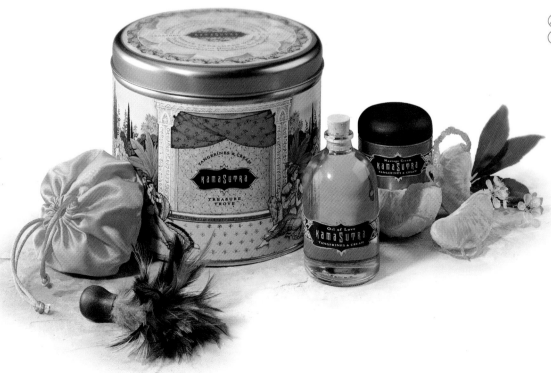

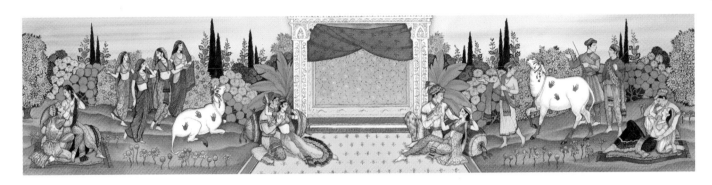

⌃ The second look created for the
⌄ client is shown in the tins the de-
signers created for the Kama Sutra
gift product line. These carried more
illustration and color. Shown here is
the preliminary comp for the Tanger-
ine Gift Tin; the approved art; the
final wrap; and finally, photography
of the finished product. The inspira-
tion gained from studying Indian art-
work, frescos, and textiles is evident.

A brand with **the good bones of heritage** can be a wonderful project for a designer. But a brand with good bones whose owners have a **vision for the future** is even better. Such was the case with **Adnams Brewery** of Southwold in the East Anglia region of England.

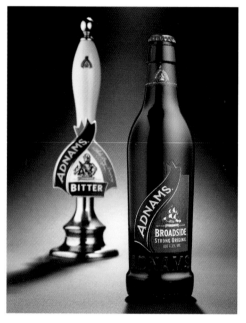

⬙ Design Bridge of London re-created the identity and packaging for Adnams, a brewery in the East Anglia region of England, founded in 1872. Both the labeling and the bottle shape were reworked.

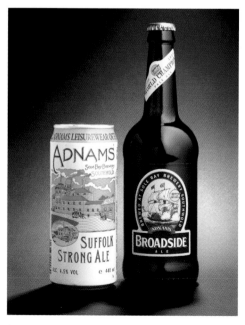

⬙ The company's identity had not been touched in more than 20 years, and each product in the line had a different look.

The company has been in business since 1872 and is among the last of the independent, locally owned breweries left in the country. At one time, hundreds of establishments brewed their own beers and served the beverages in their own pubs. But today, large corporations have swept through the market and have eliminated nearly all these historic companies. Adnams is one of the few strong, independent, regional brands left and is determined to stay that way.

The company's identity had remained essentially untouched for 20 years. Although the company's chair is a progressive thinker who wanted the company to do something different from any other regional brewer, Design Bridge, the London-based company brought on board to handle the ID and packaging redesign, knew that any redesign would have to be done with great care.

"This redesign was a big move for the company," says Jill Marshall, executive chairman for branding and packaging at Design Bridge. "The brewer is rooted in Southwold, a historic and charming part of the English countryside and coastline. It was important for them to feel whomever they entrusted with handling this untouched brand would treat it with a great deal of respect."

One thing to avoid, Marshall says, was making a patent play on the brewer's history to create an old-world feel. "We had to respect the actual history," Marshall says, "not treat it like it was some sort of bogus version of history."

Adnams' competition could be characterized in one of two ways: those that used the old-world approach (many are as old or older than Adnams) or those that remained completely static. Creative director for the redesign project Graham Shearsby compares the appearance of these identities to the metal badges from old steam engines—cold, unemotional, inflexible. Design Bridge felt that something with more life and movement—something with a more sculptural quality—would be more fitting in Adnams' packaging and mark.

After extensive conversations with the client on what it needed (Adnams includes 90-odd pubs, three hotels, and a wine business, as well as a full suite of beers), Shearsby visited Southwold to get a better feeling for the place. The visit turned out to be a meaningful one.

"It's flat there, with big beaches and big skies. Fishermen bring their boats right up onto the shore. You can imagine the winds coming across the beaches in winter, when you would want to find yourself tucked up in a pub with a pint of beer," he says.

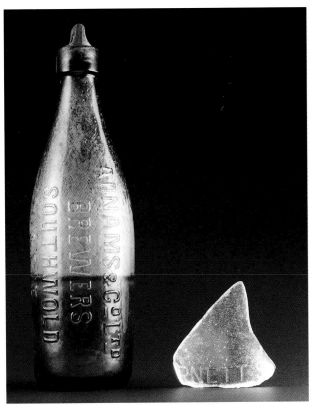

Two unique finds helped to drive the redesign of the new Adnams bottle: While visiting Southwold to get a better feeling for the place, Design Bridge creative director Graham Shearsby took a walk on the beach and found the fragment of thick glass shown here. The bottle was found in a wine cellar beneath the brewery. The appearance and heft of the items were combined in the new bottle shape.

In these sketches, the designers explored the relationship between the bottle shape and the label.

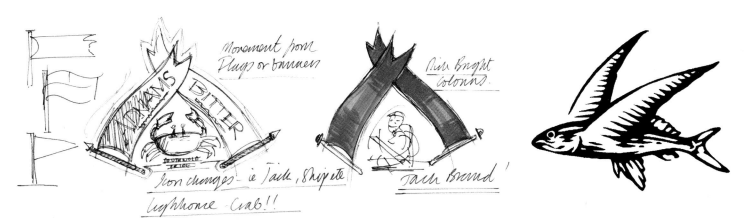

Initial sketches include visual references to flags and include icons that are representative of the area—a lighthouse, a crab, a ship, a flying fish.

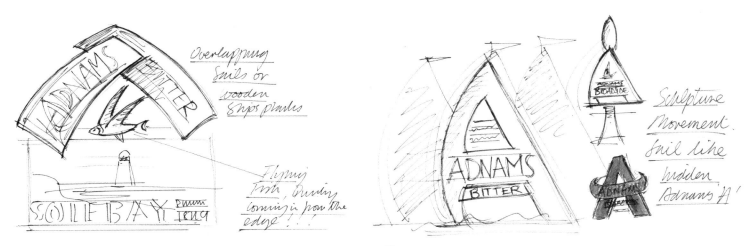

The overlapping sail design eventually won out. It had a three-dimensional feel that was adaptable for other uses.

Here the sail idea moves into a more literal interpretation.

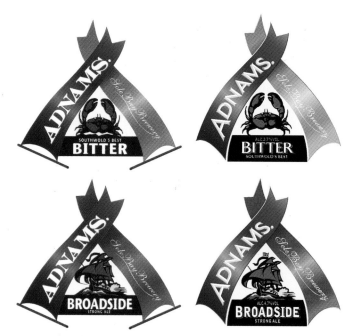

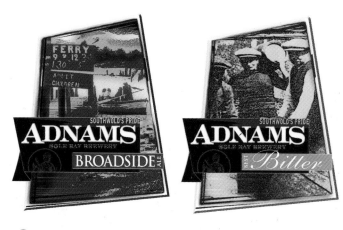

So the designers delved deep into the history of Southwold and came up with a series of icons and imagery from the area—a ship from a well-known battle right off the coast in 1692, a lighthouse, a longshoreman, and a 500-year-old carved wooden figure named Southwold Jack, who rings the bell at local St. Edmond's Church to announce services.

The latter was chosen as the symbol for the core brand and company identity; the others were used on individual beer products. The images were reproduced as linocut illustrations rendered by Chris Wormwell, an artist who knew and had a passion for the area.

The crossed flags were redrawn with more life and movement so they looked like ribbons, giving them an identifiable shape that would be recognizable on bottles, signage, pump clips, trucks, and more. Even better, the ribbons could be picked up alone and used elsewhere, such as on the company's wine bottles and collateral.

"This mark has movement and color, rather than being flat, dull, and dark. The imagery came from the notion of sails, and their curves suggest motion. When you walk into a pub and see the mark, it almost looks as if it is moving," the designer says.

For the packaging of individual products, Wormwell customized the ribbon with linocut-like illustrations, using the icons and imagery from the Southwold area created before.

⬡ Here the label design has been refined; although the client asked that the crab be replaced with a more local image. The flag design was developed into the sail design.

⬡ Another option that the designers explored was photography based.

On a walk on the beach, Shearsby found a thick fragment of old glass. "Inspiration for the entire project came from that piece of glass. It had a timeless feel, like when you pick up shells or pebbles on the beach. They are somehow imbued with memories of other times and places. They tell a story. We felt that we could use those qualities to inspire the redesign."

So the redesign of the core logo began. The old marks (each beer label had its own shape and illustration) had charm, but they also had the feel of a badge removed from an old engine. Shearsby's experiments centered on creating a single distinctive shape that could be used anywhere, from labels to buildings.

One of his first ideas was a pair of crossed flags, which came from the idea of using flags to send signals and was therefore closely linked to the town's maritime history. He chose a small crab, very much part of the company's coastal location, as a potential brand icon and positioned it between the flags. Although Adnams loved the idea of the flags, the company's representatives felt the crab was a step too far away from the brewery's heritage and asked Design Bridge to rethink the symbol.

⬡ The Design Bridge designers commissioned an entire alphabet, based on an old Adnams' font, for the new identity.

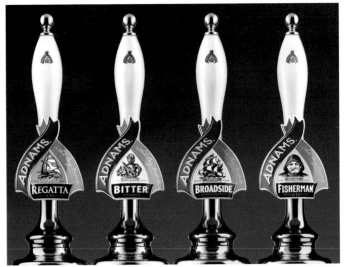

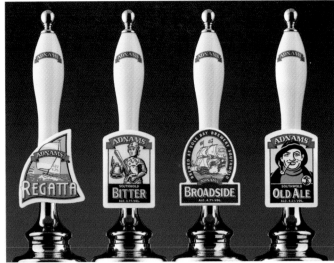

The new (above left) and old (above right) pump handles reveal how progressive the new identity is.

The contained, two-sail design is used on trucks, signage, pump clips, and other places where a defined shape is necessary.

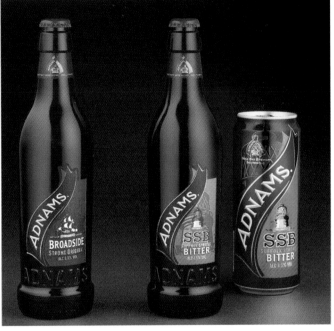

The one-sail design is used on cans and bottles, where the shape of the package is well defined. Just using one sail allowed the designers to make the name of the brand and the product larger.

Also part of the new packaging is a special Adnams' font, designed by freelancer Ken Wilson, especially for the company's new identity. The new type is based on the original Adnams' font, only crisper and more contemporary.

A new bottle was also created for the rejuvenated brand. Its shape was based on the strength and curve of an old beer bottle that the design team found while looking at old Burgundy wine bottles in a wine cellar beneath the Adnams' brewhouse.

Once the new core mark—the crossed flags—was designed, it had to be translated for use onto bottles and cans. The pump clips needed to be contained in their shape, but the designers had some freedom interpreting the mark for individual containers. So they decided to use only one flag for these applications, which allowed them to make the Adnams' name as large as possible and give the individual product names more prominence.

"It's almost as if you are taking a close-up, cropped view of the pump clip. It really emphasizes the movement and three-dimensional qualities of the identity," says Marshall.

The final packaging and logo work as well in a cozy country pub as they do in a smart city bar, says Shearsby, but the proof is in the business sense of the solution. Adnams reports that even with only limited advertising in the East Anglia region, sales have risen more than 30 percent. Sales of the Broadside beer alone have increased as much as 67 percent.

Shearsby is pleased with the outcome of the project for these and other reasons. "Together, Design Bridge and Adnams have challenged conventions and still captured the spirit of this unique area of England. These people love what they do—this isn't just some industrial project. This solution reflects their passion and involvement, as well as the human element of an independent company," he says.

VALUE PRODUCTS—DESIGN THAT DELIVERS
Chock Full o' Nuts New York Classics

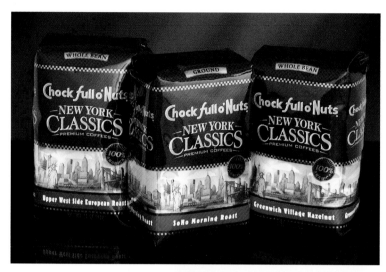

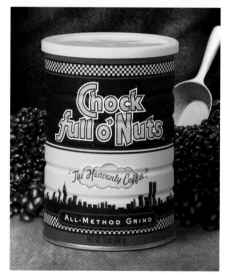

New York Classics is the new premium variety of Chock Full o' Nuts. Both the core brand and the new line are readily identifiable with New York City, the brand's birthplace.

Chock Full o' Nuts has been a New York tradition since 1932, when the first Chock Full o' Nuts shop opened its doors in mid-town Manhattan. Not only has the coffee brand been enjoyed for generations, there are few households on the Eastern seaboard that do not have at least one Chock Full o' Nuts can in the garage, closet, or basement full of nails or screws. It's a comfortable part of many households.

When it came time to update and strengthen the brand, it made sense to hold onto these well-established ties to New York's heritage. It was time to reintroduce consumers to a more contemporary brand and, in fact, introduce it for the first time to consumers nationwide. One line that Sara Lee Coffee and Tea, owner of the Chock Full o' Nuts brand, wanted to promote more widely was a yet-unnamed super-premium variant. Sara Lee Coffee and Tea charged the New York office of Lipson Alport Glass & Associates (LAGA) with the challenge of branding and packaging this product.

Walter Perlowski, LAGA senior designer; Rob Swan, LAGA creative director; Lara Holliday, LAGA brand consultant, and their design team assembled a unique crew of Sara Lee Coffee and Tea brand team members, LAGA designers, and strategic branding experts. Everyone met for a collaborative brainstorming session at Here, a chic New York coffee house, to absorb caffeine and atmosphere and then delve into strategies for naming and positioning for the product. The group considered "New York Neighborhood Blends," "New York City Scenes," and "New York Classics" as possible names and positioning elements.

The creative group eventually settled on New York Classics. The team determined that this name would best represent the brand's emotional and aspirational ties to New York City. It spoke to the genuine quality of the product, reminding the consumer that this is coffee the way it was really meant to be.

With this information in hand, the design moved into round one. The concepts developed at this stage centered around several visual themes: fully dimensional, romanticized versions of the New York cityscape; illustrative renderings of New York neighborhoods, full of people and activity; and famous New York scenes, such as Madison Avenue and representations of some of the first Chock Full o' Nuts cafes.

The cityscape approach was selected as having the most promise. "This direction was successful in that it harkened back to the Chock Full o' Nuts baseline equity, but had the potential to interpret the subject matter in a more contemporary, stylized fashion," explains Holliday.

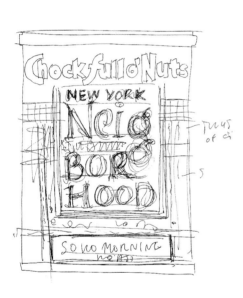
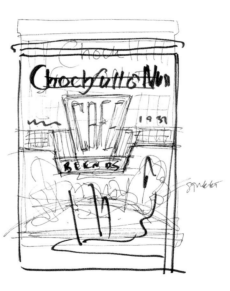
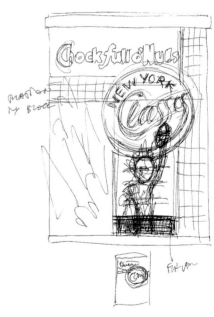

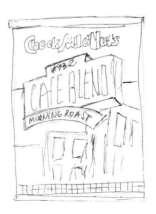

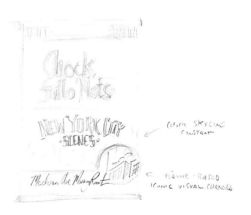

LAGA designers explored many different personalities for the new brand. Some sketches used cityscapes, whereas others portrayed famous New York City scenes. The cityscapes were eventually deemed to have the most promise.

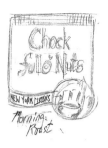

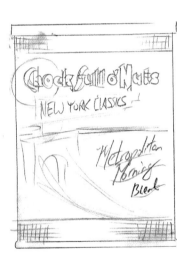

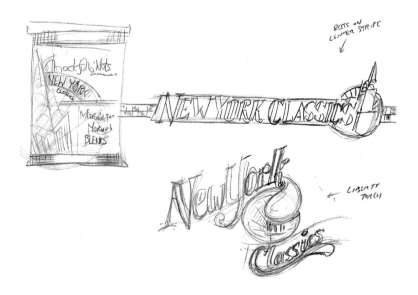

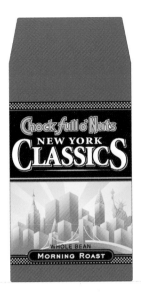

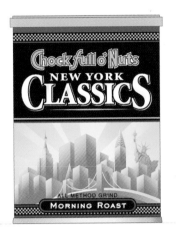

This design was moved on to round 2, where the design team started to consider ways to express the product's flavor names. The creative team took this opportunity to highlight the brand's historic relationship with the city by using iconic neighborhoods for their flavor names, such as "Soho Morning Roast."

"The client was very hesitant to walk away from the existing brand architecture of the baseline, so the primary focus was to work within this horizontal yellow and black system and retain the checkered effect long associated with Chock Full o' Nuts," recalls Perlowski. The project was moving ahead swiftly.

But on September 11, 2001, everything changed. The World Trade Center, which was naturally a focal point in the cityscape renderings, was attacked and destroyed. The abrupt and unwelcome change to the New York skyline raised many sensitive issues for the brand.

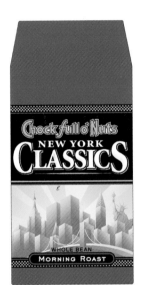

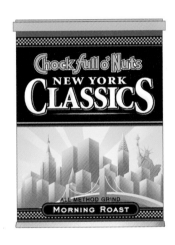

"We questioned everything about the positioning at that point," Swan recalls. The buildings were already firmly planned as a part of the packaging design of the base brand. "We did some quick research with consumers, and overwhelmingly, the sentiment was to leave it on the base brand but not to use the image on this new package."

Now the designers had to revisit the illustration they planned to use on the New York Classics package. Rather than render an accurate cityscape, they tried different representations of New York. This included gathering together New York City icons—"places that people would associate with the city," explains Swan—as well as more artistic ways of illustrating a skyline or even completing a skyline with no recognizable buildings. They also considered loosely colored montages or collages of city elements and scenes that would have a more dramatic and funky feel.

The approach that won out was the collection of New York City buildings and landmarks all compressed into one geographically

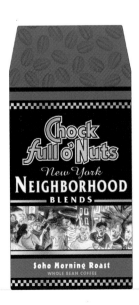

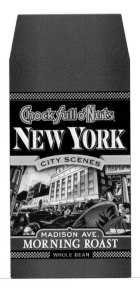

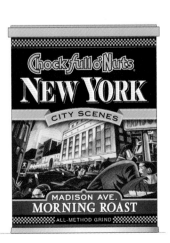

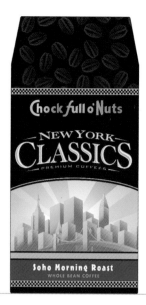
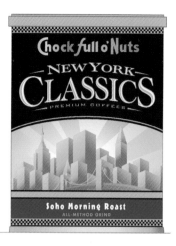
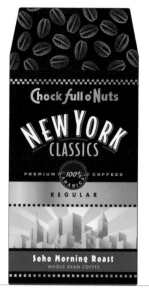
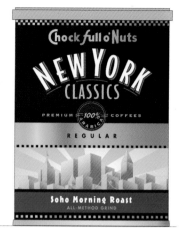

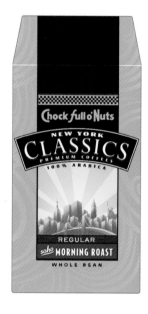
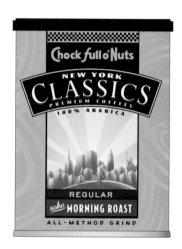

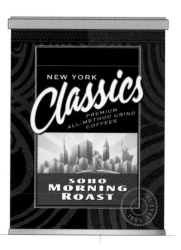
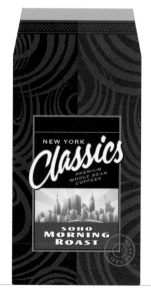

inaccurate, but still easily identifiable, representation of the city. The illustration that was developed featured a romanticized New York cityscape, including the Statue of Liberty, the Brooklyn Bridge, the Empire State Building, and other iconic landmarks. The cityscape was arranged in such a way that the absence of the World Trade Center was not immediately noticeable. The team felt that it captured the essence of New York, both for residents of the city and people across the country.

Finally, refinements could begin. LAGA's goal at this point was to finesse the typography, illustration, and other graphic elements to yield a fully integrated package design. LAGA also created back panel copy that told the rich story of the Chock Full o' Nuts brand and supported the product benefits on New York Classics.

The end result is a compelling product offering from a brand that was steeped in the history of New York City. LAGA was able to react quickly to the changing sensitivities of consumers after one of our nation's most tragic disasters, while at the same time moving the Chock Full o' Nuts brand ahead.

The cityscape image was further developed with the addition of patterning and more color.

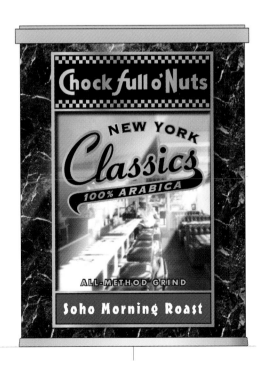

In round two of the new package design, the LAGA designers started to consider the product's flavor names. They hearkened back to iconic neighborhoods for their names, and the art followed suit.

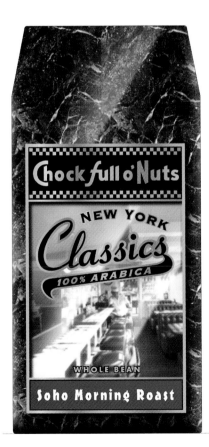

After September 11, 2001, the entire notion of a realistic New York cityscape had to be reconsidered with the destruction of the World Trade Center. Alternate approaches included a less recognizable skyline, loose montages of city elements and scenes, and other more artistic ways of suggesting the city.

What kind of packaging **appeals to consumers** for whom money is no object? Is it better to go **over the top** in terms of **opulence and quantity** of materials? Or is an **understated** approach more engaging? **Philip B** could go either way.

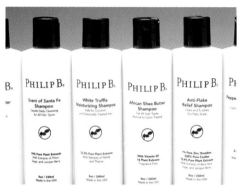

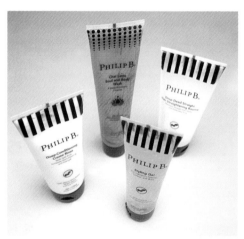

AdamsMorioka's bottle design for Philip B was understated to the extreme, but at $50-plus per bottle, it is sold to people who don't need to be sold to. The tube design took the concept to the next level: The clear containers carried more elaborate patterning, still in black and white. The product color showed through, which added yet another dimension.

Designers at AdamsMorioka (Los Angeles) believed in the latter philosophy when they created an extremely minimal packaging system for Philip B, a high-end line of shampoo and other personal care products that can cost up to $65 per container.

"The people we are talking to don't need to be sold to: They are already in the mode of wanting an understated product for their bath," explains principal Sean Adams. He compares the Philip B experience to patronizing the most exclusive restaurant in LA. "It's a sushi place that is not advertised and doesn't even have a sign on the door. You just have to know about it."

When AdamsMorioka began working with the client, the product had been in existence for several years and was selling well, but in limited venues. The client, who had designed the original packaging himself, was frustrated by not being able to convince high-end retailers such as Barney's or Sak's to carry his lines.

Adams felt that the original packaging design might be a liability: It just didn't speak to consumers on the shelf, so the store's buyers would not place orders. Clearly, a revamp was needed.

The design team began by doing an audit of many different hair care and personal care systems, from pricey to discount levels.

"We found out that the cheaper the brand was, the more flashy it became, with silver and pink and fancy bottles. One thing we knew about Philip B was that it was an honest product. He really used organic ingredients: When the label said 'avocado' or 'peppermint,' those things really were in the product. It was important to communicate that authenticity in the package design," explains Adams. "When you try too hard, it just ends up looking cheap."

He felt that this quality could be conveyed through good typography, decent but simple materials, and a basic design. The designers went out of their way to select the most generic bottle form available. This also conveyed the idea that the spending went into the product and did not need disguising. Adams says that he is highly annoyed by bottles that are shaped like flying saucers or anything other than what they are supposed to be. They smack of people trying too hard to be hip and get attention.

The formal elements of the packaging, although minimal, were chosen carefully. The typefaces Mrs. Eaves was chosen as the basis for the Philip B word mark; Avenir is the primary font used for all applications. In both instances, these faces are warmer and more casual than other traditional fonts like Bembo or Futura, Adams explains.

PHILIP | b

PHIL^b IP

PHILIP B

ꟼHILIP
B

PhiliP B

Philip **B**

PHILIP B

PHILIP/b

Because the word mark would be the centerpiece of the package design, the designers spent a great deal of time experimenting with different personalities.

The black-and-white color palette was a nod to the client's previous packaging, but it was also chosen for its strength. The client had also alluded early on in the project to the essential nature of Fornasetti plates and Aubrey Beardsley prints. "Although most of us think of black and white as being basic, how often does it get used in a final product?" Adam asks. "This combination stood off the shelf amid the sea of color and became proprietary." Another consideration in selecting black and white, although minor, was that the bottles look good in any bathroom, regardless of tile color or decor.

The iconic system was set up to delineate the products in a subtle way. The icons were designed not to be literal—as in showing a white truffle for the White Truffle shampoo—but were organized by inspiration and spirit. For example, when developing the Chai Latte Body Wash, the client had been inspired by Eastern thought. So a lotus leaf was used as the basis for its icon.

The bottle's cap is nothing out of the ordinary—just a functional stock item. Used on a white bottle, the cap is like the classic Chanel suit that stands the test of time, as other products are repeatedly recreating themselves in fashionable colors and typography.

Almost immediately after the new packaging was launched, the client sales leaped nearly 300 percent, due in large part to new distribution agreements with Barney's, Sak's, Fred Segal, and selected high-end beauty supply stores, as well as an hour-long segment on QVC. From this strong foothold, the client was able to develop and release new product lines: lotions, styling gels, body washes, and more, many of which would be packaged in tubes.

Carrying the black and white scheme through on the tubes would be important, Adams recalls. The typography and graphics were simple enough to translate well to the new package shape. And what initially looked like a production problem turned out to be a design opportunity that opened up the project in unexpected ways.

Tubes usually have some sort of graphics covering their sealed end that hide the portion of the tube that is not filled: Some air is necessarily left in the tube to allow for natural expansion of the product due to changes in temperature or atmospheric pressure. The designers felt that, in keeping with the product's philosophy of complete honesty, it would be better to leave the area completely clear. But the manufacturer prevailed.

The result was a compromise: a series of black and white stripes that partially obscured and partially revealed the end area. The stripes inspired additional designs for other products, including dots, Kanji characters, and a dot pattern inspired by a Thai textile.

"The patterns match the personality of the product," Adams explains. The Thai pattern was obviously designed for the Thai Tea Body Wash, the falling drops worked with the Chai Latte Body Wash, and the simple stripe was appropriate for a base product like the conditioner. Says Adams, "I can only explain that if you use the Body Wash, you'll understand why the drops slowly and quietly disappear."

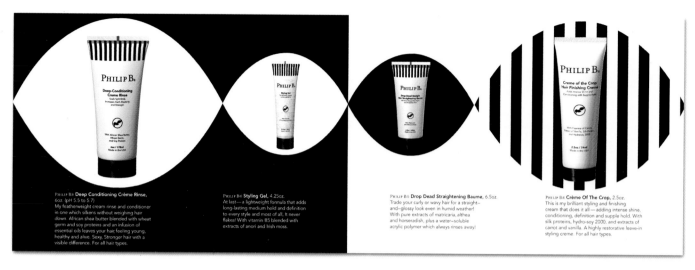

PHILIP B® **Deep Conditioning Crème Rinse,**
6oz. (pH 5.5 to 5.7)
My featherweight cream rinse and conditioner
in one which silkens without weighing hair
down. African shea butter blended with wheat
germ and soy proteins and an infusion of
essential oils leaves your hair feeling young,
healthy and alive. Sexy. Stronger hair with a
visible difference. For all hair types.

PHILIP B® **Styling Gel,** 4.25oz.
At last— a lightweight formula that adds
long-lasting medium hold and definition
to every style and most of all, It never
flakes! With vitamin B5 blended with
extracts of anori and Irish moss.

PHILIP B® **Drop Dead Straightening Baume,** 6.5oz.
Trade your curly or wavy hair for a straight–
and–glossy look even in humid weather!
With pure extracts of matricaria, althea
and horseradish, plus a water–soluble
acrylic polymer which always rinses away!

PHILIP B® **Crème Of The Crop,** 2.5oz.
This is my brilliant styling and finishing
cream that does it all — adding intense shine,
conditioning, definition and supple hold. With
silk proteins, hydro-soy 2000, and extracts of
carrot and vanilla. A highly restorative leave-in
styling creme. For all hair types.

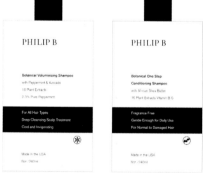

The simple bottle designs not only looked elegant but were also basic enough to be combined with other patterning and effects, some of which were quite exotic. Various marketing materials picked up on the patterning, some in dramatic ways.

Each package design was minimal from the start.

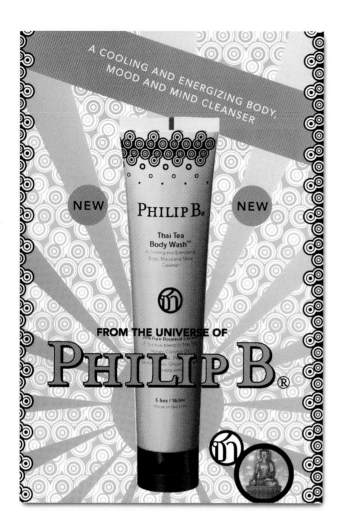

Where the design of the Philip B packaging is extremely simple, the materials that support sales of the products—ads, postcards, and other marketing materials—go in a completely different graphic direction. A postcard designed for a new body wash, for example, has everything in it but the kitchen sink, Adams says—lots of color, Asian cues, photos, different patterns, even the word "new" called out in small bursts. It is decidedly more forward.

"In the store, the products need to look consistent and clean," Adams says, "but in the home environment, the products need more sales support." The combination of simple and complex also reflects the client's personality: He is completely serious and committed to the integrity of the product, but he is also one of the most unique and exuberant people Adams knows. The client embraces the dichotomy of this situation and pushed the designers to explore it.

The whole system is essentially contradictory, Adams says. It is not an approach a designer could get away with for a Fortune 500 company product, but it has worked for Philip B, which had at this writing just opened its own store on très chic Robertson Boulevard in Los Angeles.

"When we first started working with the client, he was still working out of his living room, so to see his growth is really wonderful. He already had a really good product: We just made it possible for people to notice it," Adams says.

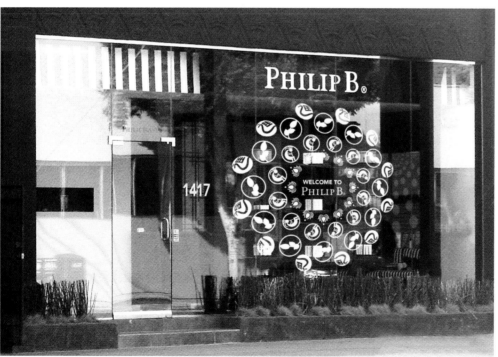

The various products carried many symbols that were representative of the personality of the package's contents. These symbols formed yet another design resource for the client. Here the designers used the symbols to form a mandala on the storefront window of the client's new store in Los Angles, California.

Blue—as a color and a distinguishing product characteristic—was important to the **Pepsi-Cola Company** for a number of reasons.

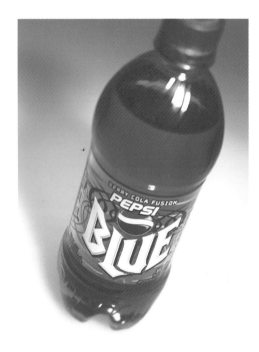

MLR Design combined many visual cues from youth culture for a new Pepsi soft drink, Pepsi Blue. Tattoos, snowboard graphics, neon lighting, and more all lent their influence.

First, it was a revolutionary color for the cola category, and it scored well with the 16-year-old male target customer the company wanted to woo with a line extension of its Pepsi product. But perhaps even more important, it gave the company a chance to integrate its own brand color right into the product itself.

After focus testing confirmed that the bottler was on the right track, Pepsi contacted MLR Design (Chicago) to collaborate with the Pepsi Design Group on the development of Pepsi Blue. Christy Russell, director of business development for MLR, explains what happened next.

"The proposed product had tested well, and now it needed some imagery," Russell recalls. "With the packaging design, Pepsi wanted to focus on the independent personality and on self-expression. The product was to be a celebration of independence—that drove our entire creative exploration."

Because the shape of the bottle itself was already dictated by pre-existing market requirements, the design team focused on the label. They began by studying imagery from extreme sports such as snowboarding and skateboarding and from youth magazines, the music field, and MTV. Another visual angle that they studied was the tattoo, which combines the notion of art and self-expression.

The designers created a diverse range of presentation roughs. Some early trials expressed the notion of nightlife or night energy by means of neonlike graphics. These had a sense of electric energy, and they also appealed to the 16-year-old's sense of wanting to be part of an older crowd with a later curfew.

Another direction had a definite extreme sports inspiration behind it. "Any activity that is a bit left of center appeals to this age-group," Russell says. "The drink itself has that quality, so visually tying it to alternate activities neatly connects the product to excitement for the buyer."

A third direction tapped into the notion of standing out in the crowd, as members of the less than mainstream youth culture would. Tattoos are a natural visual for this group. "Tattoos are a bold, personal identity—not like the rest of the crowd," says Jones.

One trial used the familiar Pepsi ball as a globe element. "The Pepsi Blue world is a different kind of place," Russell says. "Things are unexpected there, and there's a lot more energy." Another trial along these same lines used a background pattern to suggest a crowd of people in a cityscape.

BAND LOGO-CLIENT: ARISTA

MOVIE TITLE-CLIENT: BLT & ASSOCIATES

GAME TITLE-CLIENT: McELROY FCB

tribes

To find inspiration for the packaging design for the new Pepsi Blue product, targeted directly at 16-year-old males, MLR designers studied imagery from extreme sports, tattoos, youth publications, and the music field.

The Pepsi ball showed up in other experiments as well. One of Russell's favorites placed the ball so that it looked like the center of a throbbing speaker: This exploration suggested its own beat, but it also offered a subtle refreshment cue: The ripples surrounding the art could also suggest the product's liquid, thirst-quenching possibilities.

In all of the Pepsi Blue studies MLR presented to its client, the design team viewed the beverage product as a fashion statement. With a consumer profile that included the words "hip, edgy, bold, and independent," the energy level had to be high, says the project's creative director, Thomas E. Jones.

"A soft drink becomes a self-identity piece because we consume it in public. It's the same in the gum and mint category. Anything you consume in public is a statement of fashion, especially with kids who are so concerned with their images," Russell explains.

The comps created in this first stage of the project went into customer testing. Two strong directions emerged: tattoos and neon.

With the tattoo effect, the question was whether to make the name of the product a tattoo or to incorporate the name into tattoolike artwork. At this stage, the designers are developing the entire label. To up the impact of these new branding statements, they decided to make the graphics on the front larger and more prominent.

The neon studies tested very well, but in the end they were deemed to not contain enough action, even with lively backgrounds that added dimension to the designs. The tattoo approach eventually won out.

The time span for the project was extremely brief—only six weeks. Russell says that because the in-house design team at Pepsi is a very collaborative group, her firm had plenty of support. Also adding to the energy level is the fact that working on such a high-profile project is an enormous morale booster to her staff.

"The only way you end up having work like this in-house is to get through some very stiff competition," she says. "The huge boost we get from a project like Pepsi Blue helps us do that."

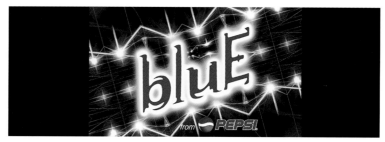

This trial expressed the notion of nightlife or night energy. The neon-like background and the neon-inspired logo communicate an electric energy.

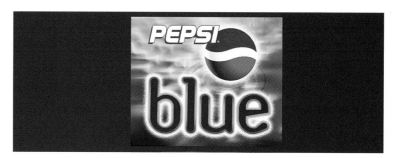

Here the designers looked at taking the "B" from "Blue" and turning it into a large icon. It is a hip look, inspired by logos on the labels of urban-styled clothing as well as on the large initial caps commonly used on sports clothing.

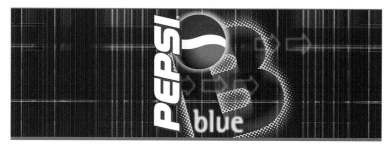

Cool and refreshing: That's the basis for this design. Although introducing the notion of water as a refreshment cue is visually effective, focus group studies revealed that this approach was far too sedate for the target audience.

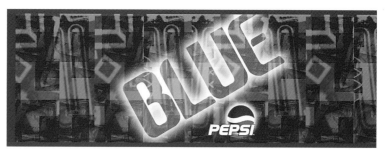

A background full of shapes and patterns suggests an urban landscape, bustling with crowds and energy. Blue, the color of both the product and the Pepsi brand, is also integrated right into the logo here, connecting the brand with the subbrand.

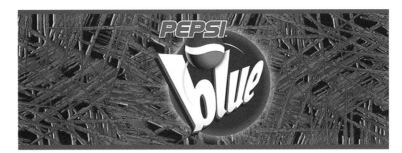

There was no sketch for this comp, because it was done entirely on the computer. The designers mimicked the Pepsi ball, but they used it here as more of a globe. The suggestion was that this is the "Pepsi Blue world," an unexpected place full of energy. The blue, frost-like background is a definite refreshment cue.

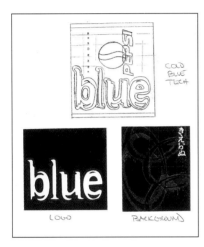

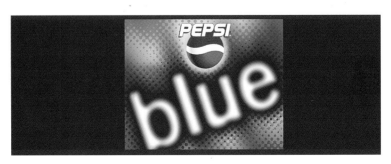

This comp was inspired by the club and nightlife scene. The designers reasoned that most 16-year-olds aspire to be older and take part in more mature activities, but this sophisticated approach also proved to be too subdued for the target audience.

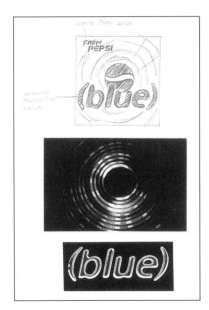

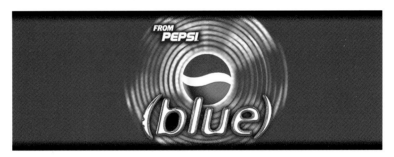

This trial emerged as a favorite with the design team: Viewed as the center of a speaker, it is a visual expression of a beat. This touched on the teenager's interest in music, especially loud, exciting music. But the circling rings can also be viewed as ripples in water, a refreshment cue.

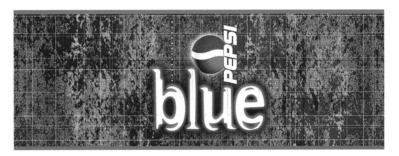

This design is another one that refers to the notion of staying up late and having fun. The logo almost looks like it is being viewed from the outside through a bubbled glass window: Inside, something fun is going on.

◇ During the second stage of trials, the designers began developing complete labels for the client's review. These five comps are five different spins on tattoos. In some cases, the product name is the tattoo; in others, a tattoo-like form embraces the name. This was the direction that was eventually refined for the final design.

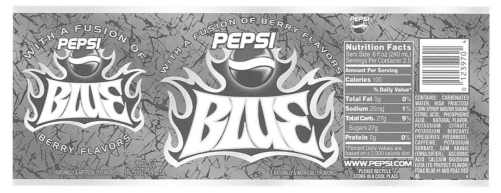

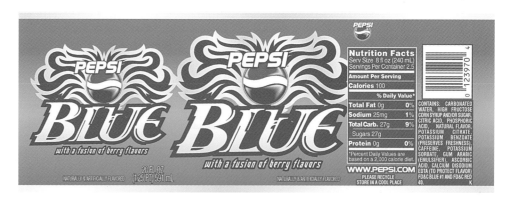

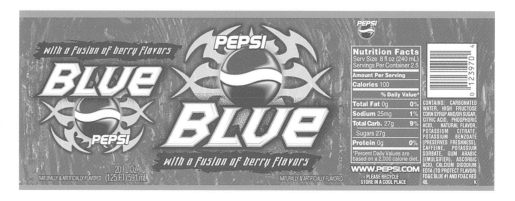

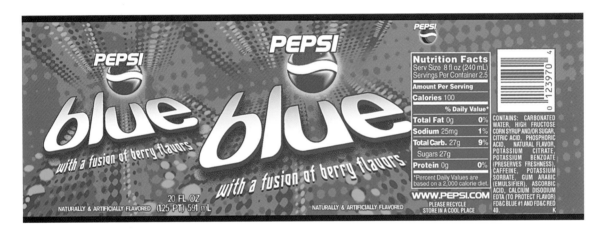

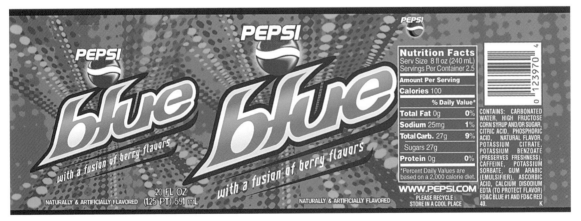

Another sketch done entirely on the computer. Here the ideas of extreme sports, music, and tattoos are combined. It was chosen as one of the initial ideas to be taken to the next level of exploration.

These glowing designs tested well with customers and received positive feedback from the client. In the first, a background dot pattern adds action to the design; in the second, the tunnel of lights is augmented by a tattoo element.

So many **package designs** are about "making the product hero." Is there ever a time to **make the packaging the star** of the show? David Richmond, principal of the London-based design firm, R Design, decided **the time was right for Selfridges,**

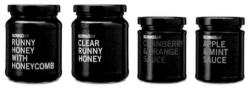

⊘ The Selfridges' packaging redesign project certainly makes the packaging—not the product—hero. R Design of London created a system that is sleek, elegant, and modern.

an enormous UK department store that sells high-end goods, including its own line of quality packaged foods. For the most part, consumers did not realize this, though. The store's products lacked impact on the shelves or its packaging mimicked other, better-known brands.

"Selfridges has a good reputation for fresh foods, but most shoppers didn't know that the store had its own packaged goods," Richmond explains. Not having a package design with impact was somewhat of an anomaly for the brand, because everything from the architecture of its buildings to the layout of its stores on down is all carefully planned to improve the shopping experience. Selfridges, as one of the most prestigious shops in London, usually paves the way for other retailers.

Another unusual twist to the project, according to Richmond: "They asked us for our opinion. Most clients just tell you what they want. Here Selfridges asked us to start fresh."

The client's forward-thinking request would be limited by only one thing: R designers would have to use stock containers.

The first design that Richmond's team developed was his favorite from the start. The store was one of the few around that could get away with a strong, modern statement, he reasoned. Simplicity could provide that message through design. From this evolved a concept in which all of the packaging was the same color—black—with no product showing and flavor insinuated through type and color. Given contemporary standards, the design was almost antipackaging.

The typography used would also be simple, restricted to a grid and kept at the same point size no matter what the size of the package was. The size and shape of the physical pack would play off of consumer's preexisting knowledge of packaging and let the shopper figure out what he or she was looking at—a bottle of wine or a package of coffee, for example.

Black felt timeless and classic to Richmond, but it is also a signature color for the store. "Color coding everything in black would make an incredible statement," he says. "Just the type would reflect what was inside—for example, strawberry jam would have pink type. People already believe in the store and its quality, so it is not necessary to show pictures of the product on a label or even show the product through clear glass or plastic."

Furthermore, because the black had such impact, the products would be easy to pick out, even if they were not displayed together in the store or were mixed among competitors' brands.

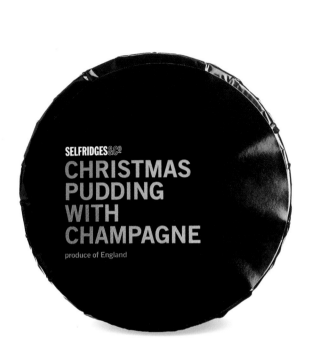

SELFRIDGES&CO
CHRISTMAS PUDDING WITH CHAMPAGNE
produce of England

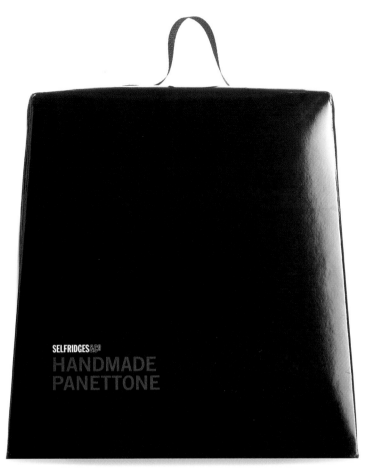

SELFRIDGES&CO
HANDMADE PANETTONE

The first set of experiments that David Richmond and his designers created turned out to be everyone's favorite in the end. No product shows. The type is extremely simple. Everything but the type would be black, and the color of the words would offer flavor or product cues.

The design brief called for three designs, so Richmond's team continued with their explorations. Another idea was to design packages that people would treasure and keep. This concept would involve frosted, acid-etched containers—which turned out to be prohibitively expensive—with all of the product's information printed on an intriguing swing tag. Bottled water, for instance, would have a swing tag that carried the image of a rubber duck: The connection to water is immediate.

"Although the concept behind this was nice—that you could keep the jar or pack once it was empty—this design did not have the same impact as the black range. It just wasn't Selfridges," Richmond says.

Another concept brought the store itself onto the labels. They would photograph products that in some way related to the product in the package—for example, a high-end toaster that the store carried could be pictured on the jam label. Each label would end up being a mini-advertisement for something else that was for sale at Selfridges.

However, the logistics of matching up 70 different product pairs in this way would be a challenge. Plus if the store dropped the toaster shown on the jam label from its stock, the label would have to be redone.

The all-black idea won out. Originally, the designers envisioned that the graphics would be silk-screened onto black glass or tubes, but this proved to be cost prohibitive. The alternative, though, created what was an even more significant design statement: Graphics were printed onto plastic, which in turn was shrink wrapped onto all containers. The effect is complete uniformity in color and surface texture.

As of this writing, the new packaging has been out only a few months, but already it has been a smashing success: All holiday goods for the 2002-2003 season completely sold out.

A second set of trials was very different from the first. White or frosted containers would carry the product. A related product—actually, another Selfridges' offering—would be shown on the label. For instance, a refrigerator would be shown on a bottle of spring water. The client liked this approach, but it proved to be impractical: What if the store decided to drop that certain line of refrigerators? Visions of reprints followed by more reprints stopped this design.

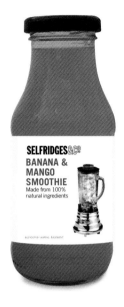

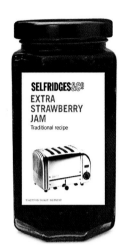

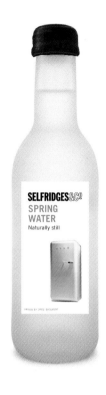

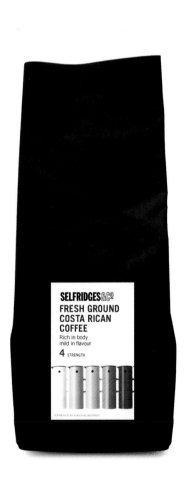

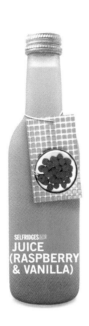
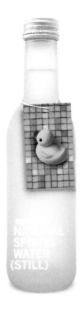

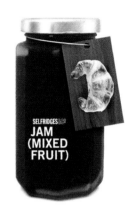

WHITE WINE
(CHARDONNAY
VIN DE PAYS
D'OC 2000)

RED WINE
(MERLOT
VIN DE PAYS
D'OC 2000)

JUICE
(RASPBERRY
& VANILLA)

NATURAL
SPRING
WATER
(STILL)

GROUND
COFFEE
(COSTA RICAN)

JAM
(MIXED
FRUIT)

A third approach could have used any color of container: It incorporated tags that carried images with themes related to the product. The spring water bottle would have a tag with a rubber duck printed on it, for example. The designers imagined that the containers used in this scheme would be attractive enough that consumers would want to keep them for reuse.

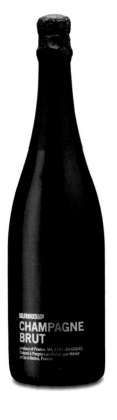
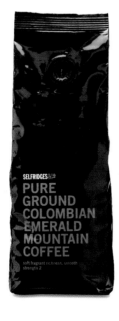
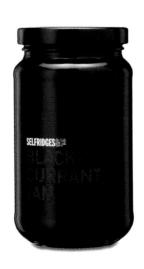

CHAMPAGNE
BRUT

produce of France, MA-2051-2G-00245,
Elabord à Pargny-Les-Reims par Mérlot
et Cie à Reims, France.

PURE
GROUND
COLOMBIAN
EMERALD
MOUNTAIN
COFFEE

soft fragrant richness, smooth
strength 2

BLACK
CURRANT
JAM

Black coats all packaging in the new line. Color as well as texture is similar across all SKUs. The type does change in color, but it is always positioned in the same place. There is no doubt that these products are from the same Selfridges family.

Floris is the oldest perfumer in London. Founded in 1730 by Juan Famenias Floris, it is now **being run by the eighth generation** of the Floris family from the fashionable address of

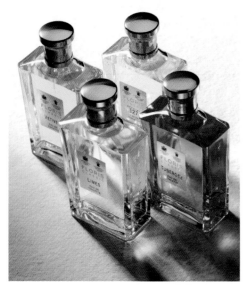

○ "To take a project with a fantastic name, which no one had really looked at graphically for 20-plus years, was a challenge," says Peter Windett, creative director for the entire Floris rebranding project, which included bags, men's products, home accessories, candles, and more. Trickett & Webb handled the redesign of the women's fragrances.

○ The original Floris packaging had a distinctively dated look and did not attract younger customers.

89 Jermyn Street, London, where it has sold fragrances since its founding. In fact, up until the 1960s, the company handcrafted and packaged all of its products in the basement of the elegantly appointed shop.

Among the company's more notable customers over the years have been Florence Nightingale, Mary Shelley, Beau Brummell, and even the fictional James Bond, who always wore Floris No. 89. Al Pacino's character in the movie, "The Scent of a Woman," said he could always "sight" a woman wearing a Floris fragrance.

All this heritage had served the company well until recently. The effects of the "Cool Britannia" movement had been hard on Floris. The brand was feeling stuffy and out-of-date, and its aging clientele base wasn't being topped off with new and younger customers.

Floris had other difficulties as well, reports Brian Webb of Trickett & Webb, London, the design firm who worked with Floris' creative director, Peter Windett, of Peter Windett Associates to ultimately give Floris an entirely new presence, mainly through its packaging.

"Their original packaging was as dreary as you could imagine," says Webb, "just a standard blue box stamped with their name. Each box had a gold fragrance label that was often stuck on inconsistently."

Floris wanted to increase its sales in Great Britain and the United States, but the big department stores either would not carry the product or they would not place the fragrances in the perfumery department. The packages' ho-hum appearance, combined with the brand's lack of apparent cache, was confining it to the toiletries department, a decided step down for a company whose home shop is outfitted with luxurious mahogany cabinets and shelving brought back from the Crystal Palace at the Hyde Park International Exhibition in 1851.

Heidi Lightfoot, director with Trickett & Webb, points out another serious problem with Floris' original packaging. "As the range of fragrances had expanded, it had become more and more difficult to tell what you were buying off of the shelf. You would come into the store and be faced with a huge bank of navy blue packs, each with only a tiny gold seal to differentiate it from the others. About the only thing you could tell from the box was whether it held a lotion or a fragrance," she explains.

The Trickett & Webb and Peter Windett Associates' designers were fortunate in their initial explorations for the client in that the original Floris shop has tucked behind it a museum of sorts, full of glass cabinets that contain samples of earlier versions of Floris packaging. The older labels were a great source of inspiration for the creative team.

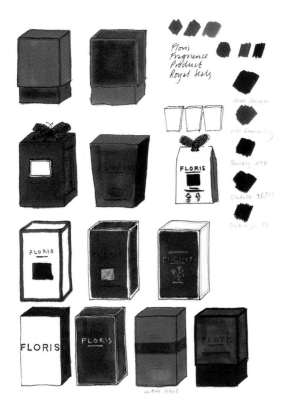

The Trickett & Webb design team discussed for a time maintaining some continuity with the client's original packaging, basically blue boxes with gold stickers. After experimenting with a number of constructions and shapes, the approach was abandoned.

In their new approach, the designers considered fragrances separately. For traditional scents, they looked at imagery from the 1920s and 1930s.

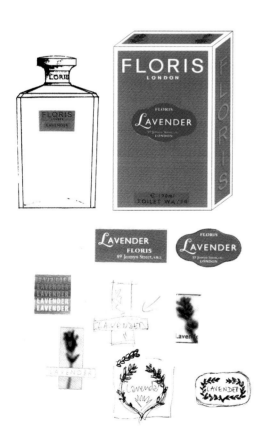

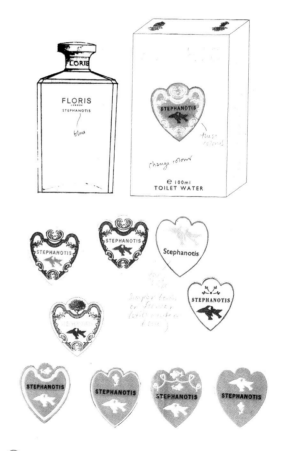

Peter Windett & Associates were developing a new logotype and new bottle shapes, which allowed the Trickett & Webb designers to settle on a box shape and size, as well as concentrate on graphics. The decision to use simple graphics was the next step.

Stephanotis is a traditional fragrance, but it is also closely associated with weddings and young love. So its design was something of a crossover creature, based on the product's original design but with a decidedly modern appeal.

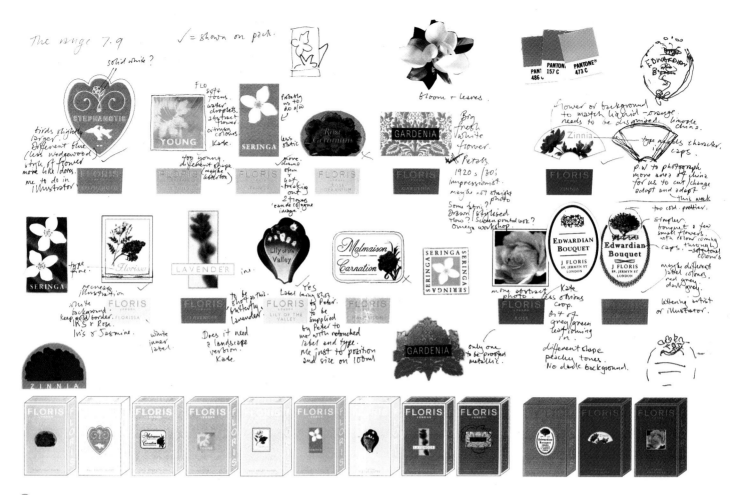

Several sheets similar to this one were produced by the Trickett & Webb team to not only finalize images, color, and typography but also compare one label to the others. All labels had to look independent, but still work together as a unit. Each fragrance has about a dozen product variants, so achieving the right mix was a bit of a challenge.

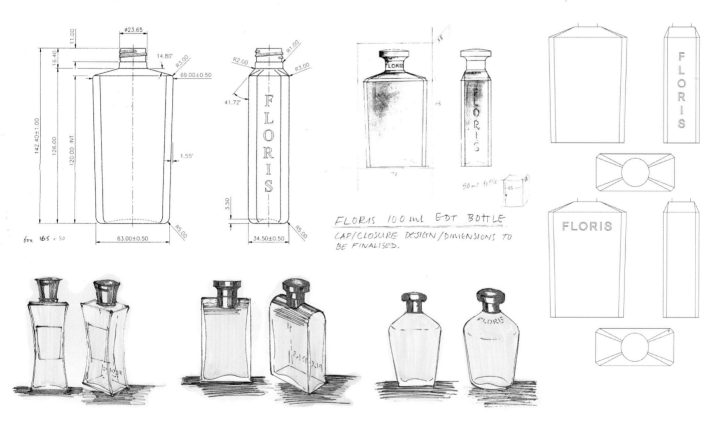

Bottle production studies produced by Peter Windett & Associates.

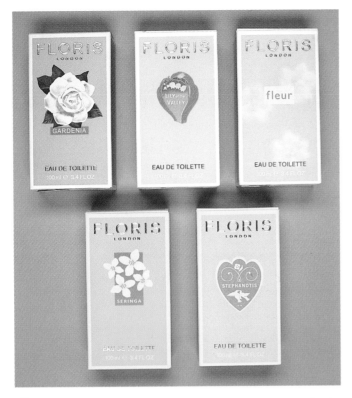

The finished set of package designs works well together as a unit, even though some are traditional and others are contemporary, appealing to customers young and old.

"Some of the fragrances, such as rose and rose geranium, have been around for many years and have gone through many evolutions. We could look back at all of their old labels," Lightfoot recalls.

This archive became especially useful for the designers as they considered the personality of each fragrance. (Ultimately, Trickett & Webb created packaging for 10 fragrances and more than 100 products.) Some fragrances, like rose, were very traditional. Some scents were brand-new, created expressly to appeal to a younger audience. Each of these categories could be further subdivided into daytime or evening products.

The design team toyed briefly with the idea of sticking with the navy-and-gold color scheme and changing the product box's shape and construction. But the old colors were somber and masculine: The client wanted to bring back a sense of femininity, so pastels and other design cues were explored.

With the traditional scents in the line, the designers could hark back to older labels for visual cues. For one fragrance, they had metal type set to inspire an Edwardian feel. For others, they looked for archived images or borders to suggest tradition and, in part, keep existing and loyal customers comfortable with the products.

For the newer scents, abstracted art or photography could be used, and the type treatment for the scent's name could be decidedly more contemporary. Some fragrances, like lavender, are particularly traditional scents, but Floris wanted to give lavender a more contemporary feel for modern customers. So it is a mix of old and new elements.

The color treatment for all products was made decidedly more modern, so that it would be more eye-catching in the department-store setting.

To tie modern and traditional together, the designers created a simple layout scheme. At the top front of each pack is the Floris name. At the bottom is the product variety name—eau de toilette, bath oil, and so on. But at each box's visual center is a different sticker-like element. Another connecting element: Each daytime scent box has a white border, whereas each nighttime scent box has a rich gold border.

"While we were working on the individual labels, we kept looking at the range as a whole. We needed a range of shapes [at the center of the boxes] to keep it interesting, but we still had to have balance among all of the packages," Lightfoot says. "It turned into a real melting pot of photography, illustration, type, takes from old artwork, and retouching."

The final suite of designs hangs together well as a block of products, much better for the retail environment found in large department stores today where "villages" of product lines are grouped tightly together on the shelves.

The original Floris bottles were square; the new molded bottles were designed with a wide front face to give greater shelf presence for pack graphics.

The end result is that sales and outlets for the products have increased enormously, reports Webb. "Saks, Nieman Marcus, Harrods, and other high-end stores, as well as specialty chemists are picking up the products for their perfume sections," he says.

Peter Windett says that the redirection of sales efforts has been a huge boon to the brand, which had been sold in less-than-high-end stores in the United States: Distribution to these destinations was closed down immediately.

The redesign grabbed the attention of the right people. "Floris got the product range and distribution corrected at the same time," Windett says.

Design Edge is an Austin (Texas)-based product development company that **normally does plenty of high-tech design** for clients such as Dell, Compaq, and 3M. But with **Wetnoz,** a project **released in late 2002,** the company's designers had a chance to **get in touch with their more animal instincts.**

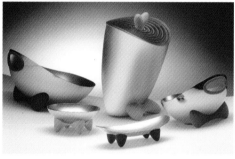

The packaging for Wetnoz, a high-end line of products for pets, protects the stainless steel and rubber offerings, while communicating their design and uniqueness. Repeated color, pattern, and photos are hallmarks of the package design.

The owners of Design Edge, Mark Kimbrough and Pearce Jones, got an itch to do a self-initiated special project. A quick look around their homes and local stores revealed that there was a distinct lack of well-designed products for pets available. With people spending more and more time at home, as well as more and more money on their faithful companions—almost treating them like children, in some cases—it seemed to be an idea with enormous potential.

"A pet has its own toys, bed, and dishes. People want more interesting products in their homes today, even for their animals," explains Design Edge designer Lauren Sanders. She and her teammates went on to create a new brand—Wetnoz (pronounced "wet nose")—which was launched with a line of wonderfully sculptural pet dishes, as well as brand packaging that is one of a kind for the product category.

Wetnoz is "dedicated to producing innovative pet products with soul," according to its mission statement. Its pet bowls come in two varieties: plastic for the economy line, and stainless steel and rubber for the premium line. From a practical standpoint, the latter product would require some protection from scratching in the retail setting. From an aesthetic standpoint, because the other products on the shelves would have no packaging or unsophisticated graphics, the design team knew that their product would immediately feel special. They wanted to give the products a gift-like feel and special appeal to the upscale buyer.

The designers' goal for this project was to look at how the consumer experiences packaging. What does a customer see from the time of entering the store, be it a tier-one PetSmart retail outlet or a high-end specialty shop, to the time when he or she picks up a box, to the time when the box is taken home and opened? The experience had to be a consistent and unique one if the brand was to grow.

The WetNoz logo is decidedly unique: One company founder applied ink to his own dog's nose and applied a print of the nose to a piece of paper.

WET ©

Gus

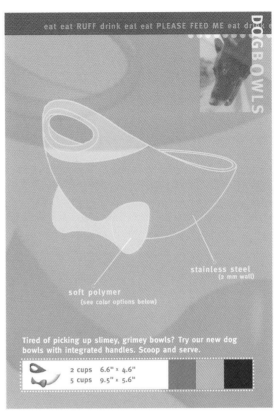

eat eat RUFF drink eat eat PLEASE FEED ME eat d

DOGBOWLS

stainless steel
(2 mm wall)

soft polymer
(see color options below)

Tired of picking up slimey, grimey bowls? Try our new dog
bowls with integrated handles. Scoop and serve.

	2 cups	6.6" x 4.6"		
	5 cups	9.5" x 5.6"		

Early experimentation for the
new line's packaging included
very informal photography, shot
by members of the design team,
and a sophisticated palette.

Pages from the Wetnoz catalog,
produced before the packaging to
inspire early orders, have a mod-
ern and progressive sensibility.

WET O2

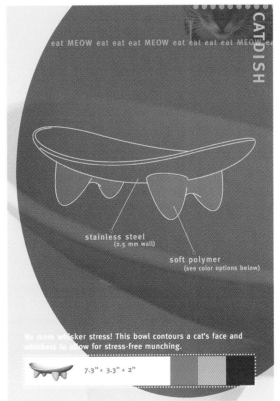

eat MEOW eat eat eat MEOW eat eat eat eat MEOW ea

CATDISH

stainless steel
(2.5 mm wall)

soft polymer
(see color options below)

No more whisker stress! This bowl contours a cat's face and
whiskers to allow for stress-free munching.

	7.3" x 3.3" x 2"		

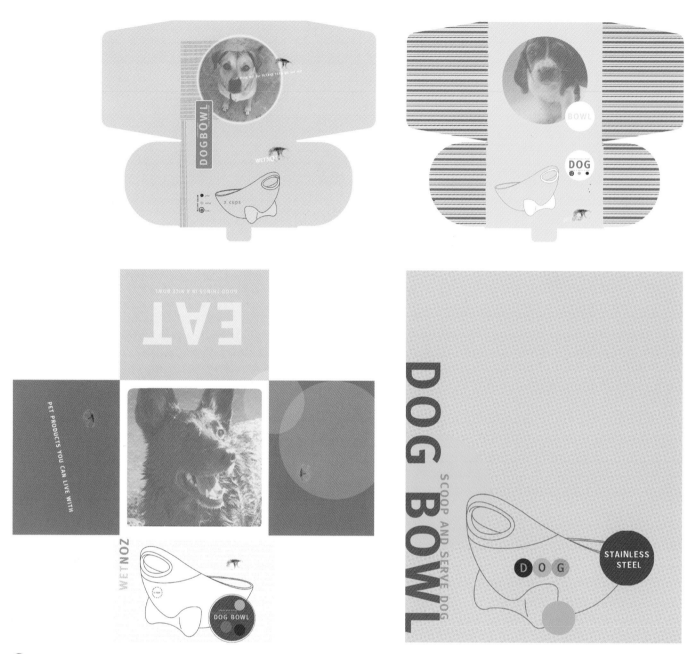

When it came time to designing the product packaging, the designers experimented with many different options. Favorite elements emerged in many trials, such as patterning, dots, and photography of real pets.

The entire packaging and collateral project centers on the image of a wet nose. Mark Kimbrough actually applied ink to his own dog's nose and impressed the image onto a piece of paper. It's a curious visual, Sanders says, one that is often misinterpreted to be an anteater. But somehow, it works with the brand name, which people often mispronounce. Deciphering the logo and trying to work out the name have become almost a game with consumers, the designer says, something that adds to the brand's playfulness and sense of fun.

On boxes and collateral pieces, three components were selected to be used on and around the unusual logo: color, pattern, and photography. The playfulness of pets drove the style of the photography. In fact, rather than use stock photography, which would be expensive as well as smell false, the design team instead took pictures of their own pets and of animals running and jumping at local parks.

"This design couldn't look too slick. It needed to look as if it were done by hand so that it had the sense of real happiness that a healthy dog has when it is running and playing," Sanders says.

Color would also be important in helping the design stand out in this category. To differentiate the brand from the bright, cartoon-like graphics that already existed on other pet-product packaging, the designers went with a more muted, but still colorful palette of green, orange, yellow, and a small amount of blue printed on light gray boxes. It's a contrary approach for the category, but it fits into the team's concept of creating a completely new experience in product and packaging for the consumer.

Color could also help organize yet-to-be-invented designs: A predominantly green box would signify one pet category, whereas another line would have blue boxes.

3" CENTERED BAND

(final) 1" LEFT / 2" RIGHT, WIDE BANDS

1" LEFT / 3" BAND + DOT

⊗ The design team could see how repeating specific, bold elements—a dot, a stripe, certain colors—could create a billboard-like effect with plenty of impact when the boxes were stacked together on the store shelf.

⊗ Here color and dimension are added to the experimentation. By isolating each element, the designers were able to study their individual impact and proportion.

Finally, pattern is important in creating a billboard-like effect on store shelves. From far away, as the consumer enters the store, the unusual Wetnoz color scheme grabs his attention. But as he comes closer, more and more information is delivered through patterning. The Wetnoz "wet nose" logo can be seen on the front of each box, centered in a large dot. A thick, vertical stripe also wraps around each box: When seen on the shelf, the products are easily recognizable as being from the same cleanly designed family.

At that point, Sanders says, the consumer would likely pick up the box and begin to read and understand what is inside. When the product is taken home, a product insert and the product itself continue the unusual visual experience.

Positioning the stripe and dot properly to create an appropriate pattern was easier said than done, however. In trying to work out the exact positioning of the stripe and dot, the designers took a systematic approach: They developed small thumbnails of the packaging in which all graphics were in simple black and white. With these skeletons, they experimented with different sizes and orientations of stripes and dots until the maximum, clean impact was achieved.

"We were trying to come up with as much repetition as possible for high brand impact and recognition, but some elements didn't look strong when they were repeated. So we played with the stripes and dots to create maximum impact while creating a consistent system," Sanders says.

The end result is a system of packaging that not only is noticeable on shelves but also complements the fine design of the products it holds. Each package has the nose-print logo, a stripe of color down the middle of the box, photography of animals, and a small amount of copy.

New products continue to be prototyped, and as they are developed, new packaging will also be required. But the Design Edge designers have already done the hard legwork necessary to make new lines feel comfortably accommodated under the Wetnoz brand name. Additions added to the shelf easily become part of the larger billboard for the brand.

The package is successful, she adds, because it protects the product, communicates the brand through design, and reinforces the brand through the consumer's experience with it. Breaking down the elements of the design was key.

"By isolating each element and doing studies of each design element, we could break the design of the information down into steps of an experience," Sanders explains.

Sanders says that the next step is to develop the plastic value line products that will appear in mass-market stores. Priority for this packaging is low cost rather than substantial product protection, because the plastic bowls are much more impervious to damage. Here the product speaks for itself in terms of design.

△ The finished design is shown here on store shelves. Note how the vertical stripes connect each of the products, whereas color and the dots attract the eye.

▷ The final art for the finished goodie jar package reveals all of the elements.

▽ Samples of the printed boxes.

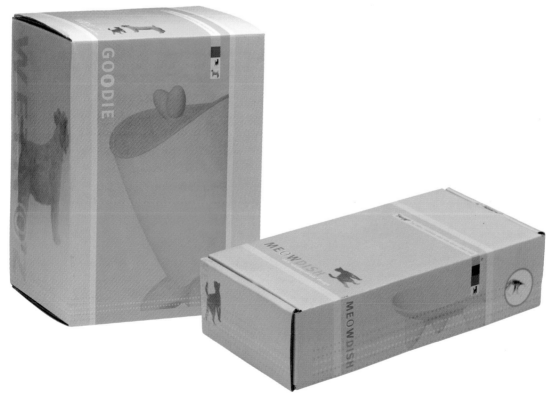

WETNOZ™
1916 Pike Place
Suite 12
Seattle, WA 98101
toll free 1.866.4.WETNOZ
www.wetnoz.com

A portion of the proceeds from the
purchase of this product will be
donated to charities benefiting the
health and welfare of domestic animals.

WETNOZ™

2002 product line

◇ Inserts placed inside the boxes with the products take design cues from the pack-
aging, creating a consistent feel across all elements.

◇ The next set of package design for the Design Edge staff is for the WetNoz value
line. Aimed at lower-priced retail outlets, the value line is made from plastic and so
does not need a box to protect it. A hang tag will be used instead.

VALUE PRODUCTS—DESIGN THAT DELIVERS
Trident White

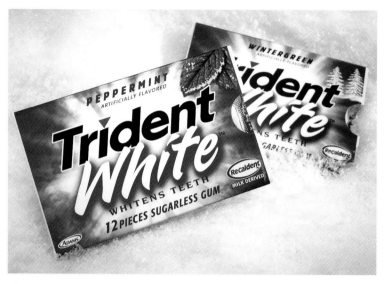

The design of Trident White's packaging, created by Primo Angeli: Fitch, bridges the gap between two apparently disparate elements: dental hygiene and candy. It conveys the benefit and taste at the same time.

 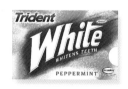
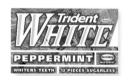 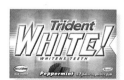 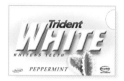

For round one of their designs, Primo Angeli: Fitch designers concentrated on bringing the taste of the product to the forefront, while still insinuating "cleaning." Sharp and angular designs presented the ideas of activity and of ice and crystals. In other designs, the letters themselves were much like the Chiclets-shaped gum; in another approach (actually the design that emerged as the winner in the end, at top center), a calligraphic and friendly look, combined with the peppermint leaf, spoke of confidence and boldness.

There's a big jump between what people consider to be candy and what they cringe and refer to as an oral hygiene product. Furthermore, consumers are likely not to be fooled by a simple candy coating, be it actual or metaphoric. Candy is dandy; the other is not.

In 2001, many toothpaste manufacturers were developing tooth-whitening gums, but these products were baking soda–based and tasted like it. Their packaging looked medicinal. Despite the ease of use—users only had to chew it to reap the benefit—consumers quickly edged away. But as improvements in formulation delivered better taste, in no time, tooth-whitening gums moved into the candy category, where packaging could be much more adventuresome. Trident, already in the gum category, had a head start with its new product, Trident White.

"Because we were moving into a new impulse-purchase area, right near the cash register, where the gum would be sitting next to the M&Ms, the packaging had to be eye-catching," explains the creative director for the project, Aaron Stapley, of San Francisco-based Primo Angeli: Fitch.

The new product packaging had to communicate great taste as well as the product's chief benefit—tooth whitening. It would be necessary to address the product's strength without making it seem chemical. In addition, explains Stapley, the new product should have traits of the parent brand—chiefly, trustworthiness and confidence—but it also needed to feel hipper and more youthful.

Finally, the gum's packaging would have to dispel any sense of self-consciousness on the part of the user/buyer. The gum had to be a personal style statement for the 18- to 34-year-old demographic, not some indictment of the chewer's appearance or lack of self-confidence.

To start the project, Stapley and his designers studied the success that Warner-Lambert, the owner of the Trident brand, already had with Chiclets (another of its holdings) and other Chiclets-shaped gum. They also studied the competition for the product, which included mainstream gums and candy bars, toothpastes, and other tooth-whitening products. "It was a very holistic view of the category," Stapley says.

"Certainly, we knew that the line would be predominately mint, so blues and greens would drive the design. We had to think about this in an innovative way, however. Everybody else who has ever tried to do mint has tried every sort of glimmer and gleam, which led us to try some different things, such as rich textures," Stapley says. "We knew we could make the packet look inviting and tasty, but to make it clear that it also had this added benefit of tooth whitening would be more difficult."

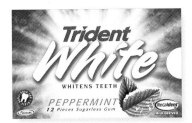
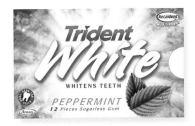

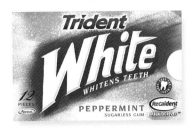
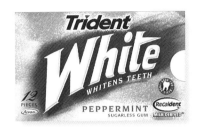

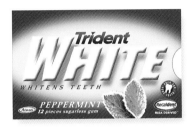
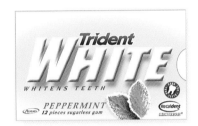

For the first round of designs, the designers' comps focused on the good taste of the product, as well as its added benefit. Visuals such as frost, ice, and crystals suggested both freshness and whiteness. Three designs emerged as client favorites, but Stapley felt that a design with scriptlike type and several leaves was the most appropriate design, and said so.

"Anytime you're getting some consensus in a meeting with the client, you hate to throw a wrench in things. But I really felt strongly about this design. It has all of the right elements," he says. Stapley insisted that the client reconsider this design, and it was eventually put back into consideration.

"I feel as though we are hired for our expertise. If you miss the opportunity to share it, you are doing the client a disservice. I suppose I could have lived with the original decision, but I had the gut feeling that this was the right place to go. It was a lesson for me, to be more vocal, because the product has actually turned out to be a big success for them," he says.

Round two was about color coding and making sure the system had logic to it. Color saturation was dialed up. The designers considered whether or not the word "Trident" or "White" should be more prominent, and other flavor cues, such as a mint leaf, were tried. It has appetite appeal and a natural sense, and adding frost to its edges provided the right flavor profile, one that did not mislead buyers.

Typography is always a focus when creating the tone and personality of a new trademark, Stapley says. As the project progressed, it became clear that "Trident" would not act as an endorsement to "White." Instead, the Trident name—and its promise of great taste—would be permanently locked up with "White."

"We had to create custom letterforms that expressed casual confidence and could complement the existing Trident mark. Kelson Mau's hand-lettered brush script brought us all the right elements," he says.

Competitors' products seem to be positioned exclusively for young people who are out on dates trying to meet mates: They have a real sexual element. Trident White is more about a person's smile, which has a much more universal and salable appeal to a wider demographic. From a practical standpoint, the product is ergonomic: It fits easily into a pocket or purse, and the gum cannot easily be crushed.

Stapley is pleased with the project for many reasons. "At the end of the day, as designers, we want to be proud of the work we have done. On the other hand, if the client does not see an increase in sales, we really have not done our job. In the case of Trident White, we are pleased with the awards we have garnered and with the knowledge that we have contributed to making Trident White the top seller in a highly competitive category."

In round two, the designers explored the client's three favorite designs. Here they are beginning to think about color-coding to make sure the system they are considering is logical. They are also balancing the words "Trident" and "White" to gauge which should be more prominent. The design at top emerged as the winner, with some modifications.

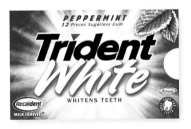
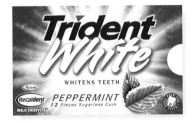

Note how small modifications enhance the final design. In the finished design, the leaves and the flavor name were both moved to the top of the package so that they would be more visible in candy displays. Also, the words "Trident" and "White" are made of equal weight to encourage buyers to call the product by its full name.

Who wrote the rule that dictates that when boxes are lined up on a shelf, **they must line up flat** and face side out, like a row of stiff soldiers? You say it is not a rule. Then why does everyone do it? Everyone, that is, except **Tea Tree skin-care products.**

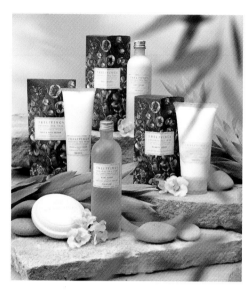

The package design for Tea Tree, a new line of skin-care products, accomplishes two challenging goals: First, it visually explains a native Australian ingredient to consumers in other parts of the world, and second, its diamond-shaped box grabs the shopper's attention with its unusual, corner-out orientation.

These were the questions that Annette Harcus and Sydney-based Harcus Design asked as they created packaging for Tea Tree, a new line of skin-care products created by Trelivings. To achieve more presence and claim more real estate on store shelves, it would make more sense to cant the box into a diamond-shaped footprint and let it sit corner-side-out. As the project progressed, the idea held other benefits as well.

Harcus Design works regularly with Trelivings, having designed various ranges of packaging for the client in the past eight years. "Most are collections of body and beauty products based around a certain fragrance or flower—either endowed with great beauty or some kind of beneficial or restorative quality," Harcus explains.

Organic Tea Tree was no exception—although the actual scent of the tea tree, a graceful native Australian shrub, isn't widely acknowledged as having a desirable fragrance. It has a strong, bush smell, as eucalyptus does, but is highly regarded for its natural healing properties. Aboriginal mythology actually relates a tale of a warrior who finds his loved one by following a trail of tea trees. Tribes also sought healing by bathing in tea tree–infused waterways. Captain Cook, the explorer who navigated the east coast of Australia in 1770, brewed a beverage from the tiny leaves, and ever since, the family of shrubs has been named "tea tree."

The plant's aroma was not so appealing to modern tastes, so the new Trelivings' range was augmented with an additional scent of light fruity tones, which soothes and calms, making its benefits more appealing as a beauty-aid product.

The plant also has a flower. "It is a sweet, petaled bloom that ranges in color from white to pale rose-pink, but it is a very small flower," Harcus says. "They make up for their size with their profusion of flowers; they actually resemble peach blossoms."

Before Harcus and her designers presented the initial round of graphic work to the client, they decided to investigate a different-shaped box—not the usual rectangular shape. A diamond-shaped box would hold the container just as securely, and it would create a unique presentation on the shelves of department stores, gift shops, and boutiques. This diamond-shaped direction also gave designers the benefit of having two face panels for graphics. But the double face also meant they would have to contend with running graphics over a fold. The diamond theme would also have to be extended to create a family of boxes that could hold containers of various shapes—a bottle, a tube, a tub.

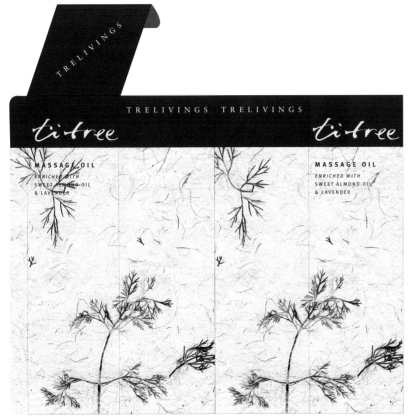

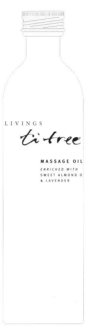

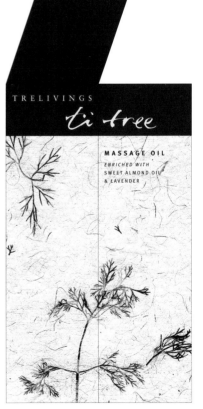

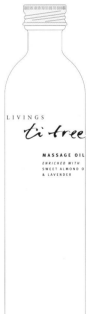

To help gauge her client's visual propensities for a project, Annette Harcus of Harcus Designs likes to present a number of very different ideas for early review. This approach suggested the use of a scan of paper, homemade with actual pieces of the tea tree embedded in it. It is perhaps the most Australian and earthy of the three early designs.

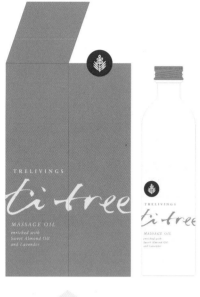

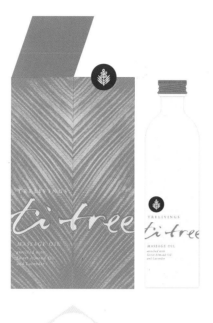

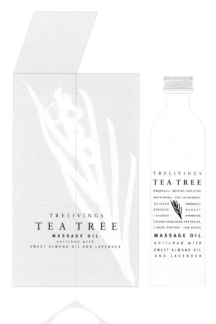

 This trial balloon is on the modern edge of possibilities. It is a graphic approach that emphasizes the small size of the tea tree flower. Note how even the name is given a more daring twist with a new spelling.

This is another streamlined design that takes advantage of the two exposed faces of the carton. The radiating lines add the suggestion of a leaf, indicating that this is a natural product.

The scale of the tiny tea tree flower is greatly exaggerated in this design, which mixes classic design cues with an overall modernist approach. The bottle has a very different feel here, too.

With the shape decided, the Harcus team could move to round one of the graphic presentations. Because Harcus likes to begin such projects with an understanding of what visual direction the client wants to take, she will present many different visual cue starters.

The first design she presented in several variations was minimal: It was at the extreme end of the modern scale. It used a silhouette of a sprig of the plant, together with a calligraphic version of the name of the product, plus a brief descriptor.

"The client is very knowledgeable about the extracts and the botanical variants used in his products, but to highlight the problems of illustrating the flowers in a luxuriant manner we brought in real flowers to the meeting," Harcus says.

The second design was unusual. A wraparound scan of handmade paper that contained embedded foliage of the tea tree plant was used to form the background. This had a contemporary feel that exuded peacefulness and comfort. It was, Harcus points out, diametrically different from the first, sleek design.

"It felt the most 'Australian,' because it evoked its natural, plant origins," she adds.

The final design presented in the first round was built on soft lines that radiated from the corner of the box. The only flower or reference to the plant in this trial was a small sticker that carried a simple, silhouetted graphic representation.

After viewing all designs, the client indicated that he would like to go in a more traditional, feminine direction. Highlighting the flower was very important to him. To further gauge his interests, Harcus showed him a series of reproductions of Dutch Still Life paintings (veritas) from the 1600s. These hyperdetailed fruit and botanical images reveled in their own beauty and were exactly what he wanted.

"To heighten the sense of scale for the flowers, in the painting we came in very close—focusing on them in minuscule detail," Harcus says, "exaggerating them so the leaves also became large fields of green, filling in the background and giving the whole pack a dark, rich look. The white flowers with their yellow stamens pop out from the dark background."

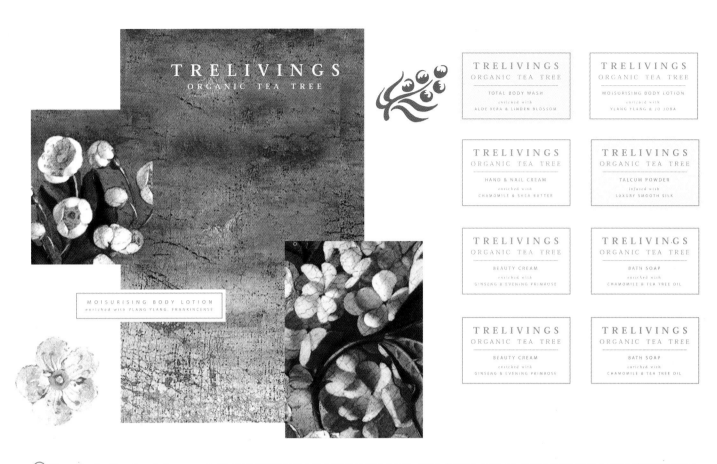

After reviewing Harcus' preliminary comps, the client indicated that he wanted to take a more classic, feminine approach. Harcus showed him a series of reproductions of Dutch Still Life paintings (veritas) from the 1600s. The hyperdetailed botanical images were exactly what he wanted. The simple, mostly open label design was eventually selected: It provides a ready and restful target on which the eye can focus.

The dark green also made an excellent ground for a cream-colored sticker that wrapped around the corner of the diamond-shaped pack. Whereas their earlier trials used large type to pull in the attention of the shopper, this design relied on the attraction of the simple, cream label centered on the rich, verdant field of foliage. With the delicate, restrained typography, the effect is understated elegance.

"These products are big in the gift market, so they need to express quality values, which also reflects the values of the person buying the product," Harcus says. The packaging not only looked beautiful but also felt sensuous to the touch with its matte, laminated finish. The inside of the boxes are dark green, and the bottles have a sand-blasted effect. Outside their boxes, the simple, translucent containers maintain their fresh appeal.

On the shelf, the innovative boxes take more space width-wise, as single units, but less space as a group when the packs are overlapped. With a dimensional front panel, they project forward: Shoppers are presented with a box face no matter from which direction they approach.

"The challenge of this project was the tea tree plant itself. We worked around its physical limitations and concentrated on evoking the essence of the flower—its inner and outer grace. We achieved this by commissioning an artist who painted with oils on the canvas. The artist, Paul Newton, recreated the atmospheric and textural detail of the veritas paintings, with a rich layered palette that highlighted the delicate beauty of the plant.

"It is the combination of the old world and the new world—the referential style of the painterly image with the contemporary shaped packs—that creates the shelf presence," Harcus explains of the design, which successfully and visually explains a uniquely Australian fauna to the international market, where the product has sold well.

IKD Design Solutions Pty Ltd. of Adelaide, South Australia, designs packaging for about **20 clients each year,** including recently, **Marquis Philips.** At any one time, the office may have 30 to 50 wine projects in house, in various stages of development.

⊘ The success of the "roogle" brand led to two more entries into the line: S2 (for the winemakers, Sarah and Sparky Marquis), and 9 (the number of the vineyard). The packaging of these higher-quality products focuses more on the makers than the actual brand, although the brand precense is still evident. The S2 and 9 marks are applied directly to the glass.

Familiarity of this sort breeds an extreme sort of competence and assurance that allows the IKD team to stay at the front of design in this category worldwide. In fact, the company has earned numerous Australian and international awards in its 30-year history for its exemplary work.

"Some 60 percent of our business is in the wine industry—there are so many brands out there that the competition is huge," explains principal Ian Kidd. "It really is quite intellectually demanding to come up with solutions for any specific brand. A design has to say everything at the point of purchase and not look like someone else's brand. And it gets even worse on the international level when we have to be considerate of what else is already out there. We have to do more and more searches out front to generate solutions that are genuinely new."

The project described in this article emerged from a preexisting relationship IKD had with two clients: U.S. wine importer Dan Philips and Australian winemakers Sparky and Sarah Marquis, partners in a new venture to create a brand of wine made expressly for import to the United States, where Australian wines have proved themselves to be very popular.

The design firm had developed a number of brand identities and packaging solutions for the Marquis team, so its designers already had a sense of what the client was all about: Husband and wife Sparky and Sarah are exemplary winemakers who freelance their services to a number of small companies, Kidd explains. The newly formed, winemaker/bottling company, Marquis Philips, wouldn't have a budget for much advertising for the new brand, so the designers knew they had to create packaging with plenty of shelf appeal.

The design began by deciding on a name for the wine. The client initially had entertained abstract names options, but the IKD team eventually convinced the partners that the name Marquis Philips had real cache: "It looked good and sounded good," recalls Ian Kidd.

"If anything, it almost suggests European connections with the word 'marquis.' In addition, we felt that by putting their own names on the label, as a new brand starting from scratch, it was a good way to communicate not only who they were but also that they were willing to put their respected names behind the product."

To combine the notions of Australia and the United States for the packaging of a new wine brand that would be imported from down under to the States, designers at IKD Design in South Australia happened on the concept of combining two familiar national icons: the kangaroo and the eagle.

The trick to creating a creature that was both convincing and not overtly humorous was to make the drawing look as though it came out of a zoological studies book from the 18th century. An animal that was silly in any way would devalue the quality of the wine.

Here the designers established the stance they wanted for the creature, but it was still not perfect.

Finally, they create the right mix of light and dark tones, of whimsy and science, and of posture and scale. This drawing eventually made its way onto the packaging.

This simplified illustration shows the roogle label used in combination with the newly designed Marquis Philips label, which is a mix of traditional and contemporary elements.

The design problem was compounded by the fact that the label had to communicate something about a wine no one in the American market had ever heard of. Of course, the design had to say "Australia," but not in clichéd terms.

Because this brand was a collaborative effort between an American and Australian group, the design team looked for ways to visually merge the cultures, The result was the "roogle," a strange but somehow convincing half-eagle, half-kangaroo melange.

Ian Kidd says that they felt strongly that the new creature had to be illustrated so that it looked as if its likeness was pulled directly from a plate in an 18th century zoological book or a set of botanical prints. "People had to take it seriously at first glance," he says. "It could not be too humorous, or else the art would suggest that this may be inferior. A label should never devalue the product."

Enhancing the notion of an art print is the way the roogle's label was ultimately applied to the bottle: alone and almost like a framed print.

The art has a traditional feel, but the labels placed above the roogle on the bottle are a mix of traditional and modern design elements. The colors chosen for the upper labels of the various varieties are elegant and contemporary. The typefaces specified for the design are timeless—a design cue meant to suggest that this product was marketed by an experienced winemaker—but at the center of the labels is a very modern stroke: a simple line of perforation.

"The perforation is being retained for most labels in the Marquis Philips portfolio. It makes the labels almost like stamps," notes Kidd, adding that, as the price point rises in the wine line, the color in its label is softened, suggesting increased sophistication. "Stamps, as subtle graphic devices, indicate a connection between countries."

Kidd likes to take a more contemporary approach with wine, a product whose design is usually dripping with historical nudges. After all, designs that blindly cater to an antique sensibility run the risk of being dull and not standing out on the shelves.

"There is still a feeling among some in the wine world that you must use crests and leaves and other rubbish in a design. But wine is as contemporary as tomorrow," Kidd says. "You can think of wine packaging like housing. We design homes now that are far more intelligent and deal with our lifestyles better. We hang on to certain elements of tradition in our wine designs, but we focus on making a contemporary statement. I call it 'contemporary elegance'."

With so many wine projects coming through the door, how does Kidd and his team know when they have found the right solution? A knowledgeable, experienced designer will have an instinctual feel about it. Kidd says that properly evaluating the creative brief will reveal the issues that must be addressed: All answers to the problem are there.

This spec sheet lists all details and special production considerations for the client and printer, such as the fact that gloss black varnish was used to simulate the seration on these labels, rather than actually punching them.

195mm to top of 9

PRINT:
Black
Gloss Varnish
Ink to simulate
etched look-
textured?

STOCK:
Clear label or
coated self
adhesive

100mm label
tilt area

PRINT:
Black
Screen Black
Gloss Black Foil on dots
Matt Varnish
Orange
Cream

STOCK:
Coated self adhesive

25mm from
bottle base

SHIRAZ 9

2001
McLAREN VALE
SHIRAZ

MARQUIS • PHILIPS

Marquis Philips is a collaboration between Australian winemakers Sarah and Sparky Marquis and USA importer Dan Philips to produce exceptional wines. The mythological creature on our front label, the Roogle, represents the shared destiny that link our two countries. the lasting friendship and

GOVERNMENT WARNING: (1) ACCORDING TO THE SURGEON GENERAL, WOMEN SHOULD NOT DRINK ALCOHOLIC BEVERAGES DURING PREGNANCY BECAUSE OF THE RISK OF BIRTH DEFECTS. (2) CONSUMPTION OF ALCOHOLIC BEVERAGES IMPAIRS YOUR ABILITY TO DRIVE A CAR OR OPERATE MACHINERY, AND MAY CAUSE HEALTH PROBLEMS.

IMPORTED BY
THE GRATEFUL
PALATE
OXNARD, CALIFORNIA

CONTAINS SULFITES.
WWW.GRATEFULPALATE.COM.
PRODUCED
PH.1 888 472 5283. PRODUCED BY MARQUIS
AND BOTTLED. 2 RIVIERA CRT.
PHILIPS PTY LTD, 2 RIVIERA CRT.
PASADENA SA 5042. AUSTRALIA.

ALC 16.0% BY VOLUME
PRODUCT OF AUSTRALIA

750ML

Approved 5/6/02
Sarah Marquis
SARAH MARQUIS

"We don't just design things that look good," Kidd says. "If we have the right answer, the design will look good in its own right. You have to do the hard work to answer these questions, or you will end up with something that is no better than wallpaper."

A design that does not answer the questions presented by the brief will not speak to the consumer, who, after all, knows nothing about the brief. "But the consumer will know if the design feels right, if it has the right depth and substance," he adds.

"Think of the process like designing a house," Kidd advises. "You aren't looking at the design you are going to make all by itself. You have to think of how climate will address the house, how many kids you may have, your lifestyle and personal interests. At the end of the day, the promise expressed on the label must be consistent with the imbibing experience, a bit like a beautiful home must be a joy to live in."

9

BLOCK 9

McLAREN VALE

2001
VINTAGE
SHIRAZ

MARQUIS • PHILIPS

750ML

The labels were applied to the bottles at an angle because off-square was more visually arresting, and because it implied that the application was done by hand, as a bond or tax sticker might be applied.

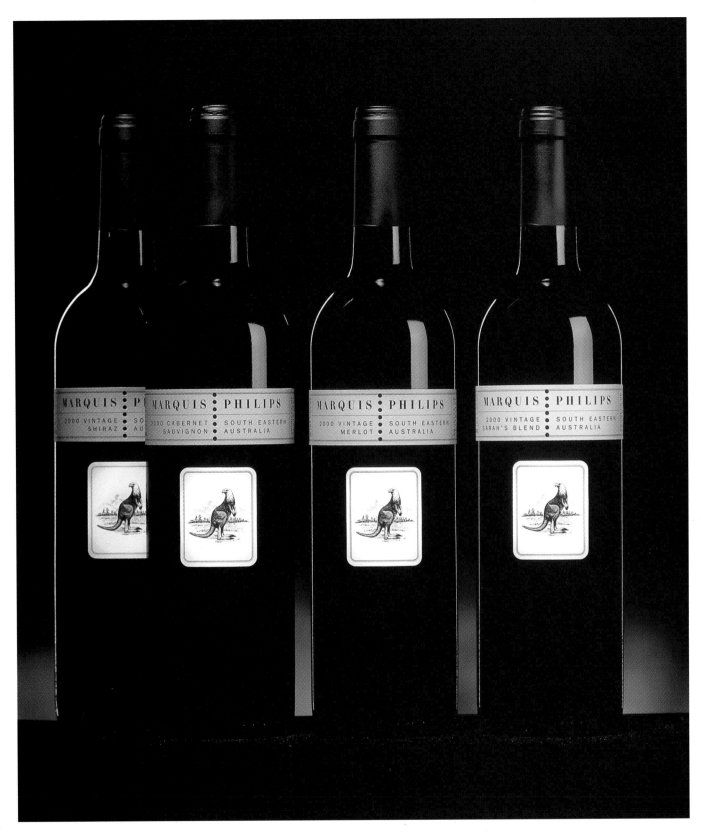

The complete packaging concept, with color coded labels to designate particular varieties. Principal Ian Kidd says that this design is effective because it is able to say everything on the store shelf: what the product is, where it is from, what its personality is, as well as what sort of quality it provides. "The worst wine labels around," he says, "are on the biggest brands. They have boatloads to put into advertising, so their bottles get no real assistance."

A reaction is good. That's the Jupiter Drawing Room's mantra. Whether the person at the **receiving end** of the design firm's work **laughs or cries,** it means success, as it did for **Foschini.**

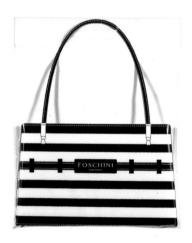

The final packaging is very convincing. It's hard to believe that each bag is printed with only two colors.

"Designing wallpaper has never been our business," says Joanne Thomas, creative director of design for the Cape Town, South Africa-based design and advertising agency.

Her office's work is strong in its concept and direct in its delivery. It's unusual "packaging" program for Foschini, a large, women's fashion retailer in South Africa, is a case in point. The client came to Jupiter suffering from a dowdy image. Its customers, aged from their early 20s to late 30s, were drifting away. An earlier corporate revamp had helped only marginally to convince consumers that Foschini was a purveyor of fashion, not a mere clothing retailer.

The Jupiter team started by improving the company's image through advertising and point-of-sale in the store. "This was done through a campaign that used fashion illustration. Whereas the competition had used the typical fashion shots featuring models on location, suddenly Foschini stood out with a style that immediately strikes you as fresh, modern, and fashionable," says Thomas. "It was brave of Foschini to break the mold in this way, and this bravery doesn't go unnoticed by the public."

The packaging project grew out of this bold move forward. The company needed special bags for the summer season—the Christmas season in South Africa, when tens of thousands of dollars worth of goods would be packaged into store bags and carted home for gifts. The shopping bag would essentially become an effective delivery mechanism for the revamped, illustrative brand.

The new bag could use only two colors, and it had to be plastic. The bag the store had been using was a white plastic bag with the Foschini logo printed on it in black and gray. It wasn't a very exciting package. The client wanted something different—but with no extra costs.

Thomas's initial ideas were to reuse some of the images and copy lines that Jupiter had developed for the advertising campaign. "But the two-color limitation meant that the illustrations—normally in glorious full color—just looked cheap and nasty," she recalls. The creative director and Jupiter's creative director of advertising Graham Lang had to come up with something else.

They knew that there was no reason to remain perfectly conventional. So why not put the concept of what a bag is on its ear? Why not turn the bag into another kind of bag—a handbag? They began to explore how they could print the image of fashionable handbags onto plastic so that the carrier would actually look as if she were carrying a real handbag.

Initially, they imagined photographs of the handbags printed on the plastic package, but the color limitation would make that impossible. So they turned to illustrations.

You don't have to be a stockbroker to buy, buy, buy.

Envy. Available in more than just green.

You can't buy love. But you can buy a lot of attention.

Do a good deed today. Take a shopping bag home with you.

FOSCHINI

Do a good deed today. Take a shopping bag home with you.

FOSCHINI

Initially, Jupiter Drawing Room creative director of design Joanne Thomas thought she would design bags directly off of the graphics her team created for a summer poster program for Foschini, a large fashion retailer.

Converting the poster graphics into two-color graphics for the new package, however, was not tremendously successful. Thomas says that the art just didn't have the same punch.

In considering a different form of art for the bags, the Jupiter design team had an inspired idea: Why not make the bag mimic a handbag? They studied various styles that were in fashion that season.

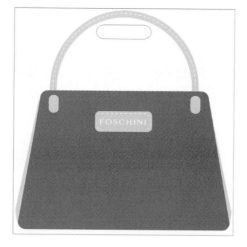

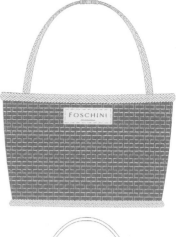

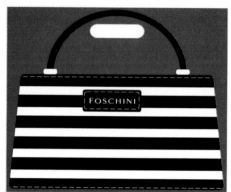

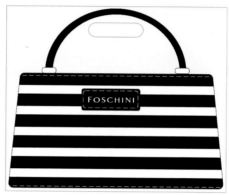

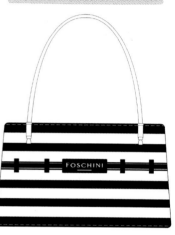

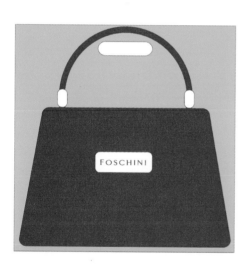

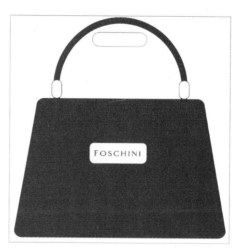

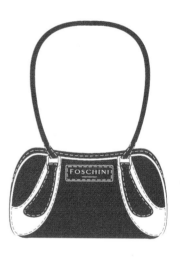

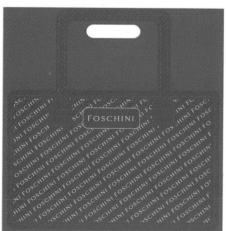

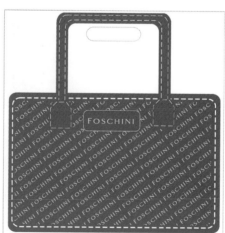

Left column: The new bags had to be two color, and Thomas thought she might gain a third color by printing on colored plastic.

Center column: But she soon realized that printing on clear plastic furthered the illusion that the bag was a handbag.

Right column: The final art for the bags.

"The final solution of illustrating the bags seems obvious now, especially considering that was the same illustration style that we used for the advertising. But it took us a while to realize that by illustrating the bags, we could achieve the desired look with only two colors. I could keep the colors flat and not have to halftone anything," Thomas says.

Now the idea had to be executed. Thomas at first thought about printing the two colors of ink onto a third color—that of the plastic—but she soon recognized that putting the design onto transparent plastic would enhance the illusion of someone carrying the "handbag" even further.

The client loved the idea immediately as a fun, fashionable way to communicate their brand in an unforgettable package. Eventually, three bags that were in style for the season were designed and printed. "The handbags were designed with the dimensions of the shopping bag in mind—that is, the large shopping bag has a basket-style handbag printed on it," Thomas explains.

The bags were an enormous success. They were only used for one season, but one full year later, Thomas still sees people walking around town with a Foschini bag in hand. The reuse of the package is especially satisfying to her.

"It is important to me that the bags are reused. If a package is desirable enough, it will be kept and reused rather than thrown away," she says. "The Foschini bags definitely seem to have fallen into that category."

Rather than produce a mundane shopping bag, The Jupiter Drawing Room created a one-of-a-kind package for Foschini's bought goods. Customers not only use the bags to bring goods home but also continue to use them past the day of purchase.

To illustrate the straw bag, the team experimented with building different types of textures.

Foschini purchases, lunches, homework, and more—the new bags are reused again and again because customers like them so much.

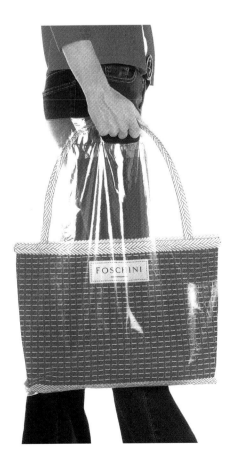
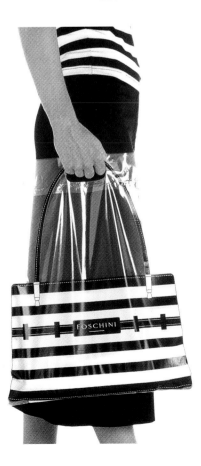
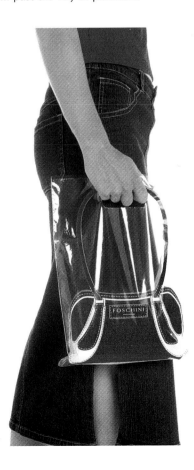

Sometimes a brand is built. Sometimes it just is. In the case of **Mr. Lee,** which happens to be the name of a range of noodle-based snack products as well as the name of the man who

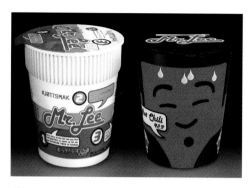

A before and after comparison reveals what a drastic change the redesign presented.

began selling the fast food many years ago, this was a brand that had its own life and energy almost from its beginning.

Mr. Lee—the person—is an individual with plenty of personality. In the mid-1950s, he arrived in Norway, where his brand is now a household name, as a former chef and now-penniless war refugee who went into business doing what he knew—making noodles. To promote the brand, he often appeared in TV commercials, wearing his wild, trademark Hawaiian shirts and exuding endless cheer.

Mr. Lee—the noodle brand—is a popular food product, particularly among young people, but its packaging hadn't been touched in years and years. It had its own quirky personality in an "undesigned" way, but it had room to step up into something more.

Rieber and Son, a leading Norwegian food manufacturer, actually owns the Mr. Lee brand. It definitely wanted to build on the popularity of the Mr. Lee brand and expand the name into new products and new markets outside of Norway. The company also knew that Mr. Lee might want to retire someday, despite his enthusiasm for the brand, so it would not always be able to depend on the sparkle of his personality. That's when Rieber asked Design Bridge, a London branding and design consultancy the company had worked with since 1995, for advice on the situation.

Jill Marshall, the executive chairman for branding and packaging at Design Bridge, recalls that the original brief from the client simply asked the design team to take the founder's kitschy photo off the package and replace it with a caricature or another identifying device.

"But we challenged the client and suggested that the brand would benefit hugely from a complete overhaul," she says.

Almost from the beginning, designer Ian Burren began searching for a way to abstract Mr. Lee's countenance and turn it into a symbol that could be used on the packaging. As he distilled the image down further and further, the face became quite simple, but it was still recognizable.

But then Burren had a flash of inspiration that truly changed the entire nature of the brand. He enlarged the face and covered the entire noodle cup—the flagship container for the brand—with the image. Everyone in the office loved the effect, as did Rieber and Mr. Lee himself.

"When Mr. Lee saw the new packaging, he said, 'Now I can live forever,'" Marshall says. "It is unmistakably Mr. Lee. In addition to that, it allows us to have fun with the character, which has more flexibility than a photo [of a person] has."

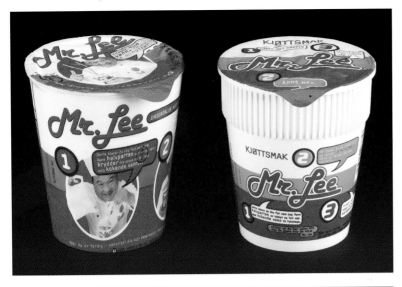

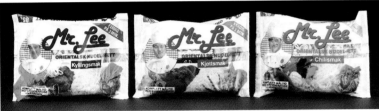

Two examples of the old Mr. Lee packaging. The designs had their own kitschy appeal, but the brand's owner felt that updating was necessary—in particular, removing the photos of Mr. Lee. Another difficulty was a production issue: Printing photos of food can be an inexact science, especially on the plastic used for the sachet bags. Products can actually end up looking unappealing if the printing is not carefully managed.

Asked to remove the photo of Mr. Lee and replace it with another likeness or identifier, designer Ian Burren distilled the essence of the brand's founder into a simple icon.

The character's expression can be changed to fit the flavor, size, or even the temperature of different products, whether they are noodle based or something completely different, such as ice cream. The irreverence of the brand is perfect for the brand's audience, and given the product's renewed popularity, brand expansion will no doubt follow.

"There are lots of product extensions in the pipeline, including nonnoodle products and potentially a Web site that will do even more with the Mr. Lee character. Mr. Lee transcends noodles—he could go anywhere," Marshall says.

This project shows that food packaging does not have to show the food it holds, she adds. The varying quality of printing, especially on a plastic like the kind used on the Mr. Lee noodle pack, can sometimes make food look unappetizing. The Design Bridge solution avoids that problem, but the designers did not ignore the shopper's natural desire to see the product before the purchase is made: They left unprinted, clear areas on the back of the pack where an open saucepan is shown as part of the cooking instructions.

She commends the client for allowing her team to create a brave design: "The Mr. Lee name is not on the front of the cups at all. The name only appears on the top," she points out.

If anyone had any doubts about the direction, those concerns evaporated when the design won a Clio in 2002 as well as recognition at the UK Design Week Awards. Mr. Lee—the person—and Mr. Lee—the design—are both still so recognizable that when the brand's founder went to the front of the room to accept an award at this second event, something spontaneous and gratifying occurred.

"When he went to the podium and bowed low, everyone realized who he was and gave him a standing ovation," Marshall says.

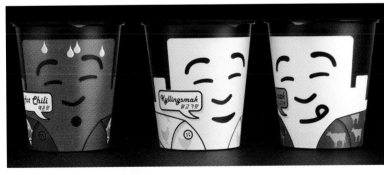

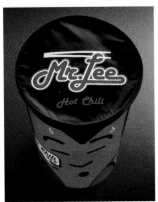

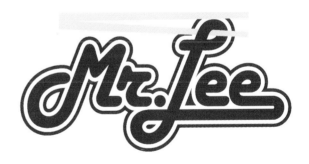

Applied to the brand's flagship noodle pot, the new Mr. Lee comes to life. Although the name of each variety is given on the cup, the visuals make the words almost superfluous: Note Mr. Lee's shirts and expressions. The brand's owner took a brave step by allowing the visual on the cup's front to actually be the brand identifier. The name "Mr. Lee" is only used on the pot top.

The typography on the packaging was also updated, although its script style was maintained. The insertion of the two chopsticks is emblematic of the type of food Mr. Lee provides. The script and the chopsticks combined transforms the written name into a unified art element that is recognizable in any language, a requirement to expand the brand into other countries and languages. (The English version is above, and the Korean version is below.)

⬆ The new icon of Mr. Lee could easily be given just about any personality or attitude.

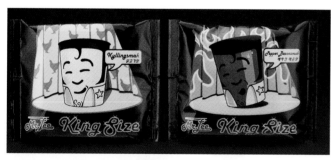

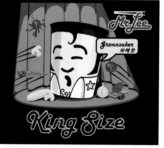

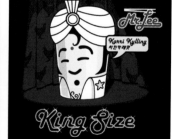

⬆ Who else but "The King" would be appropriate to announce the king-size packaging, so Mr. Lee gladly took on that new persona.

⬅ The Design Edge designers did not neglect to include the same fun on the back of the sachet package as was found on the front. The small saucepan in steps 1 and 2 of the cooking instructions actually let the consumer see the product inside. The UPC marker was even pulled into the play.

⬆ More line extensions of the king-size sachet packets.

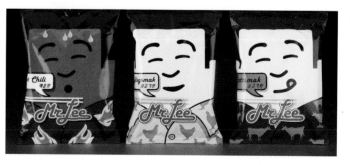

⬆ The newest Mr. Lee bags have a vertical orientation, which better fits the shape of the caricature's head and allows more of his "flavorful" shirt to be shown.

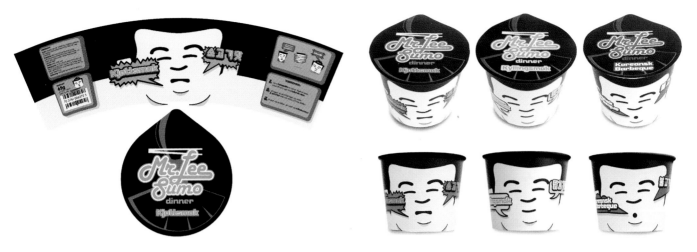

⬡ One of the newest products in the range is the "sumo size" pot. Again, Mr. Lee rises to the challenge.

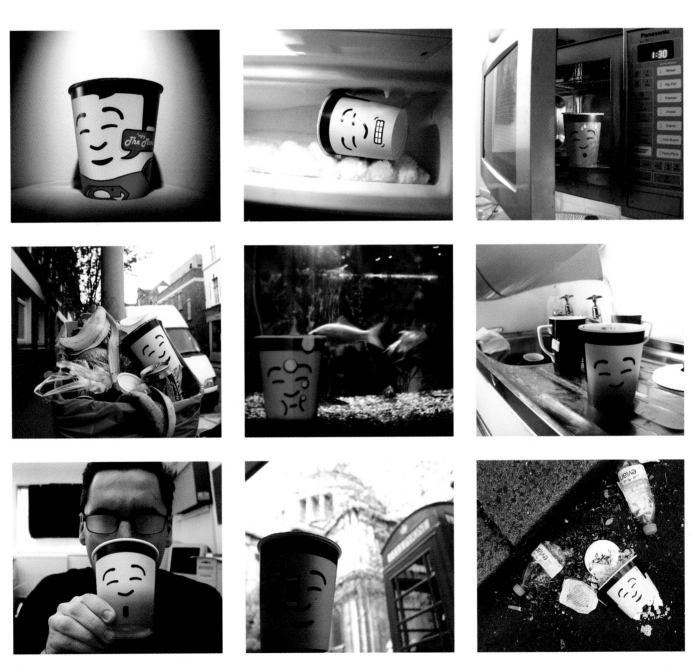

⬡ Because the character has taken on a life of his own, the designers are now imagining other situations he could operate in. Super Mr. Lee Man could be a treat at the movies. Or Mr. Lee might find himself wrapped around ice cream in a freezer or surrounding a cup of hot coffee or soup. Mr. Lee is definitely going places, the Design Bridge team says.

As the saying goes, **good things come in small packages.** But in today's crowded **retail environment,** small packages **could easily be overlooked,** no matter how fine their contents might be. This was definitely the case with **Vitalizers,**

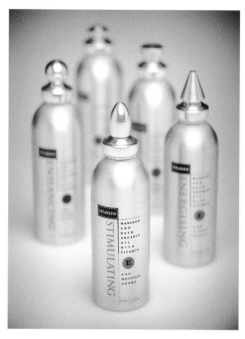

Faced with a preordained package shape and material for a new aromatherapy product, Vitalizers, the team at Harcus Design had to find another point of differentiation. The solution was to change the shape of the lids.

a unique line of therapeutic oils that can be used in the bath, for massage, or even burned in an oil burner (when diluted with water).

The oils were an offshoot of a much larger line of skin and body care products called Vitamin Plus. These products were based on specific vitamins—A, B, and E, for example—each combined with other beneficial plant extracts, such as aloe vera, sea kelp, and cactus. The two ingredients in each product were chosen to harmonize their benefits. The range is based on the simple philosophy of "feeding the skin" and replenishing the body's basic nutrients.

The other products produced by the brand owner, Trelivings, tended to be directed to an older demographic (traditionally female based). The company wanted a range of skin and body products that would attract younger consumers of both sexes and would be marketed under a different brand name. So evolved the concept for Vitamin Plus, and subsequently Vitalizers to increase their market share.

The packs, in line with appealing to the younger target market, were based on the contemporary approach of recyclable, lightweight, aluminum containers and tubes.

"Typographically there was a lot of information to express on the packs, so a hierarchical system was developed where the product type—such as Body Lotion—and the vitamin were the heroes. The plant extracts were highlighted by illustrative means rather than typography. Each product was attributed a color palette that gave it individuality, but that still coordinated it with the family."

The growing awareness of aromatherapy had given rise to the Vitalizers line—a series of organic oils enriched with vitamins and plant extracts. Each product would be packaged in an aluminum container, only 5 inches (12.5 cm) tall. The minute size of the package predetermined a number of design factors for Harcus Design, a Sydney, Australia–based design firm tapped to handle the project. A metal container was a must for protection because the oils degrade quickly when exposed to light.

"Whereas the original range Vitamin Plus implemented detailed plant drawings on the packs, the limited scale of the oil flasks didn't allow us to illustrate the individual variants of each oil," says principal Annette Harcus, "so we concentrated on heralding the resulting therapeutic effect. The individual 'moods' became the product names—such as "Stimulating," "Harmonizing," "Energizing," "Meditating," and "Enhancing."

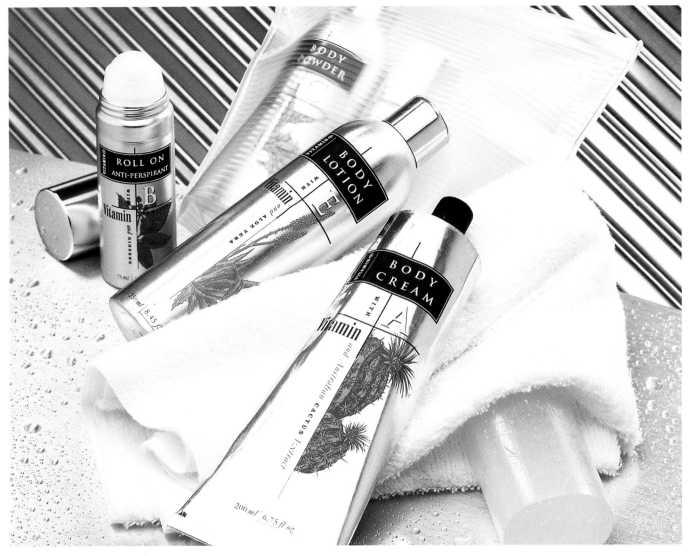

⬡ Another successful product line, Vitamin Plus, preceded Vitalizers. The design of this line established a number of parameters for the second project: polished silver metal, a sloped-shoulder bottle, and a relatively small size. The Vitalizer containers would only be 5 inches (12.5 cm) tall.

The lengthy line names would also have to be run vertically if they were to be run at a readable size. But the packages still needed something extra to distinguish them from other products and from each other: After all, the metal containers were sleek, but they looked tonally homogenous as a group. That's when the design team considered the container's lid. What if each variety had a differently shaped lid?

Because of their tiny scale, in the first design schemes, the designers suggested lids that enhanced their preciousness, making them look jewel-like. The lid shapes were based on the essential basic shapes of triangle, circle, square, and their three-dimensional forms—cone, tetrahedron, and sphere.

Custom-designing a lid brings with it a host of headaches, says Harcus. "Of course, products have to close efficiently. A perfect seal is so important," she notes. The exterior shape of a lid has ergonomic ramifications, as well. "Any shape we designed had to be easy for the fingers to grasp."

The first designs required a lot of hand assembly and finishing and therefore proved too costly. In the second round of concept drawings, the designers wanted the lids to match the polished metal of the containers. The team designed a number of shapes,

then presented them to a metal fabricator for production feasibility assessment. The designers' specifications and guidelines were to result in a series of lids that were easy and comfortable to hold on to, that were not too difficult to produce, and that were cost efficient. The fabricator also provided some variations of the shapes, based on the production capabilities of the lathe.

The result was a differently shaped lid for each of the five oils in the line. Viewed as a group, there is no question that the bottles are part of a family.

"We had great fun attributing each of the product names with a lid shape," says Harcus. "The color differentiation that we initially were trying to impart in the lid was implemented into the pack graphics—a signature color for the product name and the vitamin circular device. The graphics in the form of a self-adhesive, clear label were applied 350 degrees around the containers."

The ranges have been a success, particularly in the younger demographic that the client was hoping to attract. "The oils are sold in drug stores, beauty shops, and homeopathy stores, not just the traditional gift market stores—so they are presented in an environment more accessible and more relevant to young people and those interested in aromatherapy.

⊘ The new package's extremely diminutive size meant that any labeling or type on the containers would be small. This might make it difficult for customers to find the right variety on the shelf. That's when the designers suggested making each lid a different shape. Here, the designers experimented with various possibilities.

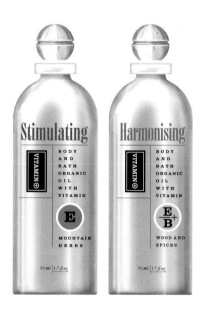

⊗ The new lids gave the varieties a precious, jewel-like appearance. Settling on these shapes was a challenge, because they not only had to look good, but they also had be practical in terms of production and ergonomic: The buyer would have to be able to grasp the lid comfortably with his or her fingers.

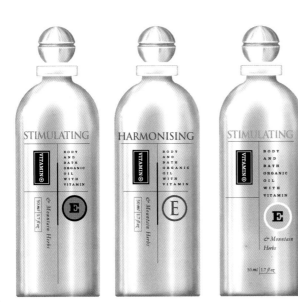

⊗ Here the designers experimented with the labeling for the containers, working hard to get the type as large as possible.

⊗ As on the front of the finished design, subtle changes in text and text direction helped to organize information in a very small place.

VALUE PRODUCTS—DESIGN THAT DELIVERS
Target

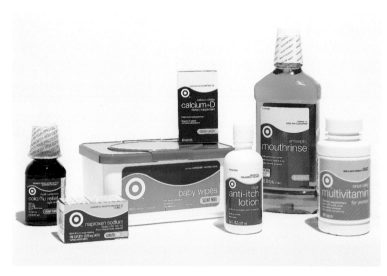

Target in-store branding had suffered from lack of consistency and recognition until Design Guys (Minneapolis) reworked the design of more than 600 SKUs to great success.

The Target bull's-eye has become such a recognizable symbol that it rivals the Nike swoosh in brand might. In terms of sheer visceral impact, though, it can't be beat: Everyone knows what a bull's-eye is, and it certainly draws the eye to whatever it is sitting on.

In the store environment, the mark is applied to more than 600 SKUs, all part of a quality house brand that competes with and offers lower prices than national brands. In late 2001, each "value brand" carried the bull's-eye somewhere on its package, but there was no style consistency. The mark might have been large or small, located anywhere on the package, or have a niche strategy.

The overall design of the packaging was inconsistent as well: Each SKU had been considered at separate times by different design groups. Some designs imitated the national brand, and some went in new directions. Even a regular Target customer might not have realized that there was a large body of house brands he could rely on for almost all of his needs: The visual expression of the brand was just too fragmented.

"Target asked us to create a store brand that would cross departmental lines and create a brand equity as the customer moved throughout the store," explains Steve Sikora, principal with Lynette Sikora of Design Guys, Minneapolis.

Sikora adds that the client also wanted to explore the idea of working with just the bull's-eye as a visual language. "This was a big step forward in the company's confidence in its own brand. Would customers understand the bull's-eye by itself? It was clear that the word 'Target' didn't need to be used together with the mark anymore," he says.

Letting the bull's-eye carry the entire brand message was something that Design Guys had wanted to experiment with for a long time, and the team had already put some thought into how it would work. They believed that the entire system could be successful using Target's corporate colors, red and white.

"We created a number of all red and white studies. But we had to be careful that the designs didn't look cheap just because they were one color," he says. "We tried all sorts of things to add dimension to the packaging."

Designers Katie Kirk and Wendy Bonnstetter explain their explorations. "Graphically, we really liked what the bull's-eye brought to the packaging. It had to make a clear statement when used in conjunction with the product name," says Bonnstetter.

One experiment that worked well was a wave design that could house both the bull's-eye and the name of the product plus any descriptors. The curve of the wave also mimicked the curve of the mark, which elegantly reinforced that brand statement.

At the start of the project, the Design Guys team felt that the entire repackaging project could be handled by using just red and white, Target's corporate colors. This was the start of an exploration of how to handle the bull's-eye graphically

The wave is given a crest and a swell here. This design is close to the finished version.

Another tabbed version studying different ways to organize information.

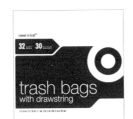

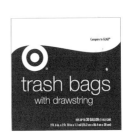

Here the designers are studying how to organize information, which, for each category, would change. Regardless, each package would have to be consistent.

The designers liked this version, which merges the wave and the bull's-eye, but the client's corporate standards restrict altering the logo shape in this way.

Ⓐ After the design team realized that 600 SKUs could not be differentiated enough using just red and white, they began to explore how to include national brand colors.

Ⓥ To see if the wave design would work under extreme conditions and on oddly shaped containers, the designers applied it to actual SKU shapes.

TOP

SIDE

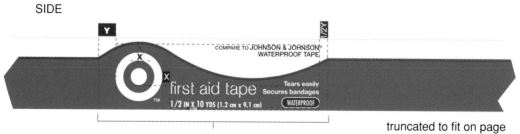

actual art area

truncated to fit on page

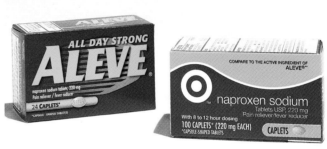

Some SKUs don't compete directly with a national brand, like the paper towels shown here. They have a more generic Target identity. Others are sold against national brands and, in coloration, they are connected to the national brand as well as to each other.

"We liked this approach because it was very graphic, and it organized the information well. We found out later that when the packaging is stacked on the shelf, a continuous wave is formed within individual lines, creating a nice billboard effect," says Kirk.

The design team and the client team loved the approach. But then Sikora attended a client meeting where it became evident that the one-color approach would not work, much to his and his team's disappointment.

"Most of the 600 or so of the eventual SKUs were laid out on the table, and we walked through the bulk of the product line. When you could see all analgesics or all mouthwashes together, it was evident that there was a huge amount of overlap between individual SKUs," he recalls. For instance, one national mouthwash brand might have five or six flavors or sizes. Using red and white alone would not provide enough distinction between wintergreen and peppermint or regular and family size.

"It became evident that we would have to do more coloration," Sikora says.

They decided to take color cues from the national brand, and soon decided on three areas where color could exist in the design they

had developed: In the upper section above the wave, in the lower section below the wave, and in the stripe that forms the wave itself. Sikora says that despite their initial disappointment, they were pleased with this new approach.

"The great thing about the program is that it can be used in so many ways. We can create packages that are in sync with the national brands," he says. The colors are the same, the stripe dimension always remains the same, and on the shelves, the Target brand is always placed to the right of the national brand. "The shopper can make the same choice for each product by going to the same place, geographically and visually.

Sikora says that although he had a strong feeling about where the project should go in the beginning, he can never know as much as his client knows. "As designers, we have a good sense of what aesthetic will appeal to people. But the client is steeped in his own business and holds the knowledge that can make our projects a success," he says. "As designers, we need to have faith in the client to know what is best for his business. Clients have to be able to trust us to know what is best aesthetically. That's the best scenario for a successful partnership."

Ask someone who grew up in the **United Kingdom** in the past 20 years what you can **wear like a ring,** comes in a bag, and is crunchy, and in **less time than it takes to ask,** they will reply, **"Hula Hoops."**

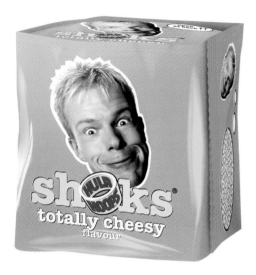

These cheeky 2½ x 2½-inch (6.5 x 6.5-cm) squares are stuffed with tiny, ring-shaped, intensely flavored potato crisps. The package, designed by Jones Knowles Ritchie, breaks the rule that snacks should come in a bag.

Hula Hoops are ring-shaped potato snacks that have allowed kids to play with their food for years. These snacks successfully compete with crisps or chips for space on retailers' shelves and have remained popular among children. Although this was good news for the brand owner, United Biscuits, it also meant that most customers grew out of their affection for the treat: Hula Hoops were generally seen as a kid food. Even its name felt juvenile. Adults might crunch on a few, but the main snack food-buying demographic—teenagers and young adults—felt that they had passed the age when they wanted to wear food on their fingers.

United Biscuits decided to reshape the product into something that would be more palatable—visually and tastewise—to this market. It shrunk the circumference of the highly recognizable rings to where they could be strung on a drinking straw and then pumped up the flavor of the bead-like snacks to the point where they shock the tongue, whether eaten one at a time or by the handful.

That characteristic is what actually inspired the product's new name: Shoks. The only thing missing at that point was proper presentation.

United Biscuits came to Jones Knowles Ritchie, a London design consultancy, with a specific request: Create packaging with attitude for this brand extension that will cause young people to pick it up again and again.

Andy Knowles, a principal with the firm, says that their job was to get consumers to reengage with the product and also grab the attention of those who had never tried the product before. "The brief was tough, because the client wanted to communicate several things at the same time: 'intense flavor,' 'lots of hoops,' and 'they're small.'

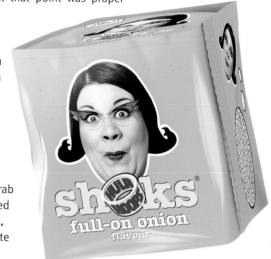

They also wanted to do this in an irreverent, more wacky way than the core Hula Hoops brand, because it was to be targeted at an audience of streetwise teens, who are more cynical and certainly know when they are being marketed to," he says.

The eye-catching 2½ x 2½-inch (6.5 x 6.5-cm) shape was unique for the snack-food category. Also, the product was stackable, meaning that it could be displayed right on the counter next to the register at the petrol station or quick mart, where customers waiting to pay are likely to make an impulse purchase.

In their first trials, JKR designers thought big for the small package.

This comp relies on photos of the main flavor's ingredient, but the designers felt that this approach wasn't personal enough.

Now the design began to reflect a more adventuresome personality. The idea was to show people just messing around, the way the main demographic for the product—teenagers—would.

This design refers to the intense flavor of the product and the reaction one might expect after indulging.

The product is known for its explosive flavor, so this design is centered on explosive devices.

Finally, the JKR designers came up with a design direction that said "fun," "friendly," "crazy," and "flavor.

Designer Simon Pendry tried several approaches. In his first trial, he filled the face of the package with type, placing the familiar Hula Hoops brand logo in the center of the design. Although a logical approach, it was difficult to say which message the consumer was supposed to receive: Hula Hoops or Shoks.

In another design, he focused on flavor and filled the front of the package with photos of the main flavor ingredient; however, it wasn't his favorite design. "Showing ingredients is a bit of a cliché—when all else fails, show a picture of the factory or the ingredients," Pendry says. "The design needed to be about more than just flavor. The people who would like these little beads would have to say, 'This product is for me.'"

A third trial began to center on a promising idea. He crammed people together in a subway car and in a telephone booth. It felt like something teens might do, he explains: "Muck about in a phone booth with their friends." The crowd also implied that the packs were stuffed with product.

Showing people made the package feel more immediate, so Pendry continued along that avenue. His next design showed the effects of the product on a loony-looking man. This spoke in the language of comics that so many teenagers like and was also very energetic, he says.

A fifth experiment was much more graphic. "When you put these on your tongue, they hit you quite hard. We say Shoks are exploding with flavor, so why not show it?" Pendry says.

Finally, he happened on an idea that really made him—and the client—smile: big, cheesy vignetted faces of people having fun with the product. This was the design that was eventually selected.

"These are people having a good time. They are charming, because they make you smile," he says of the faces, which he commissioned for the project. "With packaging, a smile in the mind is what you are trying to achieve. That's what a snack is—a spot of relief on a dull or busy day."

Using faces and bright colors to communicate the actual experience of eating the product, rather than literally show lots of little Hula Hoops and wacky type would have been clichéd category language and predictable. The way the expression-filled faces break convention for the category, he says, is decidedly irreverent, and they're—well, cheeky.

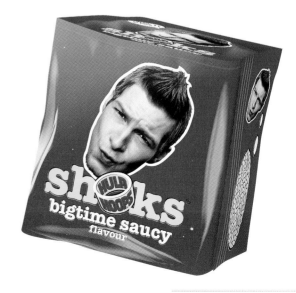

For Victorian Olive Groves, a cooperative of olive growers in Victoria, Australia, David Lancashire of David Lancashire Design **offered advice to the new group** that extended past simply selecting container shapes and **designing labels.**

 Victorian Olive Groves, a new cooperative of olive growers in Victoria, Australia, needed a new identity and packaging suite to make it stand out from the mostly provincial competition. David Lancashire Design created this unique look, which not only stood out on store shelves, but also appealed to younger buyers, an audience that was under-addressed in the category.

With packaging design, production issues such as how a product is bottled are always a concern. In some cases, they have to be examined by the designer as closely as he or she looks at the actual design of the package or labeling.

"I talked them into buying a labeling machine," says Lancashire. Joining together as a cooperative had been a bold move, as was going with the modern design that Lancashire, at project's end, had created for them. Now the client had to ratchet up its self-image to make the dream come true. Hand-labeling, as the group had done in the past, would no longer be practical if production was jumping to 10,000 cases of olive oil a year. The new labeling machine was a must.

"They were still thinking of where they were, not where they were going. The machine, plus the steps we took through design, moved this cottage industry to the next level," he adds.

Victorian Olive Groves was formed by four separate growers that had previously bottled their own products, including olive oils, bottled olives, and soaps. Up until the point that Lancashire Design was called in on the project, they had done their own packaging, which the design principal described as "pedestrian." It didn't reflect the quality of the product, and the cooperative hadn't really formed an image that it wanted to project.

Wanting to expand sales to the international market, however, a distinct image was critical. Many competitors used packaging with a folksy feel, showing photos of olives on their labels, which was logical but predictable. But Lancashire suggested that Victorian go with a more modern look, something that would not only make it stand out but also heighten its appeal to younger consumers who might be apprehensive about purchasing a high-end product with plenty of heritage.

It wasn't an easy sale, Lancashire recalls. The small growers weren't yet imagining their power as a cooperative. He had to gain their confidence to inspire their trust in his vision.

The first step in the label design process was to study the client's rather lengthy name. "Victorian Olive Groves," although an appropriate name for the group, did not sound modern. Lancashire suggested going to an acronym: VOG. Not only was the new name more memorable, it was also easier to work with in the new package design.

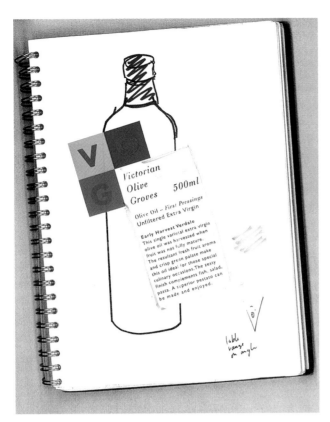

⊘ One of the first things David Lancashire did was to get the client's OK to shorten the name to "VOG," which was easier to deal with and certainly more memorable. Then he began experimenting with different looks. This idea—which was bold, simple, and evocative—would have been applied to the bottle at an angle.

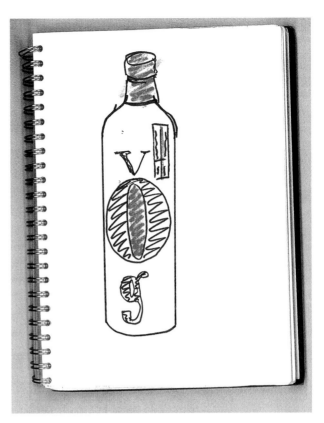

⊘ Here the "O" was turned into a focal point for the package. This held a lot of potential for bottles, but perhaps less promise for the shorter jars and bags.

⊘ The new brand had the endorsement of chef and TV personality Stefano di Pieri, who is known for his white Panama hat. The designer tried to bring in elements that would refer to the personality in this design. In the end, only the signature was retained.

⊘ In this very Australian design, a piece of printed tape would extend over the top of the bottle, jar, or bag and end under the front label. Cost and production concerns made this design impractical.

Lancashire created five different label designs: Each kept the client's bottling and labeling concerns in mind: Stock bottles and jars were used, containers that fit the mechanics necessary for bottling oil and olives.

"For a packaging design project, I like to find out all of the technical problems first, such as what constraints the client's labeling machines have, or what type of pressure-sensitive stock they plan to use," the designer says. "If there is a preexisting bottle shape, you have to design a label that works dimensionally, with the bottle's curve."

The first idea Lancashire presented put the letters "VOG" in colored squares together with a block of evocative copy about the product. The entire composition would be placed on the container at an angle. It was a festive approach and one that the client liked. The slant and mix of colors called attention to itself.

A second design would have used the acronym in extremely large letters on the container front. The "O," much larger than the other two letters, served as a focal point—another idea that was very European. The cooperative had gained the endorsement of chef Steffano de Pieri, a well-recognized personality with a cooking show on Australian television. One very familiar image of the chef, from the introduction to his show, is of him riding a bicycle through olive and almond groves with a white Panama hat on his head. This design would have either featured the hat or the bicycle at the label's top, with the chef's signature at the bottom. Although an essential connection to the chef was kept in future designs—the signature was retained—the imagery was discarded.

This package design was the one the client ultimately selected. Here the designer turned "VOG" into a piece of readable art. The simple bands of strong color were easily translated onto all of the packaging in the line, as well as into any brand expansion lines.

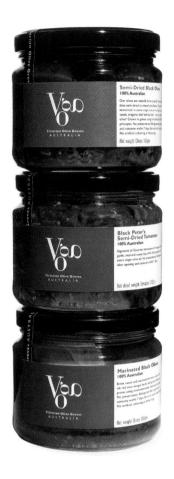

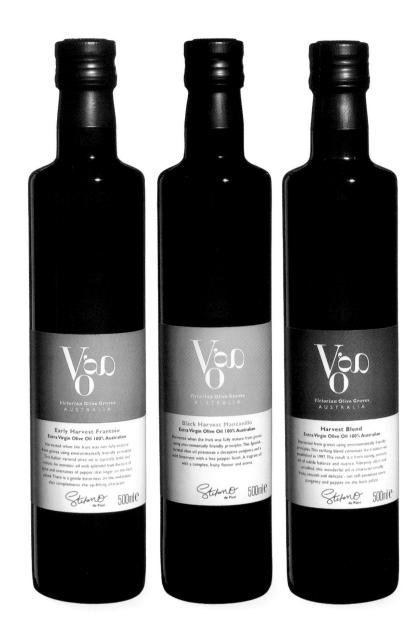

⬡ The finished design is decidedly progressive and not at all provincial. This level of sophistication will allow the product to be a contender on store shelves.

Lancashire calls the next design "pure Australian," with its winking sun and Mediterranean imagery. This idea called for a piece of printed tape that would reach across the top of the bottle or jar lid and end under the front label. Production concerns, particularly with the bottles, made this impractical.

A final design pulled together likable aspects from the previous designs: It had a bold color scheme of a dark mustard yellow, a dense green, and a rich olive green. The chef's signature was placed at the bottom again, and a descriptive copy block described the container's delectable contents.

The centerpiece of the new design is an unusual logo, which turns the brand's acronym into a graphic that sits simply on a field of color. The palette, and therefore the brand, can be extended easily as more products are added to the cooperative's offerings.

There is a lot of clutter on the shelves of the specialty stores where VOG will be sold, so the extreme simplicity of its new packaging stands out. The package has also worked extremely hard for the client. The launch was successful, and sales are strong. The new look also won a design award at a recent olive oil convention in Australia.

At the start of this project, Lancashire recalls that his client didn't have a clear picture of the future. The new package design shows the way. Very often, he says, with a forward-thinking design, it's possible to surprise a client and even change his or her mind about where the brand might go.

These facts are well known: Consumers are pressed for time these days. Their **schedules are so full,** many can't even find time to eat, much less **consume something healthy.** Fast food has become increasingly unpalatable to those concerned about nutrition. Missed meals lead to stress and fatigue. **Enter Frulatté.**

The Frulatté package design has achieved recognition and praise among consumers and the design industry for its charming range of characters.

Frulatté is a bottled smoothie that meets the caloric, nutritional, visceral, and cost needs of this busy crowd. But even with all of the product's positives, its inventor knew that he had to first convince the consumer to pick up a bottle, no easy task considering the number of competing products already on the market, many of which have huge advertising budgets.

There had to be a remarkable difference in the value proposition between Frulatté and the others, most of which were either weight-loss drinks, clinical calorie supplements, or uninspiring brand extensions of existing juice products. None of these products' packaging said "fun" or even "hello." In fact, the diet drinks even had something of an associated stigma: Who would drink them except for someone who had doubts about his or her physical appearance?

What Frulatté needed was more of a personal style statement. Its design had to be something that people would be comfortable leaving out on their desks at work, says Mark Brutten, grand strategist at Addis, the Berkeley, California, strategy and design firm that handled the project. Expressing good nutrition in a fun and engaging way was important on another level as well, he points out. "This would have to stand out on the shelf, because this would be the company's primary marketing vehicle."

Brutten and Addis principal Steven Addis agree that it would have been simpler and more direct to design beautiful and perfectly appetizing packaging with lots of pictures of cascading fruit. But where a package design can really come to life and speak to a consumer, says Addis, is by asking it to tell a story. A successful package has to do a lot more than just blurt out what's inside the box.

The designers honed in on the idea of the "happy body" and began to search for ways to express that visually. Concepts relating to spas and oases were explored: These yielded a clean, spare effect that didn't really exude personality or comfort. They also considered ways to focus on the goodness of the ingredients—on the seeds of a strawberry, for instance.

A natural extension of the "happy body" concept was to turn one of the main ingredients from each drink into a happy body itself. Actually creating these personalities turned out to be far more direct than any of them would have imagined: They played off preexisting physical characteristics of the individual ingredients—an orange, lemon, raspberry, and strawberry—to create a series of charming faces.

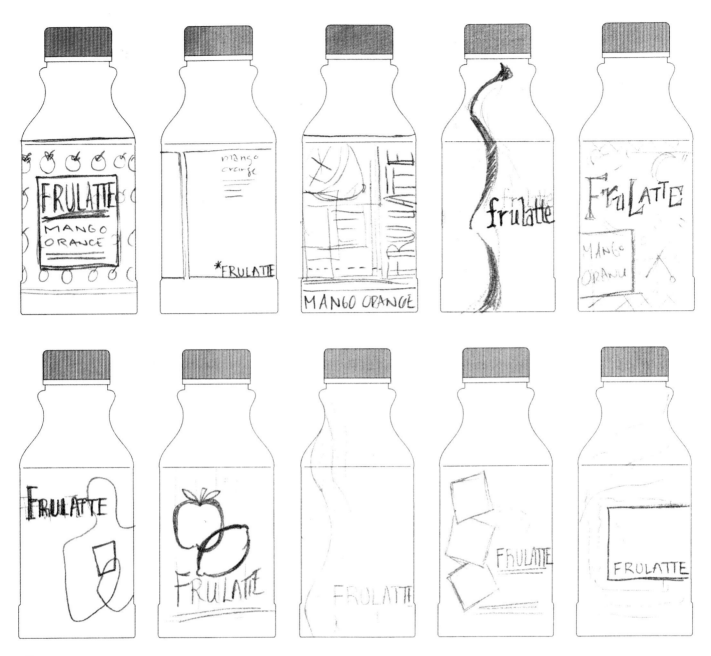

⊗ A pencil study of possible panel designs and shapes began the Addis exploration.

No Photoshop or other special electronic effects were used to create the faces—just simple styling on the set of the photo shoot as well as lots and lots of picking through crate after crate of produce to find the characteristics that would produce the richest, most expressive faces. "This was a natural product, so it had to have a design that was natural," Brutten says.

"This idea came from wanting to express the joy and exuberance of the product," he adds.

Printed on shrink-wrapped glass bottles, the characters speak of fast but friendly food. "It's almost like the fruit is calling to you," says Addis.

"Giving the packaging personality helps the consumer to form a relationship with the product in a literal way. Imagine whether a customer would rather have a Slimfast drink or this on his or her desk. There is no question about what most people would rather interact with. This is not a drink that the consumer is going to pour into another container."

The designers say that the characters are so appealing that almost everyone who comes into contact with them quickly develops a favorite, which may or may not correspond with what flavor they prefer. And even though the client initially believed that the Frulatté packaging would have to carry the full weight of the campaign, the product has been so successful that monies have become available for an advertising campaign that features the characters.

The project demonstrates, Addis says, that the design of a package, when paired with a quality project, can create and even drive an entire brand from the ground up. The power behind the work, though, has to come from an idea with a story to tell, not just pretty pictures.

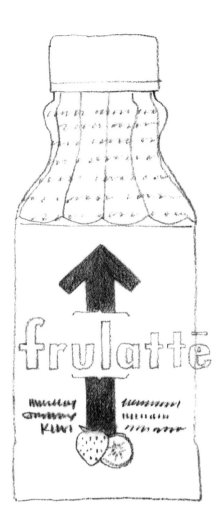

◁ Left: Here the designers were focusing on movement and energy. Forward motion and vitality is what Frulatté is all about.

◁ Right: A clock metaphor implies that Frulatté gives the drinker the stamina he or she needs to keep going all day.

▽ Bottom left: This trial was the first exploration into personifying fruit into a happy friend.

▽ Bottom center: This design speaks of the lushness and richness of Frulatté ingredients. The close-up view of the fruit creates an abstract, but captivating image.

▽ Bottom right: A clean and simple design that makes fruit the hero of this design.

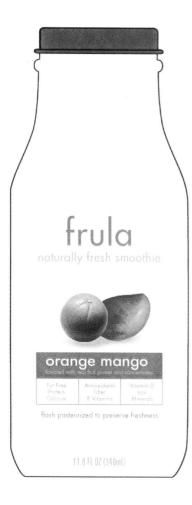

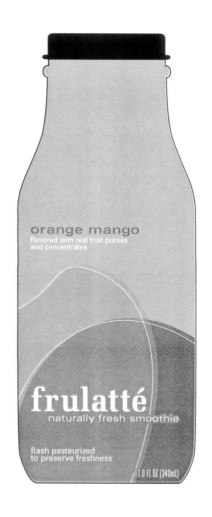

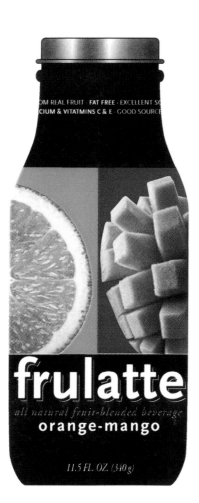

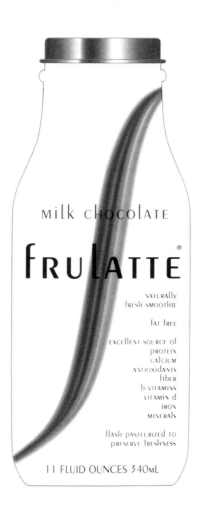

Left: This clean and quiet design speaks of the spa experience. It's fresh and simple.

Right: Some designs were more graphic, like this one. The overlapping fruit is used as more of a conceptual element than an object.

Left: A black bottle would give the product a certain sophistication and richness. This design also offered the experience to compare and contrast the texture of the fruit.

Right: The red mark at the center of this design is, on the surface, a stylized "F" for Frulatté. But it also suggests the letter S, for "supplement." It's length and shape suggests slenderness.

88 Phases is an atypical creative firm that is known for "recontexturalizing" the client products it deals with. It takes companies with no brand at all and **gives them awareness,** or it can take an existing brand, nurture it, and grow it as if the client's product was its own. **Soaptopia is such a client.**

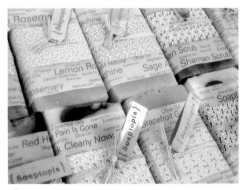

Soaptopia products are tactile, smell great, and are good for the skin. They needed packaging that was just as wonderful. The design firm 88phases helped moved the brand into its next level of business.

"It is a small client, but for our two years together, we have put our hearts and souls into it," explains 88 Phases president Yu Daniel Tsai. His client actually earns her living as a television line-producer, but creating unusual and healthful soaps is a passionate sideline for her. "I see her belief in the product. We don't get involved in craft work, so I asked her what she really wanted to do over the next five to seven years. Was this all she wanted to be? If a client cannot see anything past that, we won't work for them. When she was able to say where she wanted her product to go, we put together a proposal for her."

The client's existing packaging for her line of 18 soaps was basically an envelope with a hand-applied label. It had the tactile, handmade feel that she wanted, but it wasn't sophisticated enough to move her to the next level in retail.

Tsai explains. "Initially, the client had started to make soap, and she would give it away on film sets. More and more people would ask her for the soap. Then a good friend who is a doctor ordered a big batch to give away to other doctors and nurses. That's how she got started."

The 88 Phases team had many dilemmas to consider: First, any design they created had to allow for line expansion and contraction. New soaps could be added to or removed from the range anytime. Second, the budget for the production of the packaging was very low. Third, the product had to look as if it had been touched by human hands. And, finally, the soaps had to be properly protected, to prevent them from drying out and leeching oils.

The designers considered an enormous range of ideas, including many that were outside of the project's budget constraints. But Tsai says that they try not to let anything restrict their creativity, at least initially: They can always go back and rework good ideas so that they are less expensive.

Clear wrapping paper was considered, as was a muslin bag that could serve as a loofah. Many cardboard containers were sketched out, including a half-box that would allow shoppers to easily smell the products, which have a wonderful aroma, Tsai says. Other boxes had interesting and clever folding or closures. One idea was to use a diecut box with many tiny holes on its top—so many that the colorful product would be visible while the box was still closed.

The designers also looked into branding or stamping the soaps themselves with ink.

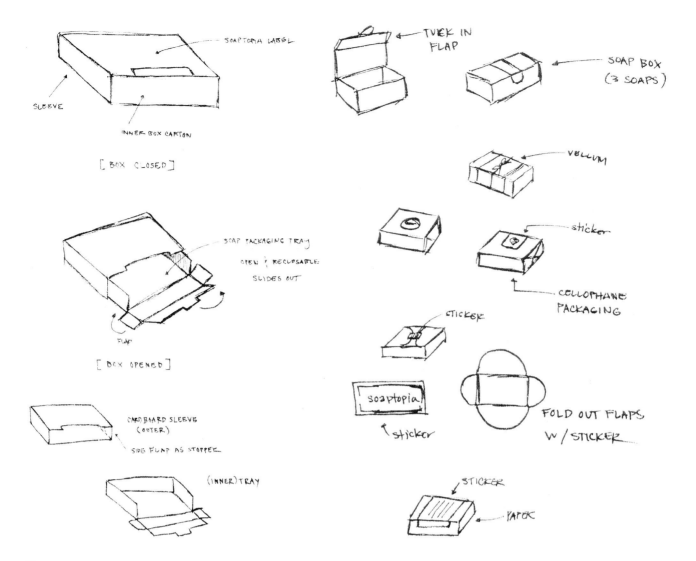

⬡ 88 Phases principal Yu Daniel Tsai performed extensive research for the Soaptopia brand. Although the client had a relatively strict budget and limited production capabilities, Tsia did not initially count out ideas that were impractical from a cost or time standpoint. Wonderful concepts or constructions can be modified to fit a client's needs, rather than be abandoned. Tsia also experimented with packaging designs for products that the client may produce in the future.

"It was so raw and simple, but the client was concerned that the ink might come off on the skin," Tsai says.

Other ideas included stitching the soap into a burlap sleeve, wrapping the soap in cheesecloth, sandwiching the soap with wooden plates and hemp rope, enclosing the soap in a papyrus-like net, and using intricate, Asian-inspired wooden boxes and bags as containers.

But the idea that emerged as both practical, affordable, and memorable was an imprinted vellum sleeve hand-tied with paper cummerbund, raffia, and a Soaptopia tag. The sleeve communicates what is in the product and what it represents, and it lets the consumer see, smell, and touch the soap. It also prevents the oils in the soap from seeping onto anything nearby—and the raffia actually prevents the soaps from touching each other.

"We really wanted to use bamboo rope, but she didn't have the budget for it. There is a lot of give-and-take on a project like this," Tsai says.

The color palette for the project has an Asian sensibility. Tsai compares it to a palette one might find on pottery discovered in a Chinese bazaar. The organic components of the soap ingredients were also considered in the selection of color and pattern on the packages.

The design team took the design to the next level when it decided to replace the plain paper cummerbunds originally specified with printed French wrapping papers. These add yet another layer of color and texture to what is already a rich package. It is also highly customizable.

"If she wants to change any of the designs, say, for the LA market, she can do it because the packaging is so modular. It would be easy for her to have different packages for the same products in different markets," Tsai points out.

Despite the smaller scale of this project, Tsai values it a great deal because it gives him perspective. Soaptopia is like a baby now, just learning to walk, he says.

"I am running a campaign for Gateway Computer right now, a very large project. Soaptopia is a different kind of work: It is very true to one person's love. Obviously, this is not a moneymaker for us, but we are learning, too, which is worth something."

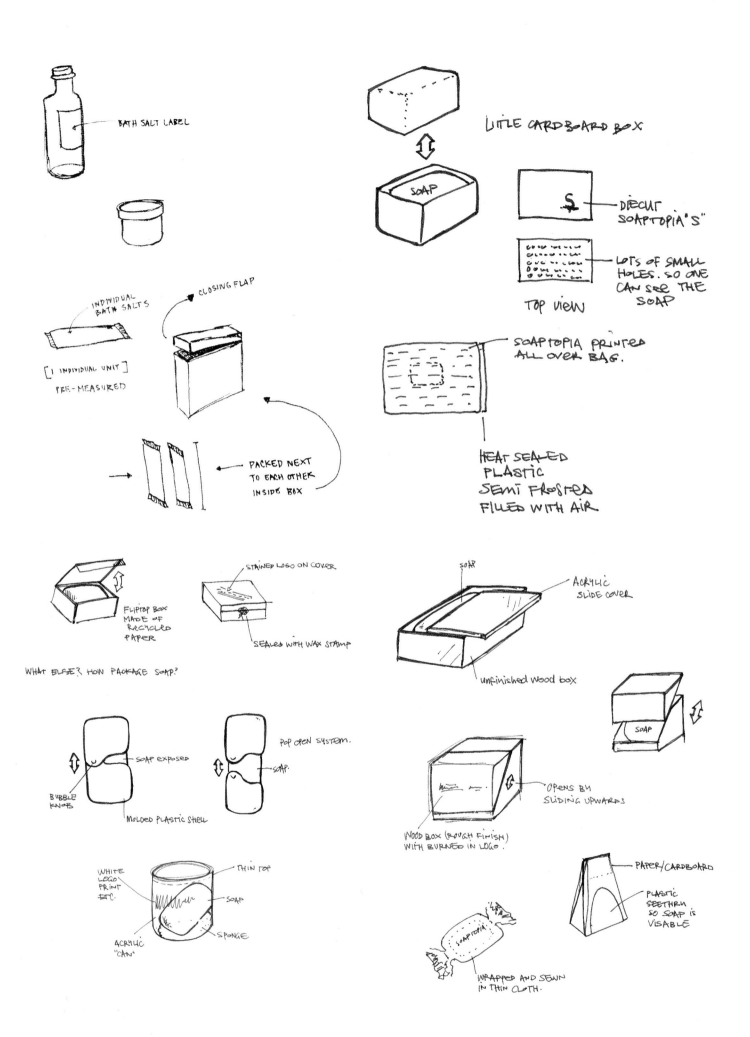

BATH SALT LABEL

LITTLE CARDBOARD BOX

SOAP

DIECUT SOAPTOPIA'S "S"

LOTS OF SMALL HOLES. SO ONE CAN SEE THE SOAP

TOP VIEW

INDIVIDUAL BATH SALTS

CLOSING FLAP

[1 INDIVIDUAL UNIT] PRE-MEASURED

PACKED NEXT TO EACH OTHER INSIDE BOX

SOAPTOPIA PRINTED ALL OVER BAG.

HEAT SEALED PLASTIC SEMI FROSTED FILLED WITH AIR

FLIPTOP BOX MADE OF RECYCLED PAPER

STAINED LOGO ON COVER

SEALED WITH WAX STAMP

WHAT ELSE? HOW PACKAGE SOAP?

SOAP

ACRYLIC SLIDE COVER

UNFINISHED WOOD BOX

SOAP EXPOSED

POP OPEN SYSTEM.

SOAP.

BUBBLE KNOB

MOLDED PLASTIC SHELL

SOAP

OPENS BY SLIDING UPWARDS

WOOD BOX (ROUGH FINISH) WITH BURNED IN LOGO.

WHITE LOGO PRINT ETC.

THIN TOP

SOAP

ACRYLIC "CAN"

SPONGE

SOAPTOPIA

WRAPPED AND SEWN IN THIN CLOTH.

PAPER/CARDBOARD

PLASTIC SEETHRU SO SOAP IS VISABLE

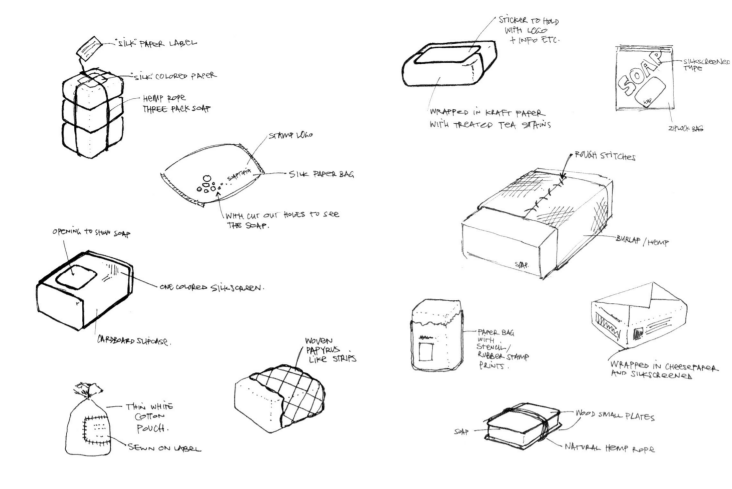

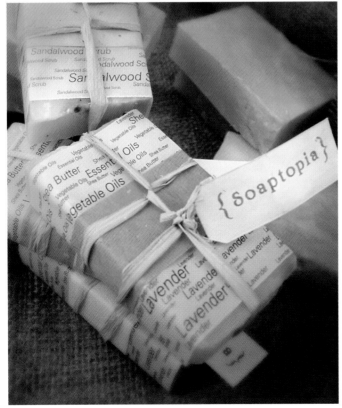

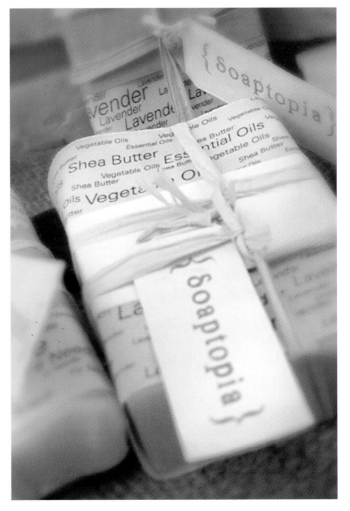

The design that eventually won out combines a tissue wrap that carries words that relate to the product. A belly band provides a ground for a hand-tied ribbon. The design is beautiful as well as practical: The tissue keeps the soap from drying out, and the bulk of the tie keeps the soaps from laying together and absorbing each other's oils and scents. The design is also customizable for various markets or occasions because the belly band can be swapped out for a different style or color of paper.

How do you maintain a brand's **star quality** while downplaying it at the same time? Make an identity **concrete but endlessly flexible?** Translate a normally RGB, on-air brand—in this case, the **Discovery Channel**—to hundreds of CMYK-printed packages?

Parham Santana (New York) managed these challenges and more when it took on the packaging program for the Discovery Channel. The client puts its name on thousands of toy, learning, health and beauty, and convenience items for men, women, and children. These products are sold in venues as disparate as high-end specialty stores to large retail outlets. The variables for the project seemed endless at the start.

But the Parham Santana team did have a head start. Five years ago, the firm helped Discovery launch its first licensed program in Target stores nationwide. In addition, principal John Parham recalls that Discovery's retail program for kids was fairly well coordinated already; although the adult products were being packaged manufacturer by manufacturer. So his team began thinking about how to coordinate the adult's and women's product lines within themselves as well as with the children's lines.

The client had four objectives at the start of the project. First, Parham reports, Discovery wanted to emphasize the product over the package or the brand.

"The product needed to be the hero," he says. "The color on the front of the package could not compete with the product, only frame it, for example. We needed to create a stage for the products where different types of stories could be told."

Second, Discovery wanted total flexibility in terms of cross-merchandising between children's, adult's, and women's products in the store setting.

"For example, at the front of a store, they may create a vignette where they want to promote a particular telecast. The in-store merchandising might bring together a pair of adult binoculars and a kid's archeology kit in one display," Parham says. Both products would need to sit comfortably together.

The third objective was to create the notion of a family destination or theme. From a design standpoint, this meant showing that the Discovery line had something for everybody.

"A lot of this has to do with the friendliness of the type we chose, as well as the approachability of the copy we included. Colors would have to be fun and upbeat, and of course, the product mix had to be sufficiently diverse," Parham says.

Finally, the fourth objective required Parham Santana to make it possible for Discovery Channel to gracefully promote its sub-brands: TLC, Discovery Health, and Animal Planet. The challenge

a universal
color family

Color and pattern were the key elements the designers used to tie the product lines together. The blueprint-like "tech" pattern is used on goods for grown-ups, while the "orbit" pattern signals products for children. The same color palette is used across the board for adult, child, and women's products, but in different configurations.

Parham Santana was faced with a formidable challenge when it designed packaging for Discovery Stores. Not only were there thousands of SKUs, but the products were sold in various venues, from high-end specialty stores to large retail outlets. By using background pattern and a related color palette, the design firm was able to relate the disparate products, yet still provide distinction between adult and kid products.

here, Parham says, was to create a brand story that was unique to Discovery Channel but broad enough to accommodate individual members of its family.

He explains: "In a store, you might see a TLC poster there, promoting a series, and the Discovery packaging would have to feel comfortable with it."

From the beginning, Parham and his design team were influenced by what Discovery was doing on-air. They wanted to get at the essence of the Discovery way of doing business—a special sense of energy, excitement, and color—and translate that into packaging.

"We studied many different retailers to see how they presented their brands, but the Discovery brand was already distinct. We decided that the channel should be the driver for the feeling and tone of the package," Parham says. The channel's naturally "smart" sensibility could be graphically translated into "smart, simple, and clean."

Parham Santana first concentrated on establishing a universal color palette that would be gracious hosts to all consumers, no matter their age, sex, or interests. An eight-color palette of white, silver, red, orange, yellow, green, blue, and black was suggested. This extensive palette was selected for its flexibility. For the adult market, the main colors would be blue, green, and red, with yellow, orange and lighter shade of the same blue specified for accent colors. For children, the palette was flipped: The main colors would be yellow, orange, and the lighter blue, whereas accents would be pulled from the deeper, adult palette.

Women's product packaging colors pulled from the children's palette, but in a more sophisticated way. "A stereotypical, pastel take on the women's market would not have been appropriate: Discovery is just not pastel anyway. Market studies showed that women really identify more with a vibrant color palette," Parham says. As a result, the women's palette uses the Discovery Kid's bright colors, but in a more sophisticated way.

⌃ The design of the Ladybug Shelter illustrates how Parham Santana balanced many different package components. Here the designers have used bursts in the forms of a paintbrush and an arrow, and they have placed a white glow behind the product to make it pop off the box.

⌃ The logo is moved to the upper right-hand corner to make it more visible to shoppers. The glow was removed, being deemed difficult to produce for the number of products that the line contains. The "bursts" are simplified here, again to simplify future production.

⌃ To make the product jump off the box without a white glow, the designers introduced a "Discovery ring" graphic and placed the product on top of it. More icon "bursts" are introduced.

⌃ This comp shows a type variation that was eventually used in the final design. The description line was also moved above the title so it wouldn't run over the product image. Also, the "Discovery ring" now has two outer rings.

⌃ More type variations.

⌃ In this design the final "burst" choice emerges. The swirl would be easier for the designers to execute.

⌃ The designers also experimented with using a white front on the package, to make it stand out in the retail setting. The solid front also starts to "color code" product groups.

⌃ A busier type treatment, but one that is still consistent with the adult packaging program. (Both use Clarendon.)

⌃ The designers felt that this type treatment was too busy. They tried a gray orbit pattern, which was more neutral and less obvious than color orbit patterns.

In addition to creating a unifying color palette, the Parham Santana designers also used silver as a background in several ways. On some packaging, a solid silver background is a simple, classic design accent that allows the product photography to star as hero on the box. On other designs, a blueprint-like "tech" pattern is printed in silver on a white background. On children's packaging, where vibrant color is commonly used as a background color, an "orbit" pattern that complements the "tech" look is reproduced. Placed side by side, the familial connection between the silver "orbit" and "tech" backgrounds is evident.

Other connecting factors were the typefaces the designers specified. Clarendon Light and Trade Gothic Condensed were chosen, a serif and sans serif face, respectively, that are recognized for their friendly, energetic nature. The copy, too, has the same feeling, says Parham. "The voice is informative, but friendly," he notes.

Parham Santana also invented Discovery Facts(tm), which appears on every package back. This panel enhances the shopper's appreciation of the product while providing "current and mind-boggling truths about the world."

In the end, the designers provided their client with a set of building blocks with which any product or customer could be addressed. The system is now being applied to hundreds of SKUs by various manufacturers, who now have the visual information they need to stay within the Discovery brand parameters.

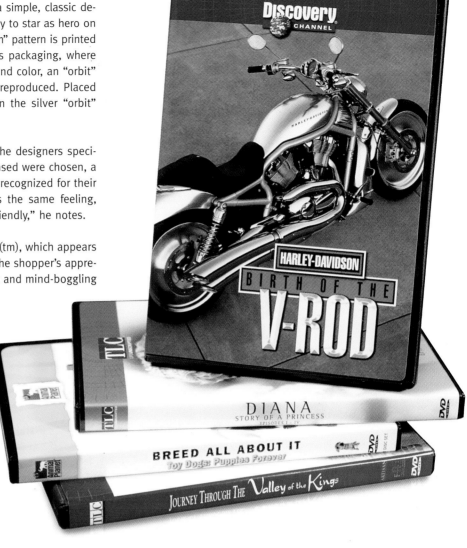

The new package design also permits every product in the Discovery Channel universe to live comfortably together on the shelf. Note how these TLC, Animal Planet, and Discovery Channel DVDs bear a strong family resemblance.

No details were overlooked, even the gift wrap incorporates the "tech" pattern for a seamless presentation.

VALUE PRODUCTS—DESIGN THAT DELIVERS
Lipton Tea

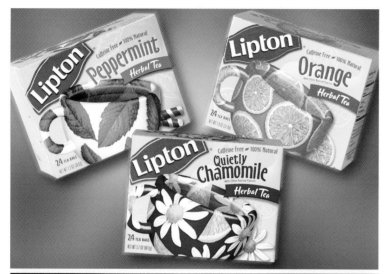

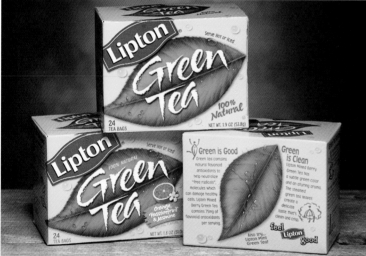

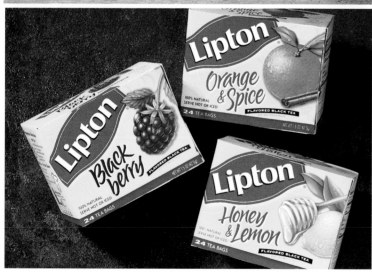

After the core Lipton Tea brand was redesigned, it was time to take a good look at its subbrands: green tea, herbal tea, and specialty tea. Lipson Alport Glass & Associates reworked the packaging for all three lines simultaneously.

With the enormous popularity of coffee and coffee-based drinks, tea has taken a real hit in the marketplace. And the tea brands that are now thriving are generally smaller, specialty varieties, not large national brands.

Lipton Teas has not sat still during this period of flux in the hot-beverage industry. Vincent Masotta, senior design manager at Unilever Bestfoods, owner of the Lipton Brand, who had been responsible for the visual master branding of the entire line of Lipton Tea products, went to New York City–based Lipson Alport Glass & Associates (LAGA) to translate its new master brand presence to Lipton's specialty teas.

Three specialty tea subbrands would have to be reworked simultaneously: herbal teas, flavored teas, and green tea. The ramifications for failure on the project were serious indeed: For instance, sales of the specialty teas were not very strong, and the company had considered eliminating some of the products altogether. After all, a product with a name like "Soothing Moments," one of the specialty teas, did not attract a younger consumer, which is what Lipton needed.

"The consumer for hot teas is getting older all of the time," says Rob Swan, creative director of LAGA. "We needed to inject more vitality and spirit into the subbrands."

Green tea was tackled first, and the work LAGA did here set the precedent for the remaining lines. The objectives for green teas included:

- aligning the new packaging with the "master brand yellow architecture" that had been developed for the core brand, while creating a distinct sense of style and authentic green tea personality, including Asian cues;

- infusing the pack with a style and energy that reflects the lifestyle of the 21- to 30-year-old, young-minded, outward-looking person who believes that balanced health in mind and body will allow them to live every day to the fullest;

- designing a "hip and cool" package that is simple, pure, and active, conveying an attitude that is natural, optimistic, social, stylish, and confident;

- orienting the package hierarchy—Lipton, Green Tea, Flavor Name, 100%, Natural, Serve Hot or Cold;

- retaining the slanted cartouche, which is its logo, and its distinctive yellow color; however, green tea should feel different from the core brand.

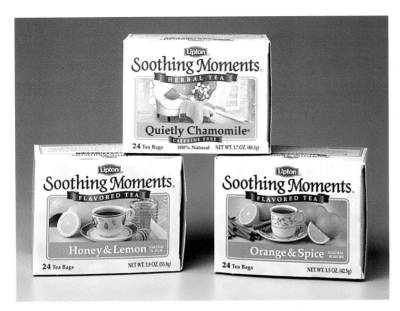

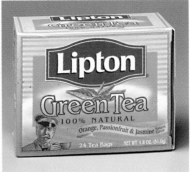

Teas already had a reputation as a drink that only elderly ladies enjoyed. The original packaging for the subbrands did nothing to squelch this belief. It was also difficult to tell that the subbrands were actually part of the same Lipton family.

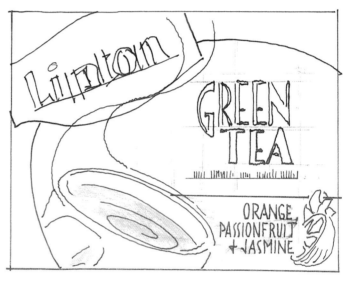

The LAGA team explored a wide range of ideas for the green tea packaging, ranging from mind-body connections and natural connections to Asian cues and flavor references. They also experimented with how to portray the Lipton cartouche.

→ balance of mind + body
Shown through 2 halves
of package
 - one side's color the
 inverse of the others
 - interesting billboarding effects

*CLEAN
* OPTIMISTIC
* ASIAN CUES/TYPOGRAPHY

- DUOTONE LEAFS. SOFT

MIND & BODY CONCET

> BENEFITS, ARE CALLED OUT IN ILLUSTRATION

– Space divided by rectangles
 ↳ Contemporary/action oriented feel
 → large blown-art photography
 → Contemporary typography
 → "Keeps me on top of my game"

– light use of asian characters over flavor illustration

light shining out from brand and onto product

↳ bottom half treating in style of Schwab illustration bel

LAGA's creative team, which included creative director Rob Swan, senior designer Mark Krukonis, and brand consultant Lara Holliday, extensively researched visual representations of authentic Asian heritage. "It was important to achieve the proper level of Asian cues without taking the effect over the top, as many competitors' products did," says Krukonis.

"This should feel genuine, not faked. It also needed to reflect the life of the 21- to 30-year-old with balance between mind and body. We wanted it to feel fresh, pure, simple, and active," he notes.

Sketching began, and the team's visual explorations were far-ranging. Some concepts focused on the balance between the body and the mind, whereas others featured natural themes, including such elements as leaves and fruit. Some designs used overt Asian cues, such as calligraphy or extremely simple designs. In each, though, the designers also played with the Lipton logo—

for example, angling it more and bleeding it off the front panel to give it a more active feel.

This exploratory stage led the team to a Round One presentation for the client. Each comp presented at this stage was unique and offered a different direction.

The first comp was decidedly more Asian; it actually has Asian lettering behind the varietal name. The words "green tea," in a calligraphic script, also carry the Asian theme.

"The next design still has the characters in the background, but they are more subtle," says Swan. "But the script for the words 'green tea' becomes even more Asian."

In a third design, the references to flavor and color were much stronger: A large green leaf held the variety name, which had an

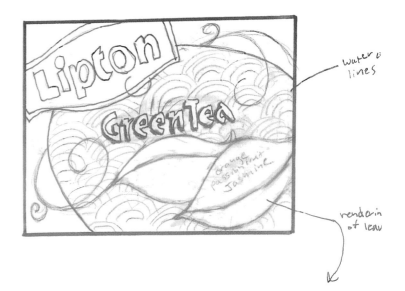

→ interaction of tea cup steam + brand mark
 ↳ relates to mister R+Y packaging
→ Sun rays in bckgrd. = asian cue

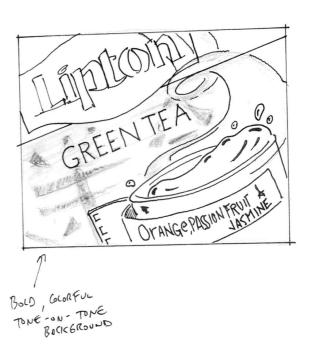

BOLD, COLORFUL
TONE-ON-TONE
BACKGROUND

Asian, brushstroked look, plus refreshment cues in the form of water droplets. Other comps explored a more holistic, new age sensibility; the energy of the flow of a river or stream; and energetic lifestyles.

"Everyone at the presentation gravitated to the third design. The leaf could be extracted for other uses, the water droplets were there, it had an Asian feel, and it had an all-natural sensibility—it just hit on all cylinders," explains Swan.

Once the group had nailed the front panel, they focused on the other panels, especially the back one, which is crucial to the package's success. "Every package needs to be a 360-degree experience," Swan says.

A brainstorming session on the back panel generated plenty of ideas to engage the consumer who has picked the box up off the shelf and is looking for both information and inspiration. The most promising approach combined the notions of "green is good" and what Swan calls "the leaf guy," an energetic, running, jumping little figure who easily conveys the ideas of vitality, green, health, youth, and more. Basically, the figures would demonstrate what the copy talked about.

The new design has been enormously successful: All subbrand teas have enjoyed the growth in sales. The green tea packaging also drove the design of the other lines: The herbal teas and flavored teas also place the Lipton cartouche on a more extreme angle, and each line uses large illustrations of leaves, fruit, flowers, and honey on the front panels. It's a fresh, fun look, and there is no doubt that the three lines are from the same family.

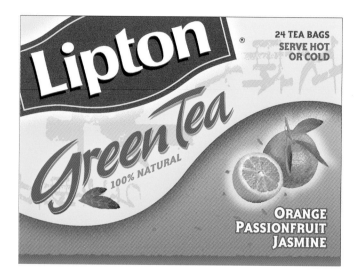

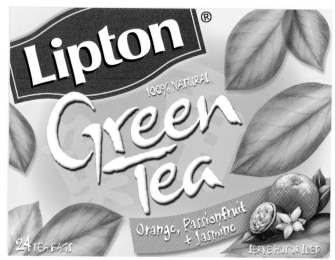

The previous set of sketches resulted in these comps, each of which had certain promise. The design with the large green leaf, however, emerged as a favorite, because it contained green, Asian, refreshment, and flavor cues, while giving a definite nod to the Lipton core brand.

Green is Great!

Green is Clean. Lipton Green Tea has a delicate taste, beautiful pale green color and subtle aroma that's clean, crisp and alluring.

Green is good. Green tea contains natural antioxidants to help neutralize "free radicals" and help you maintain healthy cells and tissues.

Green is legendary. Lipton Green Tea has a rich American heritage as the first tea imported from China to the USA.

No Matter How You Slice It...

Good for taste
Steaming gives Lipton Green Tea a clean, crisp, and wonderfully unique taste that's easy to love.

Good for Trivia
Did you know Lipton Green Tea was the first tea imported from China to America?

Good for Life
Green Tea contains natural antioxidants to help neutralize "free radicals" and maintain healthy cells and tissues.

Green Is Good.

Why Green?

Green Tea has a delicate taste, beautiful pale green color and aroma that's clean, crisp and alluring.

Green Tea has a rich heritage— it was the tea Lipton imported from China to America.

Green Tea contains 130mg. of natural antioxidants to help neutralize "free radicals" and help you maintain healthy cells and tissues.

Green Dreams

The best things in life are green. Take a moment to enjoy Lipton Green Tea's delicate flavor, beautiful pale green color and subtle aroma. It's the clean, crisp taste you'll treasure for life. Discover the tea and health connection. Green tea contains 130mg. of natural antioxidants to help neutralize "free radicals" and help you maintain healthy cells and tissues.

Energize · Body · Rejuvinate · Vitality · Mind · Healthy · Vitality · Spirit · Spirit · Body · freedom

Believe in Green.

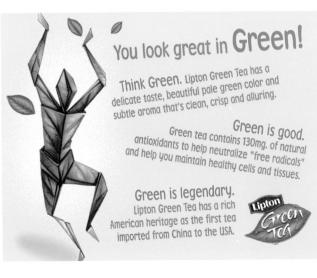

You look great in Green!

Think Green. Lipton Green Tea has a delicate taste, beautiful pale green color and subtle aroma that's clean, crisp and alluring.

Green is good. Green tea contains 130mg. of natural antioxidants to help neutralize "free radicals" and help you maintain healthy cells and tissues.

Green is legendary. Lipton Green Tea has a rich American heritage as the first tea imported from China to the USA.

The back panel received lots of attention as well. The designers tried to convey benefit, answer questions, and inspire confidence in what green tea can do for a person. The designs with the "leaf guys" eventually came out on top.

Imagine being faced with **redesigning** 150 clamshell packages. This was **the unenviable task** faced by designers at Portland, Oregon–based **Sandstrom Design** when they began working with **Gerber Legendary Blades.**

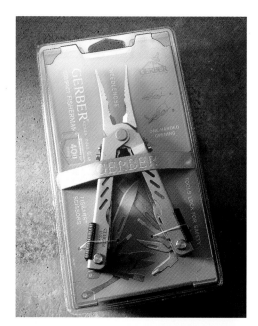

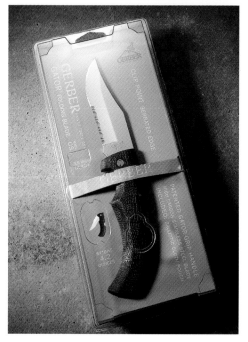

Designers at Sandstrom Design, through clever package architecture, discovered how to create clamshell packaging for Gerber knife and tool products that is safe, attractive, eminently shippable, easy to display in the store, and, in terms of simple style, miles beyond the competition.

Mention clamshell packaging to most designers, and a weary look will come over their faces. These hard plastic containers are a necessity for many products, whether they provide protection and an easy display method, discourage shoplifting, contain multiple pieces or whatever. Unfortunately, they can be as dull as they are practical. Plus, they can cause even a quality product to look somehow chintzy.

Even more challenging than the dull nature of the packaging, Sandstrom project director Kelly Bohls, creative director Jon Olsen, and their team had to deal with 27 different graphic looks within that population, the result of going from an in-house at Gerber, to a design group at Fiskars, which bought the company in the late 1980s. Here and there, an American flag or a photo would be added by different people, until the entire line had an uncoordinated feel.

The multiple clamshells were not only inadvisable from a design and identity standpoint but also expensive to produce and a nightmare to warehouse, Bohls points out. A standardized box would have accommodated many of the SKUs, which also included other tools, such as its 700 Series Multi-plier. But Target and other large retailers demanded clamshells in return for shelf space, so the designers would have to find another way.

But they didn't abandon the idea of a box altogether, Olsen recalls. They considered using corrugated boxes that were vacuum sealed in plastic, as well as making the boxes out of a thicker but still transparent kind of plastic.

"Then we started looking at different forms of boxes, boxes that could accommodate 5 to 10 different SKUs. We knew that retailers love clamshells for their visibility, durability, and security, so we tried to figure out how to use the clamshell in a new and different way."

A more interesting shape, no matter what that shape is made from, would be more intriguing than the awkward shapes of the previous clamshells. So why not shape the clamshell around a box? The product would still be secure and easily displayed, but it would have stronger, more elegant personality when displayed against the clumsy packaging of competing products.

That's when the design team began developing a board-stock tray—essentially, the J card—that would form the interior box. Most knife products fold but are displayed open. When open, they have a cavity in their backs into which the die for the cardboard could be fitted. It would hold the knife in place inside of the clamshell. But for added security and for a striking design touch, an orange rubber band was wrapped around the knife and

Custom Chip / corrugate board -
A. Common clamshell
B. Shrink wrapped

1a.

Custom Chip / corrugate board -
A. Common clamshell
B. Shrink wrapped

1b.

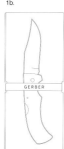

GERBER

Custom Chip / corrugate board -
A. Common clamshell
B. Shrink wrapped

1c (Back).

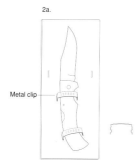

GERBER

Custom Chip / corrugate board -
A. Common clamshell
B. Shrink wrapped

2a.

Metal clip

Custom Plastic tray -
A. Common clamshell
B. Shrink wrapped

2b (Back).

Custom Plastic tray -
Inside common clamshell

Custom Chip / corrugate board -
A. Common clamshell
B. Shrink wrapped

3a.

Custom Chip / corrugate board -
A. Common clamshell
B. Shrink wrapped

3b.

GERBER

Common Chip / corrugate board -
A. Common clamshell
B. Shrink wrapped

4a.

Common Plastic tray -
A. Common clamshell
B. Shrink wrapped

Common Chip / corrugate board -
A. Common clamshell
B. Shrink wrapped

4b.

Custom Plastic tray -
Common clamshell

5a.

Corrugate box -
A. Common clamshell
B. Shrink wrapped

5a.

Corrugate box -
A. Common clamshell
B. Shrink wrapped

5b.

Custom Plastic case -
Custom Foam insert

6a.

Custom Foam insert

6b.

The various products that Gerber offers spawned 27 different looks among 150 different clamshell packages. So the Sandstrom designers spent a great deal of time thumbnailing designs that would accommodate multiple SKUs. They even looked at ideas that revolved around corrugated boxes and vacuum-sealed plastic.

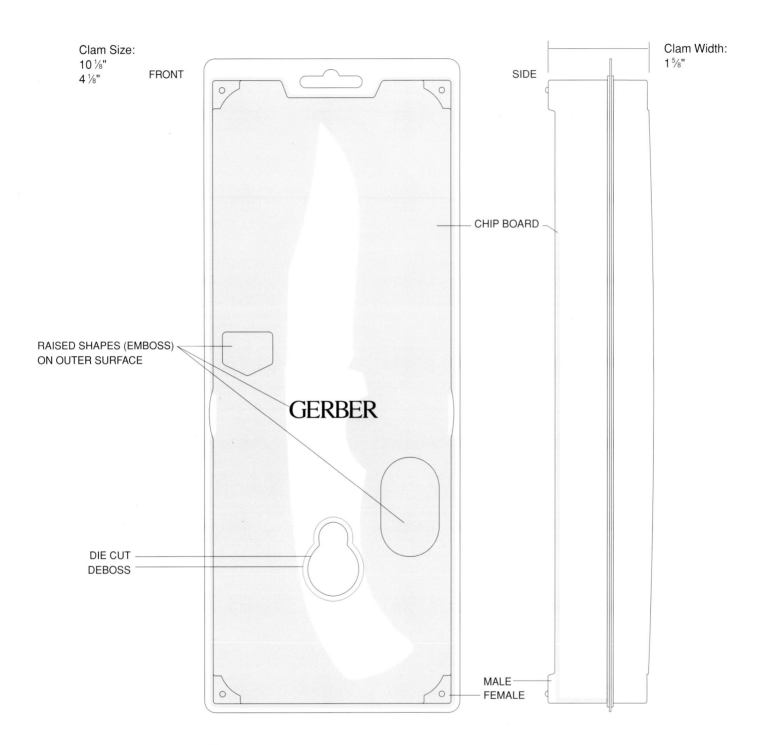

Clam Size:
10 ⅛"
4 ⅛"

FRONT

SIDE

Clam Width:
1 ⅝"

CHIP BOARD

RAISED SHAPES (EMBOSS)
ON OUTER SURFACE

GERBER

DIE CUT
DEBOSS

MALE
FEMALE

◇ The finished clamshell design had an open area where shoppers could actually touch the tool, as well as several debossed areas that directed people to important information on the enclosed J card. In addition, the packaging was designed so the "feet" on the back of one package would sit neatly into the front of the package below it when they were stacked. This feature prevents packages from shifting during shipping, which had caused damage in the original designs.

the J card. The color is a nod to the predominant color of many a hunter's clothing—blaze orange. In the plastic of the clamshell directly above the rubber band, the designers debossed the Gerber name, and this casts a shadow onto the orange field, creating a three-dimensional effect.

Another problem that the designers addressed was the way the previous clamshells scratched and scarred each other in shipment. They designed feet into the bottom of the new box, so the clamshells are stackable, but do not rub together or shift during shipping.

Other new features included finger holes in the clamshell where shoppers could touch the knife handle, which historically had proven important to making the sale. The designers also debossed several shapes in the top of the clamshell that direct people to important information on the J card, such as the length of the blade or the number of the series.

The J card is slate blue, which is quite different from the wild patterning, American flags, and alligators that the competition uses. The look is technical and precise.

"Most products in this category seem to have to scream that this is a hunting product," says Bohls. "The people shopping for this already know what it is, though. We didn't have to make it look like a hunting knife: We wanted people to know that it is a precision instrument."

"We made the product the hero and didn't add too much design on top of it," adds Olsen.

In the retail setting, the combination of the orange rubber band and the slate blue backer card is strong and dramatic and provides a unique branding statement for the category. In particular, the horizontal orange stripe draws the eye immediately. There's no question about which products are Gerber's.

Amazingly, the designers were able to reduce the number of Gerber clamshells from 150 to only 6, an enormous, long-term cost-savings for the client, even with the price of the new dies. "The boxed product looks much more sophisticated than the competition, it is engineered to fit the product, and it functions effectively for retailers," says a proud Rick Braithwaite, Sandstorm Design president, of his group's efforts.

This close-up of the clamshell design shows how the packages fit together when stacked. It is both a functional and highly dynamic design.

Greg Norman Estates is definitely a case of, "If you build it, they will come" or **"If you have it, flaunt it."**

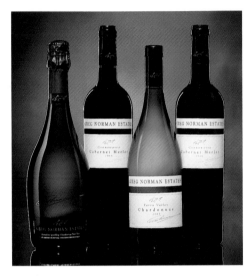

Tucker Design applied a logo that was normally used on clothing and golf gear onto a new line of wine. Greg Norman Estates has proven to be enormously popular, inspiring a new golf course in Australia, a possible vineyard, and incredible sales.

In 1999, Ted Kunkel, the CEO of Foster's Brewing, the company that owned Mildara Blass (now Beringer Blass), informed the chief executive of the wine company that his friend Greg Norman "wanted to have his own wine label" and that Mildara Blass was going to make it happen.

The idea was treated as something of a joke by the marketing people at Mildara Blass, but as the order had been given, a brand manager was appointed to launch and guide the Greg Norman Estates brand. Barrie Tucker, creative director of Tucker Design of Adelaide, South Australia, was briefed on the project and given the challenge to create the Greg Norman Estates brand identity and packaging design.

The marketing staff at Beringer Blass didn't think the concept would fly—particularly because there was no actual vineyard—but they were soon proven wrong. The initial vintage of 20,000 cases tentatively released in the United States sold out in about one month. The second vintage took only three months to sell out.

Today, the popularity of Greg Norman, the quality of the wine, and the distinctive use of the personality of Norman's Great White Shark identity with the design firm's graphics all combine to create a popular product.

Greg Norman's multicolored shark logo is well known the world over in sports and sportswear circles, and translating it to a wine product could not have been more of a stretch. In fact, the company that controls the merchandising for the brand (Reebok) asked Tucker to only use the logo in gold. Eventually, though, with the help of the Beringer Blass marketing people, he convinced them to allow the use of the color logo.

All but the sparkling variety in the line was already bottled when the design project was commissioned, so Tucker did not get to choose the shape of the bottles. He would have to accommodate several different bottle shapes and decided to keep the labels fairly conservative with a controlled elegance.

"Overdoing the shark logo would be garish. We decided to use the logo mildly on the label itself, but use it more boldly at the neck to catch attention in store," Tucker says.

The idea of the brand identity was based on the use of the well-recognized internationally established shark icon. Barrie Tucker believed that the Greg Norman wine brand had to have the use of that image to truly succeed. The Greg Norman signature inclusion was also a must to offer consumers (especially the golfing fraternity consumers) because it suggests authenticity from Greg Norman and creates the illusion of an exclusive personalized autograph.

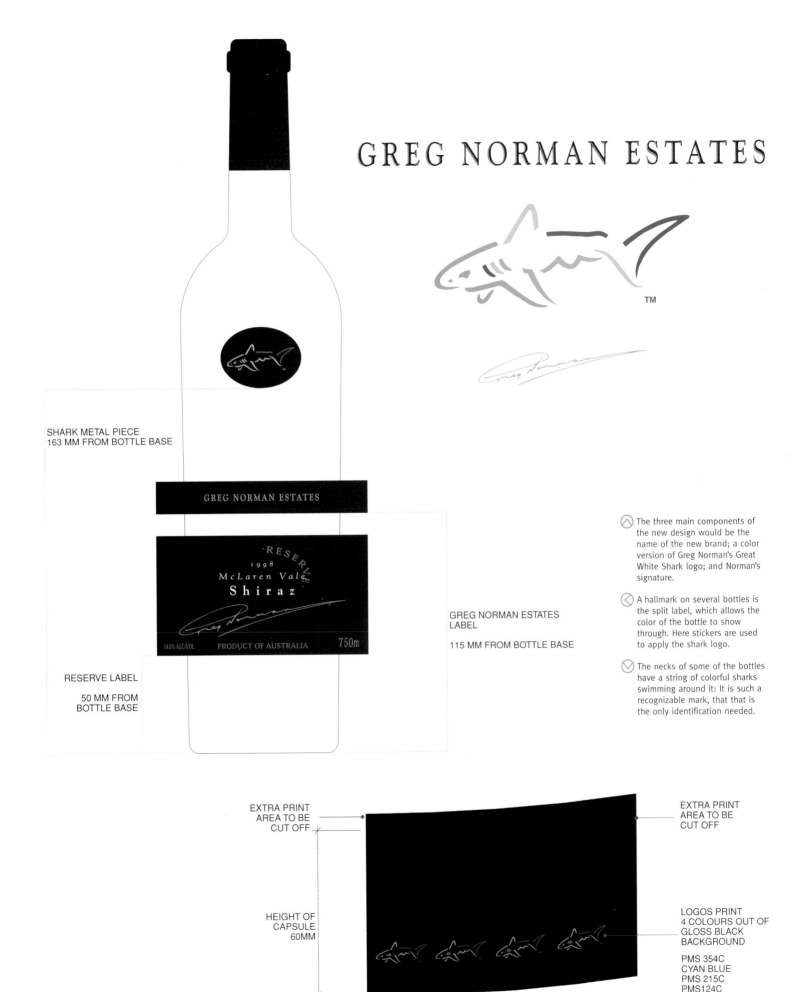

GREG NORMAN ESTATES

SHARK METAL PIECE
163 MM FROM BOTTLE BASE

GREG NORMAN ESTATES

RESERVE
1998
McLaren Vale
Shiraz

14.0% ALC/VOL PRODUCT OF AUSTRALIA 750m

GREG NORMAN ESTATES
LABEL

115 MM FROM BOTTLE BASE

RESERVE LABEL

50 MM FROM
BOTTLE BASE

The three main components of
the new design would be the
name of the new brand; a color
version of Greg Norman's Great
White Shark logo; and Norman's
signature.

A hallmark on several bottles is
the split label, which allows the
color of the bottle to show
through. Here stickers are used
to apply the shark logo.

The necks of some of the bottles
have a string of colorful sharks
swimming around it: It is such a
recognizable mark, that that is
the only identification needed.

EXTRA PRINT
AREA TO BE
CUT OFF

EXTRA PRINT
AREA TO BE
CUT OFF

HEIGHT OF
CAPSULE
60MM

LOGOS PRINT
4 COLOURS OUT OF
GLOSS BLACK
BACKGROUND

PMS 354C
CYAN BLUE
PMS 215C
PMS124C

It was deemed important to present a serious wine "face" to the brand. This was achieved with clean typography and an uncluttered layout, supported by the Greg Norman signature and the understated use of the shark icon. It is envisaged that any line extensions to the brand can be created using this simple but striking formula.

For the Chardonnay, Merlot, and Shiraz bottle designs, Tucker created a split label that highlights the brand name, which is contained in a smaller band above the larger variety label. The Reserve bottles use the same design, but their labels are black. The full color shark logo swims around the bottle neck and is presented on a hand applied metal label at the front of the Reserve bottle with the shark logo ceramic printed in color on black. The Reserve product was packaged in a handmade, black paper-covered cardboard box with the brand screen printed on the lid.

Tucker knew the designs would have to be understated because the demographics of the potential customers was wide, ranging from a Greg Norman fan who knew nothing about wine to a wine fan who knew nothing about Greg Norman.

"We had to make the product understandable to a wide range of people—the design couldn't be shocking," Tucker explains. "It also had to look like a serious wine in order for it to be internationally acceptable."

The wine and its design have been so successful that the line has grown in volume by well over ten times its original annual sales budget. New product extensions are planned at various retail price levels.

The Sparkling wine bottle was created with the Greg Norman signature ceramic printed in gold directly to the bottle with the brand and variety label printed in black low on the bottle. This design presentation was formulated to emphasize the bottle's elegant form, while highlighting the Greg Norman 'hero' signature as a status symbol.

Gift-boxed champagne glasses were also designed, with the signature printed also in gold on the outside surface of each glass and on the gift box lid, and reinforced the quality brand cues at the time of the Sparkling wine release.

Apart from branded glassware, in-store promotional cards and restaurant tabletop cards were produced bearing the brand identity. The cards were backed with a color photo presentation of Greg Norman holding two of the commercial wine products.

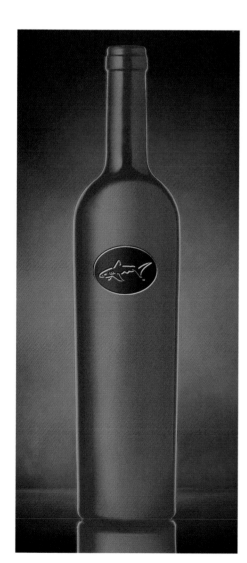
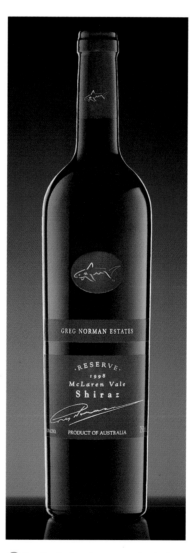

⊘ This concept drawing for the Greg Normal Reserve line shows how a hand-applied metal plate can also be used to extend the brand, but with an even more premium feel.

⊘ Despite the fact that Barry Tucker had to work with the bottle shapes the client had already selected, he was able to form a recognizable family resemblance between different lines of the new wine.

Greg Norman signature prints glossy gold, starting approx. 160mm from base of glass

160mm

The new design was also carried into gift and glassware.

For the release of the Greg Norman Estates Reserve wine, Barrie Tucker created a unique decanter especially for the occasion. The piece was mouth blown by Australia's foremost glass blower, Nick Mount, in an edition of 110 for the occasion. The decanter had the shark logo embossed on the stopper and the famous Greg Norman signature was etched into the bowl of the decanter.

The brand identity and packaging has been so successful that visitors from the United States have even traveled to South Australia to visit Greg Norman Estates, which, of course, still does not exist as of the time of this writing.

Reports of these visitors reached the wine brand's marketing manager, and now there is a move afoot to develop an actual place where people can visit and shop and, perhaps, stay in a quality hotel. A Greg Norman–designed golf course is now open.

The whole project has become a huge success, says Tucker, which is especially gratifying because the brand was nearly laughed off in the beginning. About 80 percent of Tucker Design's work is creating wine packaging for wineries around the world, and the challenge of constantly reinventing the category is exciting, Tucker says. Greg Norman Estates is a good example of how the entire notion of who might enjoy wine—the product's customer base—can also be reinvented.

For the designer creating an **identity and packaging suite** for **BriteSmile, a tooth-whitening system,** the obvious choice of color would be **white—right?**

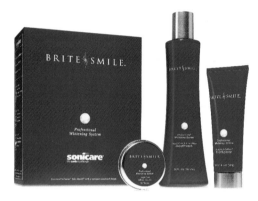

The combination of a deep cobalt blue, a distinctive and recognizable pearl, and a unique container makes BriteSmile's packaging, designed by Addis, stand out.

Not necessarily, said designers at Addis. Their ability to resist the knee-jerk response resulted in a truly memorable package design and brand.

BriteSmile approached Addis in need of an identity. In its stores across the country, customers can get their teeth whitened in about one hour. To maintain their new "BriteSmile," patrons are encouraged to purchase the company's packaged products. But because most consumers might easily relate any treatment of their teeth with unpleasant memories of the dentist, the design of the packaging had to be handled carefully. The client wanted to appeal to the consumer's sense of personal beauty, not call up visions of scolding hygienists and endless dental appointments.

"We were trying to get away from what is standard and expected in this field," explains Addis manager for brand strategy Stephanie Rose. "Dental hygiene rubs people the wrong way. BriteSmile is all about pampering yourself, right down to having packaging that you wouldn't mind leaving out on a bathroom counter."

Addis begins with brand positioning, defining how the brand would differentiate itself from all current and future competitors. Once the strategic foundation is set, Addis develops brand ideas—ideas that best bring the strategy to life. This work led the team to the idea of using the pearl as a metaphor for the benefits of BriteSmile.

The pearl seemed to be the perfect marriage of concepts. Even better, a natural pearl with its delicate mix of off-whites was an appropriate match for how a customer's teeth might really look. Displaying a ridiculously bright white would have looked unbelievable.

"The pearl also alluded to the phrase 'pearly whites,' and it has a smooth, luxurious feel," Rose says.

The pearl also translated well to the packaging. Addis principal Steven Addis likes the visual metaphor on the product packaging because it says so much in a small area.

"With it, we don't have to list all of the rational attributes of the product. There is a lot of competition in this field. The pearl was something that BriteSmile alone could own," he says.

The Addis team designed the brand identity and then looked to the package structures and graphics. For many products, Addis was able to source stock packages and then adapt them for the line. For several flagship products, Addis designed custom shapes. The mouthwash, for example, has tall, curved, elegant lines that subtly emulate the roundness of the pearl.

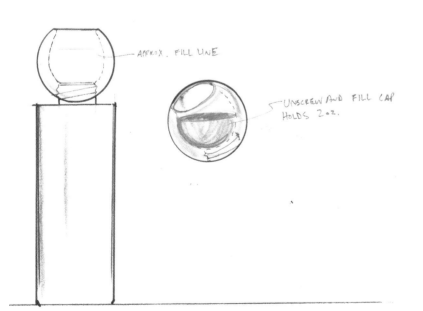

APPROX. FILL LINE

UNSCREW AND FILL CAP
HOLDS 2 oz.

Penciled shape studies compare and contrast where the design of the bottle and cap might go. The most promising designs are developed into more complete drawings.

 Pencil sketches of shape studies helped the Addis designers and the client determine what the BriteSmile on-shelf image would be. This first design of the mouthwash bottle is close to the final design.

A modification of the previous design, with a metal base.

Another variation of the initial design.

A rich blue was selected for the brand's color. It stood out as unique in the product category, it had a cool and refreshing feel, and it was a nicely contrasting canvas on which to place the pearl.

For the labeling, the designers were confronted with two shelving scenarios. In the BriteSmile facilities, there are no competing products with which to contend. For that instance, the labeling didn't have to be overly blatant. But the products are also sold in dentists' offices, where they vie for attention, sitting side-by-side with other whitening goods.

The designers decided to create impact through simplicity. They relied on the impact of the deep blue, the soft curve, and the dramatic focus point of the pearl to stand out in either setting: Type was kept small and to a minimum.

The selection of the curve as a design cue proved to be a useful one: Desks and other elements in the BriteSmile stores have also been made to be softly rounded. Clusters of deep blue packaging create dramatic formations throughout the offices. It's an effective example of integral visual identity.

So unique is the packaging that the color blue and the image of the pearl have become BriteSmile's own in the tooth-whitening category.

"We created intellectual property for the client, which is now like a physical protection for the brand. We positioned BriteSmile as the leader in the category so others will be perceived as imitators," Addis says.

⊘ Here the design gets wilder, with a wedge taken out of the bottle's center.

STAND

⊘ This design would come with a stand to help support its swooping shape.

⊘ A graceful braid or twist makes for an intriguing design.

BACK

EMBOSS

FRONT

RIDGES

⊘ The designers called this a "space ship" design. It is actually more like a cape than a complete bottle.

Perrier is a brand known around the world, yet it is a beverage caught between two **better-known** product categories. It is not a **simple bottled water,** nor is it a soft drink.

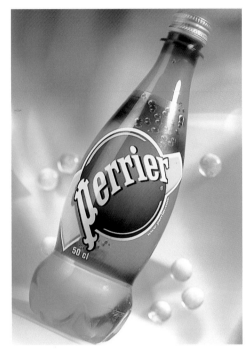

Dragon Rouge revitalized Perrier's image not only by subtly redesigning and reshaping the product's familiar glass bottle (before and after are shown here, left and right, respectively) but also by creating a brand new PET bottle that would appeal to consumers on the go.

Instead, it is a sparkling mineral drink that is to be enjoyed as an aperitif.

In the last 20 years, soft drinks and bottled waters had definitely encroached on Perrier's customer base. It was time to take a look at revitalizing the classic brand and reemphasizing the drink's unique nature. Perrier asked Dragon Rouge of Paris to give the brand a new style, but one that was closely related to the essential, refreshing, classic nature of the product and its packaging.

One thing the company wanted to do was create a PET bottle that was more portable and certainly less breakable than the traditional green bottle. Dragon Rouge used the glass bottle for inspiration, but also looked at soft drink and water bottles for refreshment cues.

"It was very important to develop a new plastic bottle to encourage nomadic consumption. The glass bottle is for the table. The plastic bottle is for out-of-the-home consumption—from vending machines, small shops, and other places you don't want a glass bottle," explains Sophie Romet, associate managing director of Dragon Rouge.

The shape of the new plastic bottle is still recognizable as Perrier. Its shape is similar to the original, 11-ounce (33 cl) bottle, and it even reinforces the link with the historical bottle shape. Its molded base, a technical necessity, was exaggerated and enlarged with the idea of making it look like a rocket, not just a simple bottle.

Green and yellow are strongly associated with the Perrier brand, so naturally, these colors were used on the new bottle as well. The plastic is a strong green color; the final label uses the same mix of green and yellow as the original label. The type on the label also has a new orientation: It angles up and to the right to suggest motion and excitement. All of these components added up to a renewed vision of Perrier's traditional graphics.

The glass bottle was also reexamined. The classic shape of the bottle was so recognizable as to be nearly sacrosanct, and the type on the label is so closely identified with Perrier that consumers can recognize it as property of the brand even when it is used to spell out another word.

"We couldn't make a revolution with the glass bottle, but we could reinforce its uniqueness. People always remember the color of the glass and the label, so we increased the color values on these," Romet says. The design firm also changed the bottle shape, although slightly. Over the years, the bottle shape had become more and more industrial. Although it was easier to manufacture, it was slowly eroding the brand equity. "We found the original bottle from 1910, which was much rounder, more like a weight. So we went back to this rounded shape, which after all, is not just a normal bottle—it is the Perrier bottle," Romet notes.

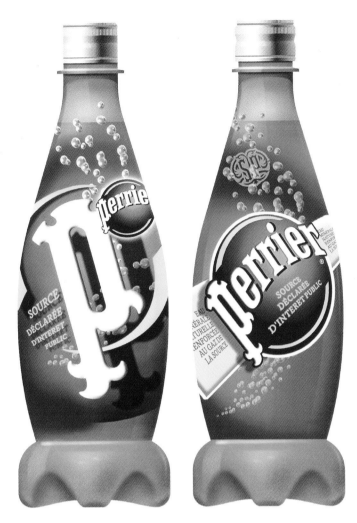

The new PET bottle was designed to look more like a rocket ready to take off than a standard bottle, which made the container more dynamic. A strong green is used for the plastic, and various type treatments were built off of the glass bottle's label design. Perrier's custom typeface is recognizable as such, so the Dragon Rouge designers took care to emphasize these forms even more.

There are two labels on the glass Perrier bottle—one at the top, which focuses on the brand, and one on the lower part, which reinforces the source of the product and what it is. Here the brand was made stronger by slightly reworking the typefaces and by making the green and yellow colors stronger. The green glass used to produce the bottle was also made stronger in color.

The Dragon Rouge team looked for other ways to revolutionize the brand. The designers suggested repackaging the existing product in event bottles that could be issued for holidays or other special occasions.

The client loved the idea, and soon new bottles were being issued every six months—one for the French Open-Roland Garrow, of which Perrier is a sponsor, and the others for New Year's Eve events—each one based on the classic Perrier bottle shape. Collectors loved the concept as well: For example, three bottles were designed for the new millennium. Each carried the same style of swirling, celebratory graphics, but each was a different color: White represented air, blue represented water, and green represented life and related to the Perrier communication claim. Each color, although not directly related to the original green and yellow color scheme, was still representative of the sparkling water product: H_2O equals life.

The Dragon Rouge team thought of another clever way to extend the brand without completely reinventing it: They created collector bottles for special occasions. These sketches are from the trio of bottles they created for the new millennium.

"People began collecting the bottles immediately," Romet says. "Perrier gained 1 percent market share in one month. The design spoke of a fantasy world that people like to dream about."

The latest step in revitalizing the brand was to introduce an entirely new product—not a flavored Perrier, but a new drink altogether, called Fluo. It was a drink conceived to meet a younger person's expectations, but it was not too sugary or falsely aromatic. Three recipes were developed—cherry, mint, and lemon—each low in calories. The new drinks were discreetly endorsed by the Perrier brand, mainly through bottle shape, which is the same as the one used for the PET Perrier product.

"It has all of the qualities that Perrier delivers, but Fluo has its own stories and special message for a younger set," Romet explains. The drinks are brightly, almost fluorescently colored—hence the name—and the design of its labels was equally

strong. Anyone placing the plastic bottles of the Perrier and Fluo brands side by side would see a familial relationship, but each is independent from the other. "The new product stretches what Perrier can be, but it does not take equity away from the mother project," she adds.

Fluo was introduced in France's most fashionable clubs and restaurants in late 2002, and quickly became the most trendy drink of the year.

A brand with strong heritage can remain contemporary without losing its essence, Romet says. "Innovation is the key to long-term success, as long as it is respectful of the brand values. It is their interpretation that may differ according to the core target and the product's specific nature," she notes. Today, Perrier is back to profitability after a long period of "convalescence" and is ready to continue its success.

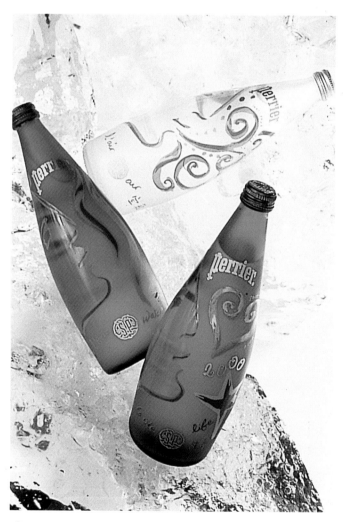

⊗ The finished designs for the millennium celebrations. Consumers latched onto the concept of collectibles immediately, and the project was an enormous success, almost overnight.

⊗ Another collector Perrier bottle designed by Dragon Rouge for New Year's 2003.

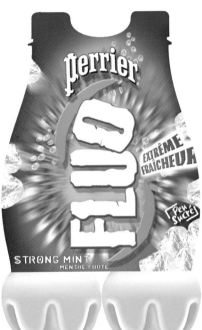

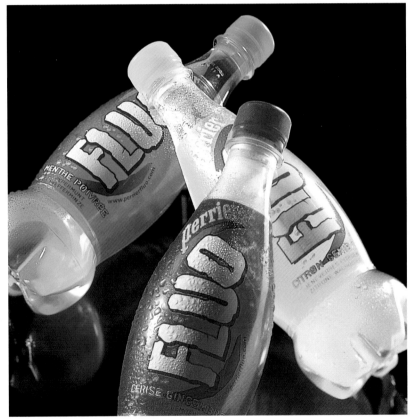

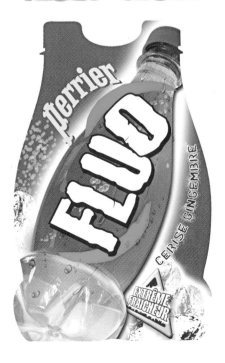

Another step in revitalizing the brand was to introduce a new product called Fluo, a brightly colored, naturally flavored drink aimed at younger consumers. It used the same bottle design as the core brand's PET bottle, but its label design is different. It is bold and brash, and it speaks of movement and fun. The finished Fluo designs successfully speak to their target audiences.

Paxton & Whitfield is the oldest **cheesemonger** in the United Kingdom, having **been in business** for more than 200 years. Its **products are of the finest quality,** and it has an **unparalleled reputation.**

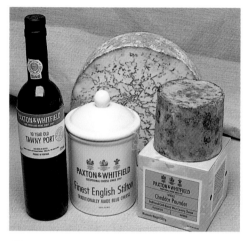

⊘ Paxton & Whitfield has been in business as a cheese-monger for more than 200 years. It is a brand of un-paralleled reputation, but it was also apparently a bit intimidating for some customers who felt they didn't have the knowledge they needed to come in and make an educated purchase. Stratton Windett helped the firm make it more contemporary and broaden its ap-peal through new packaging.

The brand is even the holder of three royal warrants, which means that it supplies its goods to the royal household, an un-mistakable mark of standing.

But even with all of these pluses, the brand was not growing. Its customers were generally mature and wealthy, but even more cru-cial, they knew what they wanted. They were confident in their choice of cheesemonger and their shopping experience. Purchas-ing truly fine cheese, it turns out, can be as intimidating as shop-ping for wine, especially if you are not knowledgeable about cheese provenance. And the original packaging for the product was doing nothing to invite new customers into its unique shop, located right off Piccadilly in London.

"There were many people who would not enter the shop to buy cheese because they were not confident about what to buy. All the cheese is cut personally for individual customers in the store, which means you have to commit to a conversation with the cheesemonger behind the counter," explains Peter Windett, princi-pal of Stratton Windett, the firm that was brought in to repackage the brand and broaden its appeal.

The plan was two-part: First, the store itself would be redesigned so that a small range of prepackaged cheeses and grocery foods could be sold in a self-purchase environment: Those who were in a hurry or who did not want to converse with the cheesemonger would no longer have to do so. Modern shop fixtures were to be introduced and contemporary colors and materials were selected to brighten the store.

Second, the packaging for all products would be remade to be more friendly, descriptive, educational, and appealing to a broader base of customer. The intention was to produce a prod-uct range that would be sold in premium stocklists as well as the Paxton & Whitfield shop.

"The existing packaging was about 10 years old, and it was all printed in a tasteful dark green and cream. But it didn't make a bold or individual statement about the company. It didn't indi-cate that its main product was cheese," Windett points out. "In fact, the packaging could have been for a wine merchant or florist—actually any establishment that was a tasteful purveyor of goods. The identity needed to be more cheese-specific."

The store already had a lot going for it: an excellent reputation, the royal warrants, a distinctive storefront with three-dimensional gilded letters in a desirable part of town, a brand with plenty of personality, and a loyal customer base. Stratton Windett needed to find a way to communicate all of these pluses to the new con-sumer while still honoring and not alienating the existing cus-tomer base.

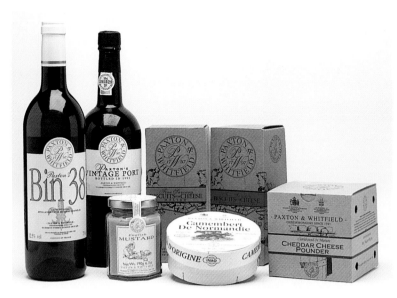

This is a selection of the client's packaging before the redesign project. The products were not unified with a single and consistent look.

They began by studying the gilded sans serif letters on the store's front. It said a lot about the store's personality, and in keeping with updating the Paxton & Whitfield's identity, it felt modern in a traditional manner, rather than the serif type that was being used throughout the store's existing system. The designers decided to bring the face, a three-dimensional Grotesque-based font, into the new design for packaging as the main logotype.

For example, on the wrapping paper and transit boxes that were used in the retail setting, the original design repeated a Paxton & Whitfield seal over and over. On the boxes, an uninspired rectangle repeated the store's name, showed the royal warrants, and delivered the matter-of-fact tag line, "Cheesemongers since 1797."

In the redesign for these pieces, the designers changed a number of things. First, they freshened up the color scheme by adopting a cheese-related palette—a cheddar yellow and a gray-green, representing the cheese rind, were used on all retail-related packaging and supplies. The wrapping paper carries an unexpected bit of whimsy: a repeat pattern of romantic cheese-type names, and the business cards are shaped like a wedge of cheese.

The tag line was also strengthened. "We changed it to 'Exceptional Cheese since 1797.' It's a punchier statement that they have to live up to. This is not just any cheese you could buy at the supermarket: This is exceptional cheese from Paxton & Whitfield, a mouth-watering, seasonally changing selection, matured to perfection, and individually cut to any size," he points out.

The boxes received even more specialized treatment. The box that is used to carry Stilton cheese, for example, incorporates the distinctive veining texture of the cheese—as it would look when cut—and is used as wallpaper to cover the container. "It's treated in an abstract manner, like a pattern, but it is specific to Stilton," he explains. The boxes for cheddar cheese are printed with the distinctive cheddar texture; other boxed cheeses incorporate photographs of the cheese rinds, giving visual clues to the cheese

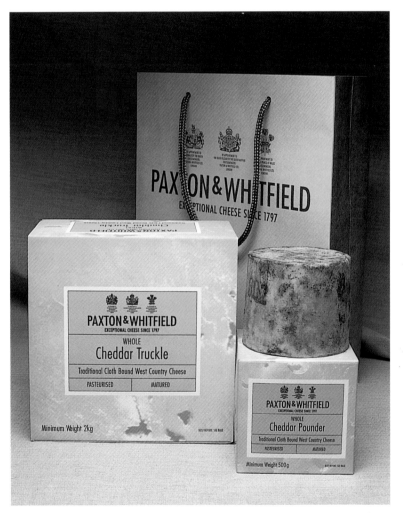

Here are two mockups of cheddar cheese packaging that were considered. These show the development of a color palette and of textured backgrounds that would be used for product identification.

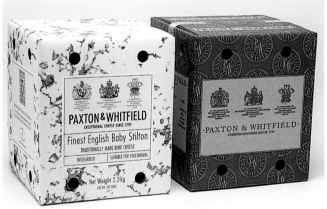

Before (right) and after (left) designs for the Stilton product. Although the previous box made plenty of supportable claims, it did not actually say what the product inside was like. The designers wrapped the box with the Stilton texture and added information about how the cheese could be enjoyed.

type inside and differentiating one cheese from another, making it easier for the customers to locate what they are looking for.

On all boxes, more information is added as an educational service for consumers. When is a cheese ripe and ready to serve? When should it be taken out of the refrigerator in preparation for serving? Which foods should the cheese be served with? These are questions that might be asked of the cheesemonger, as well as questions that may have previously caused a consumer not to buy a certain variety: Some buyers just don't want to seem ignorant when it comes to something so apparently commonplace as cheese.

"In all packaging, past the main title of the product, we are trying to bring out salient features of the products—whether it is vegetarian-appropriate or pasteurized, whether the rind be eaten, how it can be used in cooking, what wines can be served with it, and so on—so that consumers are getting real information about the diversity of cheese. There is also a small booklet underway that gives even more detailed information on cheese types, producers, and recipes," Windett says.

The store also carries a number of other foods and beverages that might be served with cheeses, such as jarred chutneys, mustards, biscuits, crackers, and wines. The packaging for these companion products also needed to be addressed.

The bottles in the original scheme bore little familial resemblance to each other. Statton Windett designed a simple label format that could be applied to any bottle shape, at any place in the bottle's height, and still visually relate one to the others. Across the board, the redesign is much cleaner, more simple, and decidedly more modern, while giving appropriate visual product category clues.

The biscuit boxes were originally made from a stiff corrugated board that was functional but not terribly emotive. The designers decided to apply the texture of the food here, as they did with the cheeses, but in a slightly different manner. For this, they created grainy photographs of the crackers inside and used these as all-over texture for the new boxes. A window in the front of each box allows the shopper to see the product inside.

The same labeling and texture concept was used on jars for products as disparate as jarred olives, pickles, and goat cheese in oil: An abstract photo is used as texture on part of the label. When differentiation is not needed—such as for jarred honeycomb, which is recognizable through the glass jar—the photo is not used.

This was an enormous project to manage, Peter Windett says—72 products, a new corporate identity, 16 suppliers, endless food safety regulations, and ongoing print and production management.

"With the various products all demanding different packaging containers, materials, shapes, and sizes, the application of the design concept across the range has to develop organically, to grow to suit each product group or type. It is not possible to rigidly apply a constant brand application," he says. Changes and refinements were made right up to the last minute. Stepping back and looking objectively at each product or category and its relationship to the whole sometimes required that.

"The criteria was always to emphasize their point of difference—from the customer's point of view," he adds.

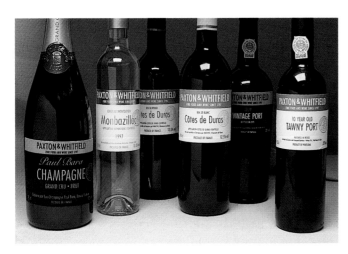

Mockups of different alcohol-content products show a direction toward strong and consistent branding while retaining the personality of each product type.

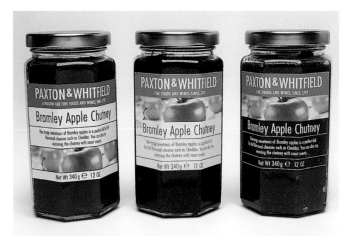

Jarred products presented different challenges. Here the designers explored alternative positions for type and illustration, as well as the use of different materials. Eventually, a clear PVC was selected because it provided the best product visibility.

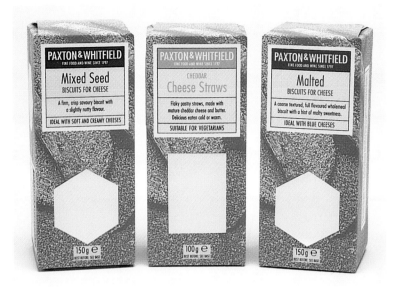

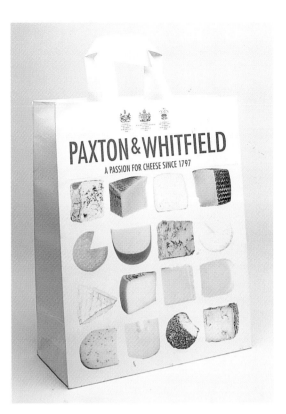

Another exploration, this time for the biscuit packaging. As on the cheese boxes, the designers wanted to wrap the box with the biscuits' texture, so as to give the consumer a better idea of what was inside.

The final bag design was printed on polypropylene for added strength. The softer photographic image prints well on this material.

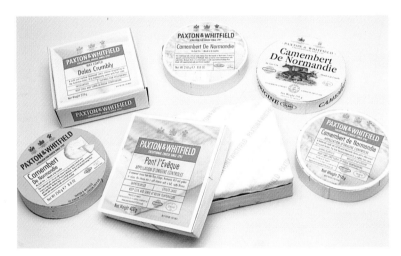

The top right package shows the client's original design. All other designs are explorations for the new design, starting at the lower left, bright yellow sample and proceeding to the right to the final design, with used soft, textured photographic images.

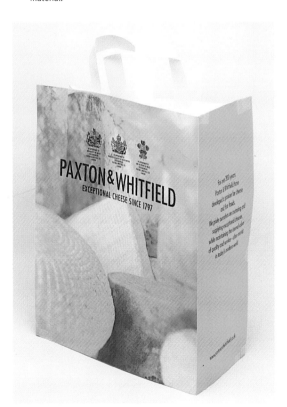

The designers also created a second bag for trade promotion packs and public relations purposes. When compared with the original packaging, it's clear how much the packaging system and identity has changed.

The original concept for the shopping bag showed many different types of cheeses. This bag would have been paper for the best printing reproduction, but ultimately, paper was not deemed to be a good choice: It had to hold a heavy product, and it was easily weakened by rain.

VALUE PRODUCTS—DESIGN THAT DELIVERS

Krusteaz

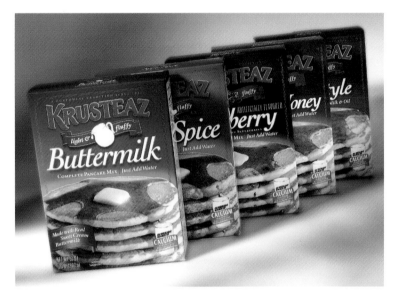

Krusteaz, like many brands in the baking aisle, is very traditional and conservative. The project turned out to be an interesting lesson in client and marketing tolerances, says designer Bill Chiaravalle.

The brand's original packaging did not say "quality" or "fresh," it looked dated, and it didn't provide proper differentiation between separate SKUs.

Krusteaz is one food brand with a curious name whose origin is rooted in history that most consumers have forgotten. Today, it is a major manufacturer of dry mixes, including muffin and pancake mix. At its start, though, it sold pie-crust mix that could be made quickly by just adding water. "Crust ease"—get it?

There was clearly a disconnect between its name and current product offerings, but the company wanted to revitalize the brand, not change its name: There was plenty of healthy equity in the name, as well as a trusted line of products. But in 2001, Continental Mills—the brand's owner—wanted to freshen up its image and so came to Bill Chiaravalle for help.

The client was concerned, says principal Bill Chiaravalle, that the pancake packaging looked dated. As a result, it didn't say "quality" or "fresh." It wasn't clear to consumers that Krusteaz offered an entire family of products, nor was there clear differentiation between products.

"Krusteaz is a family brand, not something trendy. Pancake mix is almost a commodity item for American families," the designer says, noting that the main demographic for the product is 30- to 50-year-old mothers. "They wanted the look of 'quality,' but not 'premium.'"

A request like this can be a challenge for designers, Chiaravalle says. "Designers love to make things look premium—it always feels like the best thing to do. But there has to be restraint involved. You have to get into the mindset of the client. Even if they do not know the specifics on how to make a good design, they live and breathe their business, and they certainly know more about it than me, no matter how much research I do," he adds.

But the client did say they wanted to try something "different and fun." At first, an alarm went of in Chiaravalle's head: "Different and fun" did not seem like a good match for a brand that was addressing mainstream America. But for the first round of designs, he went with their request, creating packaging that did push the limits for the category.

Some designs showed product shots, as most mix packaging does, but his designs cropped in very tightly on the image. He also tried to change the viewer's visual perspective on the product. For instance, he showed pancakes flipping through the air and a stack of pancakes viewed from an extreme low angle. Other designs alluded to the fun of the product, showing families having fun together. On all of these trials, Chiaravalle developed more interesting typography.

"This first group was expressive and energetic," he recalls. "We came in with 10 different concepts, and there was this big silence. Finally, somebody said, 'We know we're going to get there with

 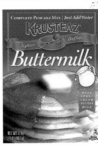

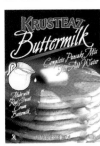 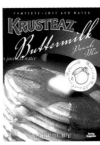 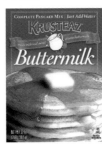

⊘ The client asked Bill Chiaravalle to create packaging that was "different and fun." This set off warning bells in the designer's head, but he did create this set of comps. Unfortunately, these trials were turned down by the client as being too different.

⊘ In round two of the design, Chiaravalle began looking at the original packaging and decided what incremental steps he could take with type, color, and photography. His results were conservative, but entirely appropriate for the grocery store shelves.

you, but this isn't it." Their definition of 'different and fun,' was different from mine. My gut reaction had been right."

Chiaravalle had worked with Krusteaz on a previous project, and at that time, he and his team had suggested updating the brand's word mark. They completed many renditions, even including some with tag lines that helped suggest the name's proper pronunciation. And even though he believes they had some good ideas, once they created mockups and placed them on store shelves, the new designs proved to be far too revolutionary.

"This whole genre of products is hard to work with. Take a look at Duncan Hines or Betty Crocker: They both look a bit dated. People have to be able to make an emotional bridge to this type of product line," he explains.

He was back at square one for round two. Chiaravalle began by looking at the existing packaging to see what incremental steps he could make to revitalize the brand. Carefully examining each foundation element—the type, the colors, the photography, making the brand mark more prominent, improving product association. Some designs from this stage used only one of these changes, whereas others incorporated several.

It was a study in facelifts, the designer explains, and it was successful. The client liked designs that revitalized the overall appearance and brand. Using new product photography, brightening the colors, adding flavor banners and illustrations for flavor differentiation, and using classic and clean typography provided a strong shelf presence, while updating the appearance of the entire line.

Colors for the background were chosen to provide adequate contrast for the red Krusteaz brand mark. The new colors also provided clear flavor cues, and they worked well in staging the new product photography. One problem with the original design was that the product photography was not as appetizing as it could be.

The client was very pleased with the results, Chiaravalle says, and that's what is important, When he looked at the finished package alone, however, it looked mainstream. But once they created new mockups and tested them in the store setting, he was pleasantly surprised.

"In the store, Krusteaz is very different from competitor's products," he says. It's crucial to take a design into the loud, obnoxious retail environment to see if it can survive and thrive, even if it ends up sitting on the bottom shelf.

Designers often want to tow a client down what might be an adventuresome but ultimately misguided path. "We say, 'We must educate the client,' or 'We have to be different from everyone else.' But realistically, this will only lose a lot of market share for a client. You have to be honest with yourself and do just what will sell more pancakes."

It is helpful to Chiaravalle to ask himself this: What will help my customer and his customers most? "Once I know that, I do a good job," he adds. "I don't think this is compromise. I have not lived the last 25 years in the pancake industry. They know their customers and product better than I do."

After all, if a client trusts him enough to hire his office and expertise, it's simple, common courtesy for him to trust their expertise.

AG Hair Products had become a victim of its own success. It **started as a small company in 1991,** and after more than 10 years in business and **expanding its line from 4 to 28 products,** the brand needed coordination.

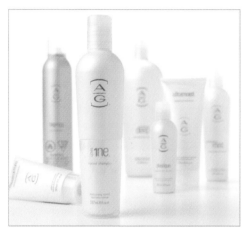

After 10 years in business, AG Hair Products had grown from 4 to 28 products, and from an orderly branding system to a hodgepodge of colors and package shapes. Dossier Creative reorganized the brand by means of its packaging.

With healthy pockets of business in Australia and the United States, there was plenty of room for expansion, but all of the company's packaging would have to be brought onto the same platform first.

Don Chisholm, creative and strategy director for Dossier Creative of Vancouver, British Columbia, describes Advanced Group Hair Care, the client's name when his group began working with it in 1998: "AG is like a cosmetics company, but instead of making over your face, they want to help you make over your hair. Their products are designed to give you the best-quality hair care. The company spends an enormous amount of money on high-quality ingredients: Each product is organically driven or contains very few chemicals," he says.

The client's goal was to relaunch itself into the U.S. market with a new identity, while maintaining existing clientele. The company's color-coding system had worked well when its product line was smaller, but now it had become a confusing mix of shades on the shelf, far too many colors for the customer to remember: This would have to be remedied, Dossier Creative advised. Also, the logo needed to be redone, ideally to accommodate the new name the design firm was suggesting: AG.

"The client was understandably nervous about changing its identity: They had an $18 million business they didn't want to upset," Chisholm recalls.

Once the client was convinced that the "AG" moniker would have much better customer recall than "Advanced Group," the Dossier team could begin working on a shelf presence for the brand, which is only available through salons. AG shampoos cost from $12 to 14, whereas styling products range from $15 to $26, which was in line with other salon products, but still pricier than retail store brands. So the new packages needed to look upscale.

Dossier suggested that the client organize its products by the existing 34 subbrands—such as Fast Food, Tech One, or Plastic—rather than by category—shampoo, conditioner, and so on. This idea was also accepted.

In one early design, the AG symbol was anchored by a circle or umlaut, to give the product a European feel. A system of dots formed matrixes and, in turn, letters, such as "V" for "volumizing." A similar trial was more typographically based, and a completely different experiment used photography. With this design, the photos would literally show thick or thin hair, or different styles that can be achieved to explain what the product was for. This design would also have a stainless steel band around its top.

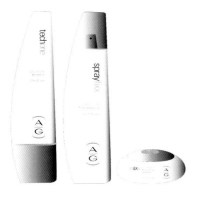

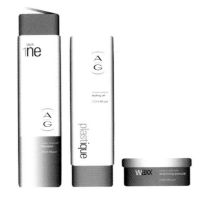

⊗ This design was anchored by an umlaut over the letters "AG." A system of dots formed a matrix that, in turn, formed letters, such as V for "Volumizing."

⊗ This design incorporated an indented area where a sticker, printing, or even an imprinted rubber band could sit.

⊗ Although the designers liked this round of designs, it proved to be ergonomically inadvisable: The bottles were hard to hold onto, especially when wet.

⊗ This trial showed how relating the line through subbrands would work. Although the Plastique line, Waxx line, and 1ne lines would all have a distinctive look and color, it is apparent that the three products clearly come from the same family.

⊘ One distinctive feature of this new design is that the tallest bottles in some lines have a clear plastic cap that fits over the bottom of the bottle. Right now, the cap is for appearance only, but for future products it may be functional as well, serving as a measuring cup or mixing container.

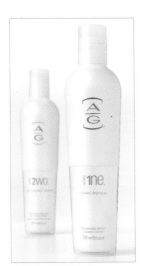

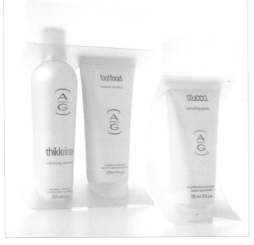

⊗ Two examples of separate, but clearly related, subbrands.

The design, Dossier and the client decided, would move the consumer too far from the existing system, causing confusion and potential loss of brand recognition. The change, they agreed, had to be evolutionary, rather than revolutionary.

A second round of designs was based on color coding, as AG had done in the past, but with far fewer categories—five to represent each product grouping versus one for each of the 34 subbrands. The designers experimented with such interesting effects as depressed areas in the bottle where an imprinted rubber band would sit, providing color coding and traction, and a depressed area in the bottle to hold a debossed sticker.

In a third series of experiments, the final type treatment started to be worked out. Here uniquely shaped containers with arched sides were studied. The client loved the logo and type treatments, but from ergonomic and production-cost standpoints, the more uniquely shaped bottles were impractical. But Chisholm says that these studies were fruitful in stretching the notion of what the container could actually be.

Squared-off bottles were also tried, but eventually the team decided on an elegantly round-shouldered bottle, a standard tube, and a squat jar for the final designs. "These were clean and contemporary, with an upscale, elegant shape which fits with the simple European design," says Chisholm. "The tapered shape elevates the brand, providing it with a refined sensibility and a simple Zen elegance that targets a fashionable and sophisticated consumer."

The subbrands are color coded in a subtle way, using just enough color to guide the buyer yet still maintain a cool, clean polished presence on the salon store shelf. This classic approach is a departure from the pool of competitors' packaging designs, many of which relied on novelty shapes and colors.

The white bottles were also a nod to AG's former design, but in this redesign, a pearlized white was chosen. "White is used to symbolize a lab coat or the professional formulation of the product. We stayed with white, but added the pearlized finish to give the packages a more premium feel," Chisholm says.

The tallest bottles in the line were adorned with a mysterious little extra: a plastic cap that fits onto its bottom. Right now, Chisholm explains, the cap is purely cosmetic, but in future products it may be a functional part of the product, used for mixing or measuring. The frosted, translucent cap on the tube and silvery lid on the jar mimic the subtle shine of the bottle's seat.

"Color coding has been a huge part of AG's business, and this new design still allows consumers to 'cherry pick' what they want, following the 'prescription' of their stylist," Chisholm says. "But with this system, consumers will have an easier time seeing the products on the shelves and gravitating toward and remember the subbrand they prefer."

The South Australian Company Store was founded in 1835 at the inception of the then-fledgling Colony of South Australia to stimulate the new colony's agricultural economy and to sell the region's unique agricultural products to the rest of

⊘ The South Australia Company Store had been defunct as a registered trade name in South Australia for more than 50 years, until an entrepreneur revived the brand and Motiv Design created an entirely new identity and packaging system for it.

the world. The "mother country"—Britain—and the rest of the empire were ready markets for a wide array of products from wheat and wine to meat, wool, and fruit. But by the late 1940s, the name fell into disuse and operations were disbanded.

However, in 2001, a pair of American entrepreneurs, Paul and Kerrie Mariani, resurrected the brand, this time to be the purveyor of gourmet products from the entire state. It would be based in the Barossa Valley, Australia's premier wine-producing region. It would offer a panoply of products, from wine, chocolates, and jams to olive oils, nuts, and organic honeycomb, in 50 to 60 SKUs.

The entrepreneur knew he needed significant design assistance. He contacted Motiv Design of Stepney, South Australia, for help.

Early discussions with the client made it apparent to the Motiv team that the "Company Store" part of the name was to be both a contemporary interpretation of a heritage theme as well as a brand identity that would have to work across a multitude of packs. These might include silk-screening onto wooden slats and reproducing cello packs, wrapping paper, bottles, jars, and other types of containers using diverse techniques.

Motiv designers began by developing a distinctive logo and look that would speak of pedigree, quality, and relevance to contemporary tastes. Various concepts, including a southern-quarter compass rose, which focused on South Australia's geographic location, to variations of a round, badge-like or stamp-like mark. Eventually, designer Hannah McEwan developed a circular mark that included a fish, an olive sprig, cheese on a board, and a honey pot at its center. This would be used as a sort of stamp throughout the range.

"The South Australian Company Store is a showcase of South Australia's finest gourmet products, including magnificent cheeses and dairy products, produce, fruit-based products, olive oil, vinegars, bottled sauces, chutneys, conserves, honeys, confectionery, seafood products, and more. The logo illustrations were chosen to represent broad product categories and to have distinctive silhouette shapes," Hannah McEwan says.

Once the basic look of the logo had been decided upon, Hannah McEwan and creative director Keith McEwan began to explore other ways that consistent values could flow through diverse pack ranges, collateral materials, and a cobranded restaurant called the Company Kitchen. Distinctive illustration, they decided, would be an immediate visual cue to consumers. But any art used would have to be consistent in style, scale, and color palette, or it would not work.

S. H. C. S. | Logo dir directional concepts ①

emphasise the SOOTH
in SOUTH AUSTRALIA.

Compass rose southern
Quadrant to Mark
South = South Australia.

In export southern
quarter of compass also
transfers to 'Australia'

Enclosed panel. Quarter circle more 'modern'
Type follows forms free style compass
Quarter circle shape rose.
arc.
✱ explore colour ways and drawing styles

② ROUNDEL / BADGE TYPE.

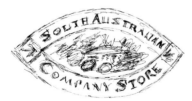

illustration

Square format.
Type might be awkward

inverted square
to form diamond
shape.

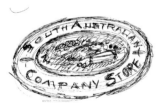

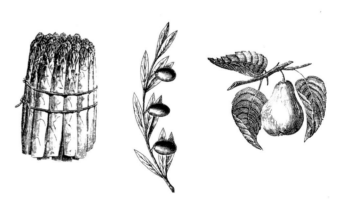

✱ This may be too traditional. Let's have a look at it in
different colour ways.

④ OPEN ROUNDEL with illustrations

The panel box looks a bit
odd with open type.

This looks promising
these shapes
may be tricky.

Traditional illustration
style might work well.

 The first step in the packaging project for Motiv Design was to create a new logo. Themes revolved around the compass rose, local produce, and history.

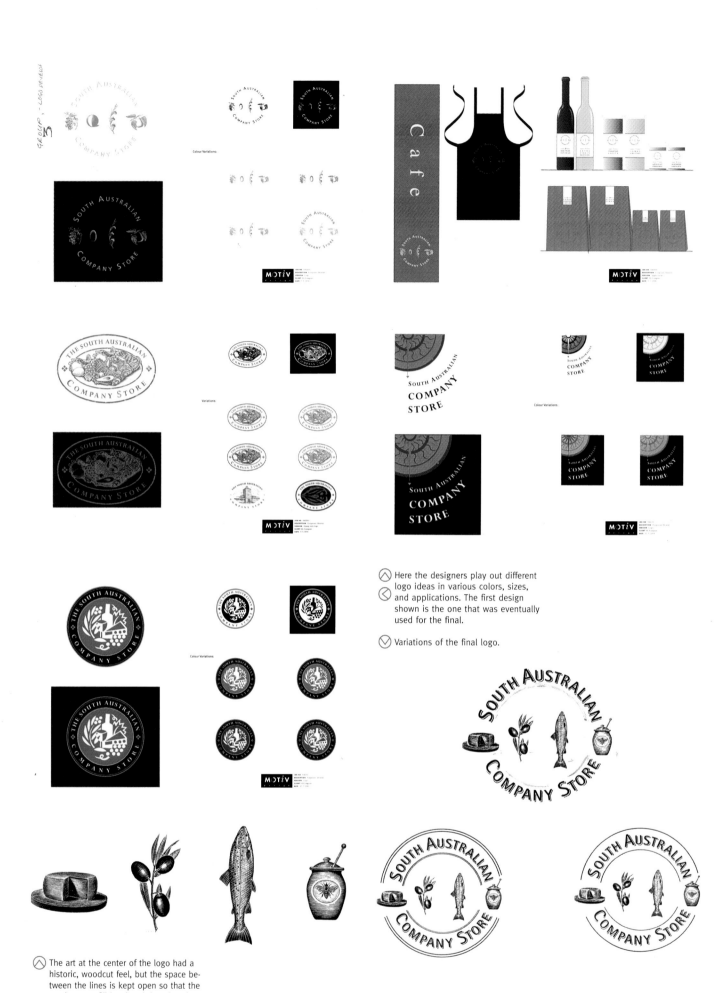

Here the designers play out different logo ideas in various colors, sizes, and applications. The first design shown is the one that was eventually used for the final.

Variations of the final logo.

The art at the center of the logo had a historic, woodcut feel, but the space between the lines is kept open so that the art does not fill in when it is reduced.

The solution was to create their own illustrations. Keith McEwan, who is also a well-recognized illustrator, took on the task.

"The four original illustrations we created had a more 'open' woodcut style, which worked better at big and small sizes, and looked handmade," McEwan explains. For some packages, the label contains a full frame of lush-looking ingredients—tomatoes on a sauce bottle, raspberries on a jam jar. On other packaging, the woodcuts are portraits, such as a bunch of grapes ghosted behind type on the front of a wine bottle or a scoop of ice cream on a cold pack. On still other designs, smaller woodcut vignettes are printed on bag gussets, the band that seals the top of a cello pack.

Hannah McEwan realized that color could play a major part in how the brand would work, especially in the appeal that was created when the woodcut illustrations were overprinted or reversed out of a keynote color. It was ancient and modern at the same time. "Just what we wanted," she says.

A suite of colors working in permutations could give an attractive and distinctive point of difference to the brand and help to organize the ranges of products in flavors or varieties.

"Hannah took the logo illustrations and reversed them out of squares of color, starting with 16 to 18 variants of color until we had a palette of colors that worked beautifully with each other," Keith McEwan says of the colors they selected, which included warm ochres, misty blue, golden yellow, and deep, rich blue and green. "They are based on colors that you would see throughout the seasons in South Australia—the misty green of gum trees, the golden ochre of summer. They are not normal colors, but instead burnt or misty."

The food, too, has its own color in many cases, which adds to the mix. "A blueberry jelly next to a red chili jelly looks wonderful," McEwan says.

The new brand has a definite regional and patriotic appeal. It has been a real success, both through the Company Store and a new export catalog. "The Barossa Valley is where the wine industry started in Australia—it's very well known. It's also a very picturesque place: It was originally founded by Lutheran Germans, so there are little churches and buildings nested in the hills," says Keith McEwan. This revitalized brand lives here very comfortably.

⬡ These jar neck labels exhibit the color scheme and the open woodcut art that is now a hallmark of the brand.

⬡ The color palette chosen for the packaging reflects the colors of South Australia: warm ochre, misty blue, rich red, and deep blue and green.

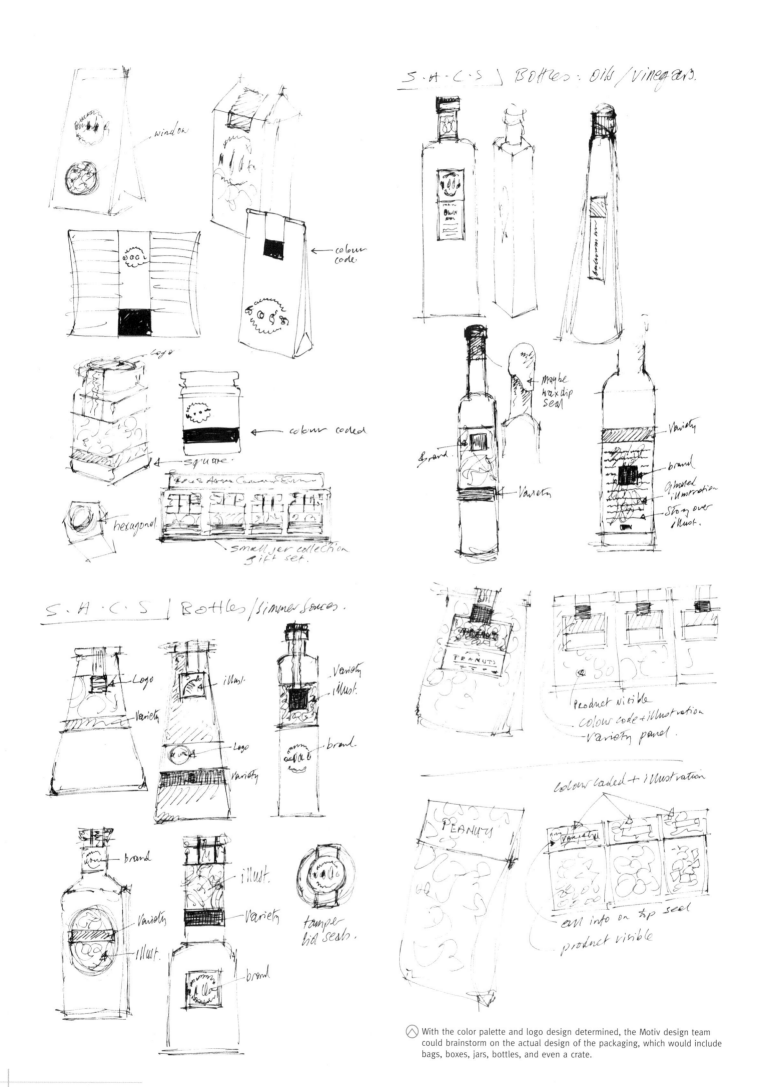

With the color palette and logo design determined, the Motiv design team could brainstorm on the actual design of the packaging, which would include bags, boxes, jars, bottles, and even a crate.

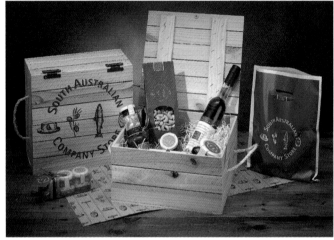

The flexibility of the system that Motiv developed is evident in this broad range of package shapes and sizes. The designers even included take-away containers in the suite, for ice cream.

Is it possible to **build an empire from a garbage can?** The founder of **SimpleHuman,** a new brand of well-made, well-designed **products for the home,** would tell you, "Absolutely."

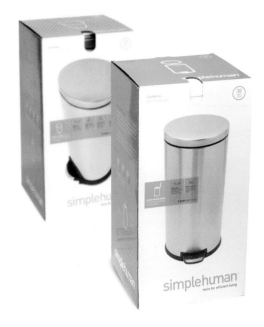

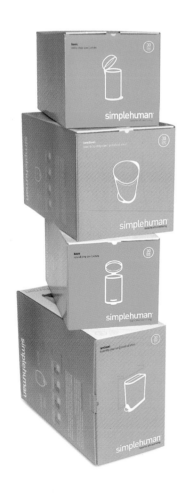

SimpleHuman began as a company called Can Works, which produced high-end trash cans. The company grew quickly, and soon, will be expanding into everything from food canisters to small appliances.

"The client produces products to match your lifestyle. There is nothing too 'out there'—very elegant, but no extreme style. His products are comfortable, but are engineered to be innovative. For instance, the company makes its own trash bags because they fit the SimpleHuman trash cans better," explains Paul Hamburger, creative director of Smart Design, New York City. In developing the SimpleHuman brand, Hamburger and his staff were asked to help the entrepreneur not only package the existing line of about 40 trash containers but also create a packaging system that would perform equally well for all future extensions of the brand.

"At first, we thought it sounded crazy: Why not just focus on the trash cans and forget about fragmenting the brand into too many product categories? But in today's superstore environments, we could see how Frank Yang's, founder of SimpleHuman, vision of rapid growth could create areas of strong brand impact throughout a typical housewares store.

At the core of the entire Smart Design approach was a simple sensibility statement: products that are like tools for everyday living. Every bit of packaging in the SimpleHuman line should speak clearly that these are essentials for life: something to hold trash, a place to sleep, an essential for making toast. They are all products designed to make the consumer's life better, although by their definition, they might sound mundane. The packaging would have to prove otherwise in order to get the consumer to pick up the box.

The design of the packaging could not be too "out there" or say anything about extreme style. "You might think of these products like clothing from The Gap: It's well designed, but it's comfortable," Hamburger says.

Another requirement for the packaging: Because the products would be sold in large retail stores where help from knowledgeable sales associates is often scarce, the packaging would have to provide all the information the consumer would need to make a choice about what to buy. For brand consistency, that information should be treated the same way on every box.

One of the first things designer Nao Tamura had to consider was what information should be on the packaging. For example, what made SimpleHuman trash cans so good was that they were designed by engineers who were passionate about the efficiency of the

FRIENDLY

ideal positioning

FASHION / ELEGANT

HARDWARE / UTILITY

SERIOUS

SimpleHuman

SimpleHuman

Simple Human

SIMPLE HUMAN

SimpleHuman

simple human

SIMPLE HUMAN

Simple Human

simplehuman

simplehuman™

The development of the word mark
for SimpleHuman demonstrates how
Smart Design used a matrix to eval-
uate different traits of a design.

Here the Smart Design designers considered how to graphically communicate the various features and benefits of the product. Would it fit underneath a counter? Did it open easily? Was it big enough to hold a pizza box? Did it look good? and so on.

The matrix was used to evaluate four different package designs. In which direction should the final design go? Getting closest to the center was not the goal: Getting closest to all of the desired attributes was.

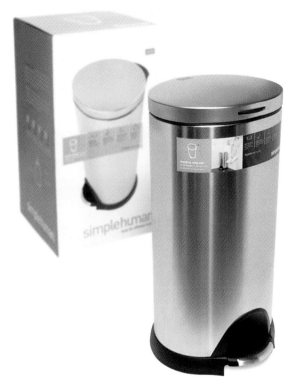

Experiments on how to convey attributes of the product.

The final package design's clean, elegant lines are a clear reflection of the quality product within.

gear mechanism that opens the lid. Although this information was too scientific for most buyers, it did translate into one customer concern: Is the product practical? Does it work well? The designers knew that buyers would also be interested in seeing the product on the box (what does the lid look like?), understanding how it fit into their lifestyle (would it fit into that space under the sink?), and gauging whether or not they felt the object was beautiful (do I like it?).

To visualize how their initial design trials met these customer needs, the designers drew a simple matrix of crossed lines with the words "practical," "lifestyle," "beautiful/design," and "product" written at the ends of the lines. Each trial design the team created could be placed on the matrix nearest to the attributes it met.

The idea, says Hamburger, was not to create a design that hit the center of the matrix, but rather to help them prioritize all attributes in a way that met the strenuous needs of a new brand struggling to become known in a crowded retail environment.

To jump-start their explorations, the designers began by considering how to graphically show the cans' various features and benefits. "Many cans have wide openings that will accept large pieces of trash, but if you say, 'Able to accept a large pizza box,' consumers can picture that and imagine the value of that benefit. This kind of explanation humanizes the products," Hamburger says.

Not every piece of information could be reproduced on every panel, so the next step would be to divvy up the type, graphics, and photos on the various panels. Splitting up the information in different ways would make different style statements, but overall, a simple style was developing: lots of white space with the product as hero on the front panel.

"Basically, we were looking at the box as a big billboard," Hamburger says.

It was here that the matrix became useful. One design clearly emphasized the product more, whereas another was completely about lifestyles and the people that lead them. As each approach was entered onto the matrix, the designers could see how each compared to the other.

One approach that combined a mix of product-as-hero, a stress on beautiful, and some amount of lifestyle attributes won out. Hamburger says it is a good philosophical match for the client.

"It's clean and simple, like science. We made sure, in our guidelines, that the proportion of the product photo to the size of the container would be consistent throughout. Even if boxes are different sizes, the amount of white space around the product photo would always be the same. This amount of white is one of the key brand signatures, immediately recognizable as Simple-Human," he notes.

"Walking through a large store, a consumer would have a very strong brand perception of SimpleHuman," he adds. The packaging advertises the brand clearly.

When a shopper buys a pack of gum, he or she is in pursuit of the confection. **Blue Q asked a new question:** What if the equation were turned around and, **instead of the gum,** the buyer was much more interested in the pack?

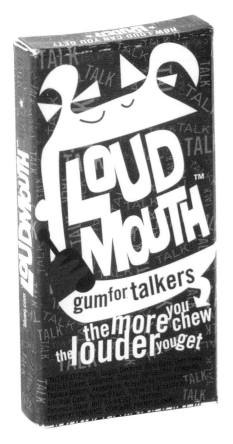

⊘ **Loud Mouth Gum, by Vito Costarella**

"The idea for this design came from thinking about my sister," says Vito Costarella, a San Francisco–based designer. "I remembered a time when we were just shouting out, 'Loud mouth!' at each other."

Costarella also considered, given the prevalence of cell phones today, using images of blathering individuals on the box. But he wanted to keep the image simple and high contrast. This design also established a relationship between the mouth and the gum, which Costarella liked.

The designer says he could imagine a teen or preteen girl buying this gum to give to a friend or just to have something interesting to pull out of a purse.

Brothers Mitch and Seth Nash are the cofounders of Blue Q, the Massachusetts-based company that has already made consumers reconsider their basic suppositions on exactly what a consumable-like soap can be: Dirty Girl is the leader of the Blue Q line of personal-care products. Now, the company has turned its attention to an alternative persona for an edible consumable.

There is a Dirty Girl gum, but there are also completely new and contrary varieties, such as Gum Philosophy (which also has multiple permutations), Bad Ass gum, and Make Out gum.

The Nash brothers equate the new line of 40 SKUs of gum to buying baseball cards. "When baseball cards came packaged with gum, people didn't want the gum. They were buying the cards. That's what the Blue Q gum is: The key is the gifty package. The gum is merely a transportation vehicle for the graphics."

Think of the new products as greeting cards, but with the added benefit of a little treat—gum. Priced at $1.25 per box, the gum is affordable, fun, and certainly more novel and inexpensive than your typical, trite greeting card.

"You could buy the Total Bitch gum, for example, for yourself just to show you have a good sense of humor," the brothers say. "In almost every case, though, we imagine that the gum is being bought as a gift."

The idea to produce gum grew from the challenge of keeping Blue Q's world of consumables fresh and surprising. The Nash brothers and their team looked into other confections, such as chocolates and endless varieties of penny candy. However, the gum category stood out as being untouched and unexpected. Even better, while Blue Q's soaps and personal-care products generally sold only in certain types of specialty stores that tended to be spaced out geographically—retailers don't want to carry the same products as their neighbors—gum could be sold anywhere and is inexpensive enough to be a successful impulse purchase that consumers come back for again.

So the Nash brothers contacted 10 talented artists and designers from across the country, gave them lists of ideas that might be translated into a gum variety, and let them run with the concept. All they asked was that each package design have "pop from the shelf" pizzazz.

"It is cool to be in an industry that is so influenced by the impatience of the consumer," Mitch Nash says. "The public's appetite for newness is the only sure constant."

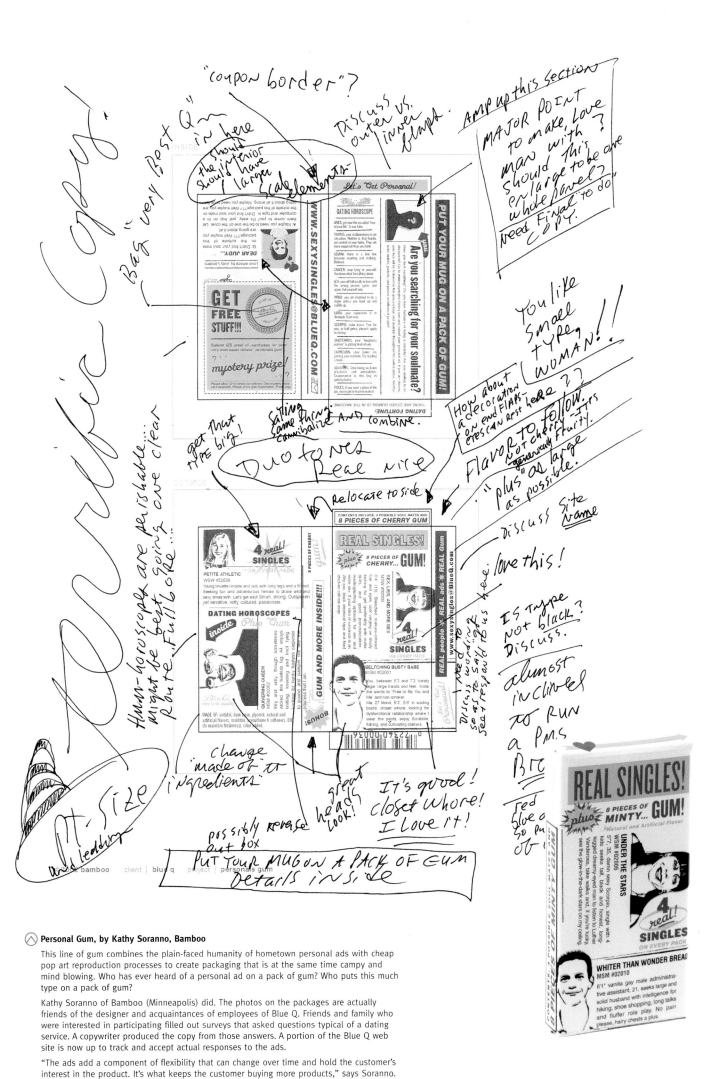

Personal Gum, by Kathy Soranno, Bamboo

This line of gum combines the plain-faced humanity of hometown personal ads with cheap pop art reproduction processes to create packaging that is at the same time campy and mind blowing. Who has ever heard of a personal ad on a pack of gum? Who puts this much type on a pack of gum?

Kathy Soranno of Bamboo (Minneapolis) did. The photos on the packages are actually friends of the designer and acquaintances of employees of Blue Q. Friends and family who were interested in participating filled out surveys that asked questions typical of a dating service. A copywriter produced the copy from those answers. A portion of the Blue Q web site is now up to track and accept actual responses to the ads.

"The ads add a component of flexibility that can change over time and hold the customer's interest in the product. It's what keeps the customer buying more products," says Soranno.

Gum Philosophy is an intriguing and eminently extendable line created by **Design Ranch** of Kansas City, Kansas. Mitch Nash provided lists of quotes about life and creativity, and designers Ingrid Ziti and Michelle Sonderegger created 12 different variations that are almost completely typographic and full of personality.

"This purchase makes you think of someone; it's a message that you want to share. It's fun to have more than one quote per box—three on the face and one on the inside of the box," says Ziti. All of the SKUs have additional graphics inside their boxes. "If you are intrigued enough and inquisitive enough to take the box apart, it's like a fortune cookie: There is more inside for you."

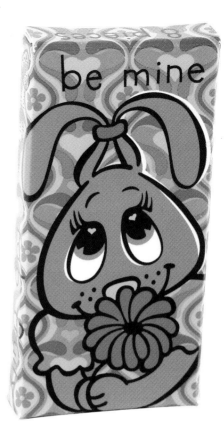

Gay Gum, by Kelly Lear

"Mitch has lots of very girly products in the Blue Q line. I wanted this to be for a guy. We just decided to go with beefcake," explains designer Kelly Lear of Miami. At the time, she and Mitch Nash were working on another project with illustrator Owen Smith, an artist known for rich, dimensional, pulpy, retro images. He seemed like the perfect artist to handle the job.

Lear says they felt some trepidation in creating this design. "We aren't making fun of anybody. We did a lot of research on the period and the look, and this presented a different look for the line," she notes.

Bad Ass Gum, designed by Haley Johnson of Haley Johnson Design sprang from the notion of chewing gum. "I thought about gritting down with your teeth. That gave me the springboard for the copy and for the face. You can look at the big face and get the concept pretty quickly," says Johnson of the cinnamon-flavored gum.

After this design was done, Johnson and Nash decided that women can be bad asses, too. So she created a mate for this design, which features a grandma-type character.

Animal Love Gum, also designed by Haley Johnson, was created for the younger teenage market. It's a very cartoony, "friends forever" message. It was made "intentionally sappy," the designer says.

"I have a hard time leaving things the way they are," Johnson says of the over-the-top cuteness. "There is something charming and likable about the box—it calls back a childhood feeling, more emotional than logical. Actually, you may not really like the design, but it will still play back on your emotions."

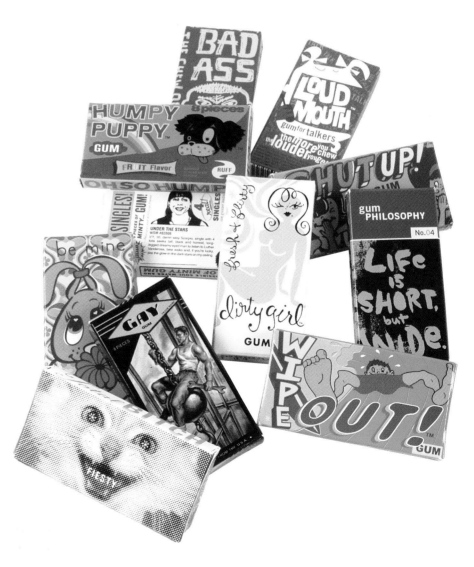

Nk'Mip, a brand of wine made from grapes grown north of the 49th parallel in Canada, in a **pocket desert that extends** across the Washington–British Columbia border, where temperatures can reach **105 degrees Fahrenheit in summer** and dip to **near 0 degrees in winter,** has worked hard to get here.

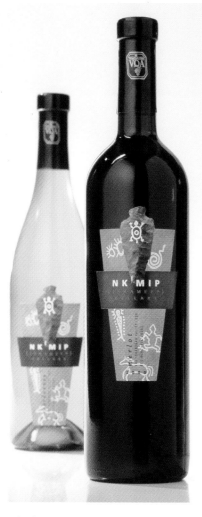

A wine from an unusual place—a pocket desert right across the Washington State–Canadian border on an Indian reservation—deserved a package design just as unique. Dossier Creative found a way to communicate the makers' heritage with a contemporary twist.

The people who have grown the grapes, entrepreneur Sam Baptiste and his family and employees, most of whom are members of the Osoyoos First Nation, a central–British Columbia Indian tribe, have worked hard to establish a successful vineyard that today produces a remarkable line of ultra-premium wines.

This wine was unique. That's why Don Chisholm and his design team at Dossier Creative of Vancouver, B.C., worked so hard to create one-of-a-kind packaging for its client, Nk'Mip (pronounced "Inkameep"), the first native-owned and operated winery in Canada. The winery's offerings included a Chardonnay, Merlot, Pinot Noir, and Pinot Blanc; an ice wine—a wine made from frozen grapes—may be produced in the next two years. The proper packaging and labeling could give the wines the boost they needed to attract the attention of the highly educated, highly experimental wine lover. These early adopters, if they can be encouraged to try a product and like it, are the trendsetters who give a brand the word-of-mouth reference that a wine needs to succeed.

Inkameep is the name of the Osoyoos Indian band in the native Okanagan Salishan language. The Salish tribe has lived in this area since the 1870s. Like many reservation areas offered by governments of the time, the land was deemed worthless: scrubby, rocky, and too dry to grow anything without irrigation. Today, though, the Osoyoos band, which is part of the larger Salish tribe, produces some of the finest fruit in the region.

Inkameep is a sophisticated brand, Chisholm says. It represents the tradition and heritage of the Okanagan Nation, while encompassing new-world design. "The packaging we created supports the premium positioning for the brand and conveys rich, native heritage through images of strength, mysticism, pride, and the deep historical roots of the Osoyoos Indian band," he says.

At the center of his team's design are two symbols of Inkameep people and of native people in general: the turtle and the spearhead. In native legend, the turtle challenged the eagle, who had enslaved the animal people, to a race and then won by outsmarting the eagle. The spearhead symbolizes strength and success.

To begin collecting what they knew would be rich imagery, Dossier designer Peter Woods spent two days in the Okanagan meeting members of the band, visiting the band's museum library, and interviewing historians. He gathered many different images, including a snake, coyote, bear, horse, feather, and dancer. All of the symbols hold meanings of strength, mysticism, and honor, among other qualities, for native peoples.

This early option used symmetrical, flipped pieces of what might be ripped fragments of ancient documents. The Nk'mip name was placed at the center. The background used Indian picture writing; each symbol was chosen for its specific meaning.

Left: This design used a shape as its base that is reminiscent of a stretched deer hide. The vertical rectangle, carrying the brand name, was brought over from the first design. Although the client liked this approach, eventually it was decided that associating the new wine with a dead animal might not be a positive connection.

Center: This comp was ultimately taken to final stages. It incorporated the picture language that everyone had liked since the beginning, plus it brought in an arrow or spearhead as well as some additional texture. The single pictogram presented a stronger brand image.

Right: This design brought together maps, pictograms, photos, and artifacts. Although this approach brought together many visuals that both the design and client teams liked, this was deemed too busy and too historically based for a new wine.

"The snake, for example, we felt held ambiguous symbolism—both positive and negative—that we liked. We felt that it would be interesting to highlight a symbol that had broad, universal associates that could border on controversial. The snake could be poisonous and evil, but if we used a coiled snake, we could form another universal symbol—the spiral—a powerful icon in all cultures around the globe that is generally seen as a symbol of life, death, and eternity," Chisholm says.

After extensive study, however, the design team and client agreed on the turtle and spearhead as symbols for all of the wines.

The design process was an evolutionary one that went through many stages. One early option presented symmetrical and flipped pieces of what might be ripped fragments of ancient documents. The two pieces are joined by a thin vertical rectangle carrying the Inkameep name. Chisholm liked the power of this look. It was almost like a petroglyph on its own. "It's the power of the symbolistic brand mark," he says.

This idea was initially popular with the client. They were enamored with the power of the shape. However, there were many problems to be solved with this solution: Maybe the word mark should be broken up, but maybe breaking the name in this fashion would render it too hard to pronounce.

Another design explored the idea of a stretched deer hide. "We felt this was a strong direction. Deer hide was an important material within the band's life, as they were known for clothing they created from deer hide," Chisholm explains. "The simple graphic form that represented the hide and the word mark were working more as symbols for the brand."

However, the client felt that the skin might make consumers think of dead animals—not a concept they wanted associated with their new product—and decided not to go with this approach.

Yet another option—there were eight design ideas presented in all—relied on pictograms. "The client liked this direction because of its unique label shape, but we decided that one pictogram was a stronger image for the final design," says Chisholm.

A fourth design direction used a mix of imagery—pictograms, photos, maps, and the brand mark—to uniquely express different varieties of wine. Each set of visuals would tell a different story for each variety. Each arrangement of art would be dramatic and distinct. However, this approach was ultimately judged to be too much of a period piece.

The third option was eventually chosen, with slight modifications. "It is a good representation of the brand strategy and of native heritage and symbolism," Chisholm says. It is both traditional and contemporary. It has also been commercially successful.

"The overall brand image created through the packaging program has allowed the client to enjoy many successes—articles in publications on their wine and winery, public relations exposure, and so on. Initial indications are that sales are healthy," he adds.

VALUE PRODUCTS—DESIGN THAT DELIVERS
Butternut Bread

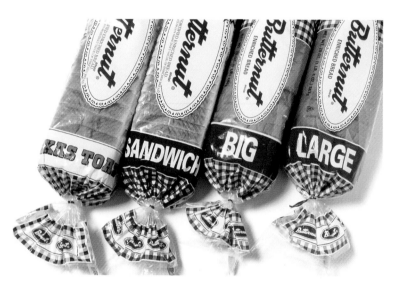

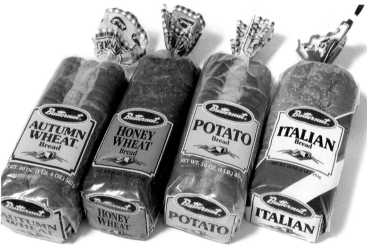

The new Butternut Bread packaging, created by Willoughby Design, clearly creates the impression of a family of products. The brand is consistent across the SKUs, and the varieties are easily distinguishable.

Complacency: It's a danger many commodity products face. If consumers have to purchase your product—milk, eggs, bread—do you really have to promote it? Does your packaging have to look good and work well?

In the case of Butternut Bread, the answer to both questions was "yes." Although the brand owners regularly conducted soft promotions such as price discounts to encourage new trials, product packaging lagged behind market demand. Butternut's presence on the shelf was not strong. Even worse, it was inconsistent. It was difficult to tell which products were related: The shopper simply had to work too hard to find the Butternut brand.

The client wanted to revitalize the brand, and fast.

"Before, if you laid the Butternut products on the table, you could see that there was a problem," recalls Anne Simmons, vice president of strategic services at Willoughby Design Group, Kansas City, Missouri, the firm that was tapped by Butternut for the repackaging project. "The client called it 'cats and dogs'—there was no consistency between package design, package structure, or anything. Some designs were actually done by printers hired by bakeries across the country that commissioned their own designs. The decision was made to centralize all of the design."

Besides inconsistent branding, the packaging didn't "pop" on the shelves. Everything looked dull, Simmons says. The inks used had poor opacity, and none of the colors were true to the brand specs. Also, individual packages in the line seemed completely unrelated. "The potato bread and the Autumn Wheat bread looked different from each other, for instance. The brand panels were different shapes, different type and colors were used, and on some, the brand was portrayed in red and on others in white," Simmons explains.

With the white breads, the consistency problems were less dramatic, although poor branding and shelf impact needed to be addressed. Differentiation between thin sandwich bread, the big loaf, and the small loaf was hard to discern.

All of this being said, Simmons and her team knew that drastic changes to the identity of a commodity product can spell the death of a brand. Even if the product is a "must have," if consumers can't find their regular brand, they will choose something else: After all, they have to have it. This design would have to be able to communicate improvement, but not mystify the customer.

The designers began by examining the bottom gusset of the bag, which is the end that is visible to consumers when the bread is on the shelf. "We spent two full months of research looking at this 4-inch (10 cm) square. We looked at the typefaces, the colors, the descriptors for the bread, and how much of the gingham background to show," Simmons says.

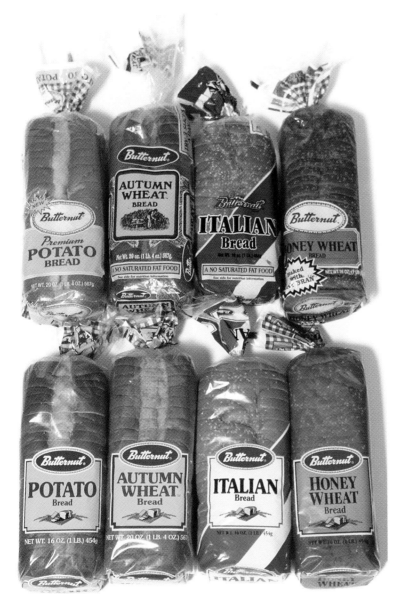

This familial relationship wasn't always so clear. A comparison of the "before" design (top) shown with the new designs (bottom) reveals that plenty has changed.

One thing they determined was that it was important for this brand to have a white background with colored type to differentiate the products—for example, the small loaf would have orange type, sandwich bread blue, and the big loaf purple.

They also found that showing as much gingham as possible was also important. "The gingham is sacred to the brand. This is what consumers look for, and it was the only thing that Butternut had that was actually consistent," Simmons says. They decided to reveal more gingham on the new designs, especially on the gusset of the bags.

Although gingham prevailed on the "ponytail" end of the bag in the original design, the designers felt that adding the brand name there would help reinforce the message, especially when packages are accidentally turned around on the shelf and the ponytail is left sticking out.

Other improvements included standardizing the size and position of the panels on the top of the bags. On the white breads, a wide stripe carrying the name of the variety of bread, together with the improved and bolder bottom gusset, clearly lets the shopper know which variety is which.

Up to this point, Butternut Bread had not taken advantage of the better printing inks being used today, particularly bright, super-white whites and opaque reds and blues. Willoughby Design did complete shelf sets of more vivid mock-ups and placed them alongside competitive brands. "The results were dramatic," Simmons reports. It was obvious that the new packaging would no longer pale in comparison to the competition.

The new system has been in place for just under a year at this writing. Sales have improved, Simmons reports, and sales even remained steady on the days the new packages were swapped for the old.

"With a commodity product like bread, sales can drop dramatically—as much as 20 to 30 percent in a month—if things aren't handled correctly," she reports. "Shelf impact is so important for this category. If you can get the shopper to pick it up, then he might like it and buy it again. Cost can be a factor in changing people's minds, but it really comes down to consumer preference."

One difficulty with the old design was that different varieties used the Butternut logo in completely different ways.

Willoughby Design standardized the mark.

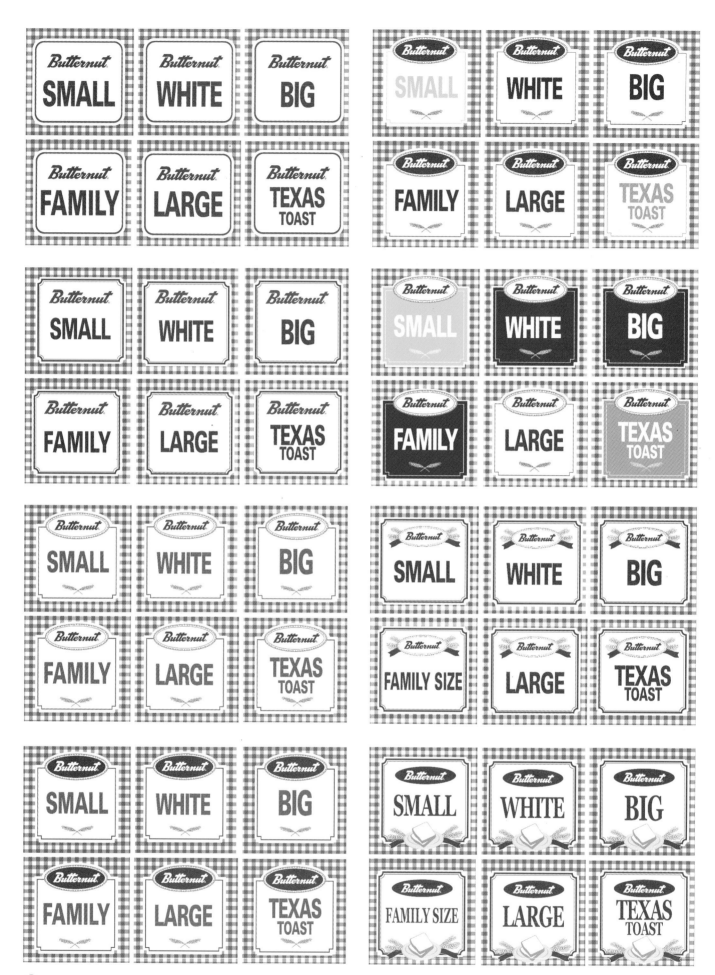

The bottom gusset of the bread bag is what is exposed on the retail shelf, so it is what consumers spy as they are browsing. This study examined a range of gusset designs, from most basic (at top) to most premium (progressing to the bottom).

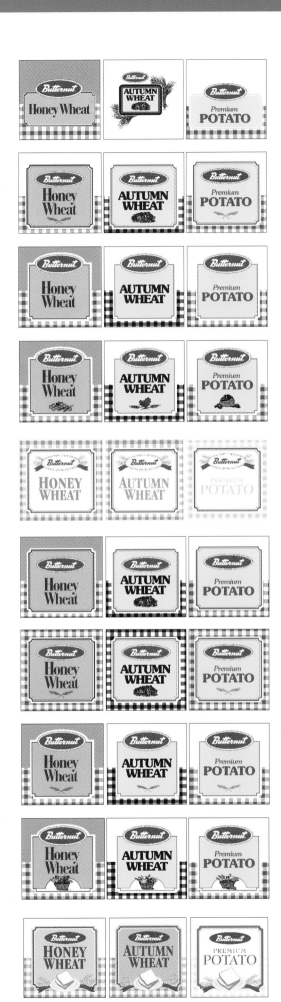

The other bread bag gussets were also studied in the same manner, from most basic (top) to most premium (bottom).

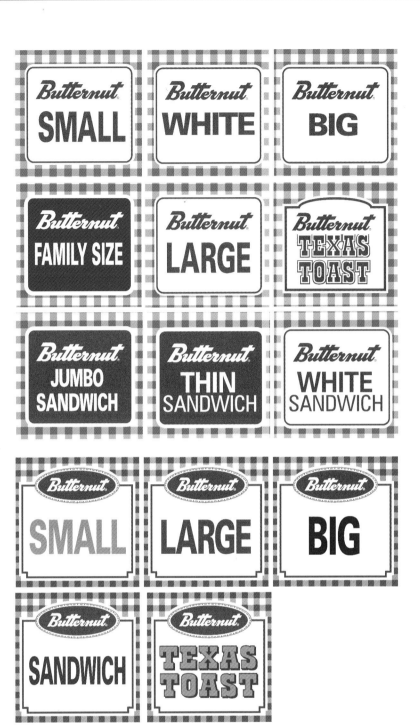

The final design (below) is an enormous improvement over the original one, which had become fragmented and inconsistent. Now, shoppers can easily distinguish the specific variety they want. Colored type on a white field communicates quickly. Note how more of the brand's trademark gingham is exposed.

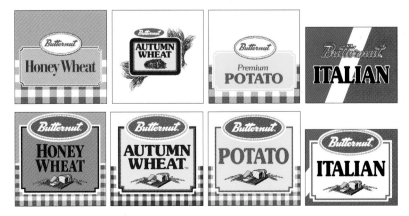

The variety breads also benefited from a much more consistent design (below). The redesign is especially evident in these lines, which looked like they might be from completely different bakeries.

When **Alexander Isley, Inc.,** partnered with client Animal Planet to create a **style guide for the cable network**, both parties entered the venture with **high hopes** for future reward.

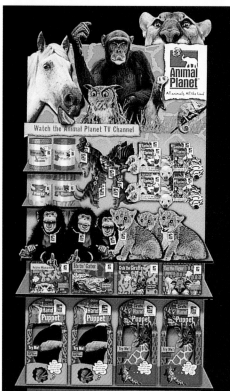

⬡ Although each product in the Animal Planet line commissioned by Toys "R" Us and designed by Alexander Isley, Inc., was packaged differently, the entire group was meant to function as a "store within a store" in the busy Toys "R" Us retail environment.

With its new style guide, Animal Planet hoped to attract partners and licensees who would want to develop products with the Animal Planet moniker. Alexander Isley, Inc., hoped it would be tapped by those future partners and licensees for future design projects.

Both parties did well. Among others, Animal Planet captured the attention of the giant toy retailer Toys "R" Us, which in turn asked Alex Isley's team to extend the sensibility established in the style guide into packaging and even into new products. In the end, Isley's designers created close to 200 packages for the client, in addition to sell sheets, in-store displays, and other materials.

"When we were first approached by Animal Planet, we were asked to create a look that would appeal to kids and grown-ups," Isley recalls. "They wanted to develop products, but really only had their on-air ID to work with as source material. Our job was to extend their brand by developing their graphic personality."

The completed style guide was really more of an attitude guide, he notes. It didn't contain as much about nuts-and-bolts issues like typefaces and such as it did about the personality of the brand. Throughout, it cleverly suggests that "Animals are people, too."

One such indicator were the thought bubbles—which Isley's team called "animusings"—that are detailed in the guide. "The balloons are the irreverent or witty thoughts of the animals. Making them more human like this really gives them personality," Isley explains.

Other visual cues that the Isley team included in the style guide were a saturated, tropical color palette, animal patterns (such as leopard stripes), and a refinement of the torn paper effect already in use for the client's on-air identity. Some new typefaces are also suggested in the guide.

Toys "R" Us was one of the first licensees to become interested in producing Animal Planet–branded toys—unusual, because the toy retailer usually markets toys produced by outside parties.

The project was an enjoyable one, says Isley, but a tough one as well. There are many animal-related toys on the market, but many are indistinct: "What makes one stuffed monkey different from the next one?" Isley points out. The client asked that each package include some sort of real-life information, not just be cardboard surrounding a toy.

The designers decided that the packaging should combine offbeat scientific facts and feature a photo of the real animal the toy was depicting, to link each product to reality and reinforce Animal Planet as being true to life. A good deal of the editorial component of any packaging is aimed at adults—the people who actually purchase the toys—even though the product is ultimately meant for children.

This is where the thought bubbles became effective. "The elephant on the [elephant toy] box might say, 'Does this box make me look fat?' or the hippo on the Hidden Hippos game would say, 'I've been trying to find myself for years.' This type of humor resonated well with our client as well as with the customer," Isley says.

The Isley team of designers determined that colors for the packaging were to be bright, but not suggest any particular geographic area of the world. Each color selected for the palette also has a muted cousin that can be specified when contrast or emphasis is required. The resulting palette maintains consistency across the brand whether the packages are printed in four colors or two colors.

The actual structure of the packaging, especially the boxes, involved a great deal of experimentation. Everything from cylinders to completely irregular shapes was explored. Some early packaging concepts resembled pet carriers, complete with handles and air holes. Some animals offered unique design opportunities. For example, an ostrich hand puppet was temporarily housed in a nest, an egg, and a domed box as various experiments were tried.

Any packaging the designers created could not be too expensive or gratuitous, especially given Animal Planet's connection with conservation interests. "Packaging gets discarded, so we never want to be wasteful with paper," Isley says. The packaging could also not make the midpriced items look too expensive so that consumers looking for a reasonably priced gift would never pick it up.

The client wanted to develop a "store within a store" for its new Animal Planet products and approached Isley's group for initial conceptual development in this area.

△ As Alexander Isley designers discussed the style guide project with their original client, Animal Planet, the idea for one of the major design components in the project was born—thought bubbles emerging from the heads of animals.

◁ Although Animal Planet's old style guide was an all-words affair, Alexander Isley, Inc.'s, new design was full of visuals, patterns, and colors. It was in itself an example of how to do design for Animal Planet.

"There is a section in Toys "R" Us called 'Animal Alley' where there are all kinds of stuffed animals that only have hang tags—no boxes. You would have no way of knowing or controlling what your product is competing against," Isley says. Another failing of some toy retailing is that manufacturers spend a lot of time figuring out the most efficient ways toys can be shipped. Their aim is to ship as many toys as possible in the fewest shipping containers. But what a manufacturer gains in terms of shipping efficiency, he loses in product awareness, Isley says. "Those products are just dumped into big wire baskets and lose their individuality."

The Isley designers used the color scheme, animal patterning, and whimsy of each package in the Animal Planet line to build what Isley calls "goodwill" for each of the other products. "The packaging ends up being like a sign for the Animal Planet section: It points out the store within a store," he explains. And even when a Toys "R" Us/Animal Planet toy only has a hang tag, the designers upped the tags worth and bulk by turning it into an eight-page booklet containing a short story or scientific facts.

Isley's team has designed plenty of products, packaging, and other works for children over the years, and the team members have always approached their assignments with a respect for a child's intelligence.

"When people design for kids, they think, 'Hey, kids like animation and video games, so let's put things at wacky angles and make the layouts look like they are moving.' Kids are smarter than that. You don't have to pander to visually appeal to them," Isley says. "Through the smart use of text, color and typography only, you can make things appealing to any particular audience. On this project, for example, the copy is written for adults, but I hope that kids will get it, too. I read Mad magazine when I was a kid, and although I didn't get all of the jokes, it made me determined to find out what they were talking about, so I did—and I learned. So the trick is to challenge kids without going too far over their heads."

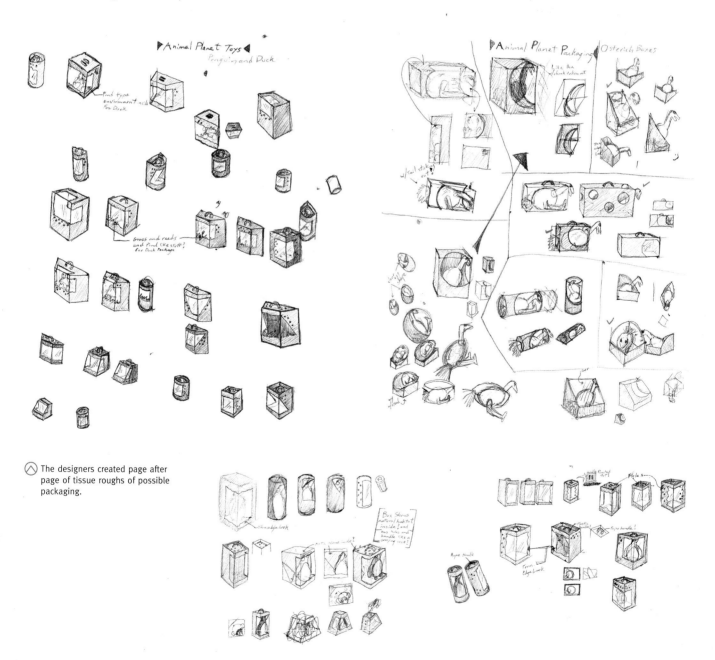

The designers created page after page of tissue roughs of possible packaging.

Pages from the finished Animal Planet style or "attitude guide" upon which all of the Toys "R" Us package design was based.

Zaki Elia compares **designing a new proprietary bottle for the soft drink Fanta** to containing a genie in a bottle— "A genie that wanted **desperately** to get out," he laughs.

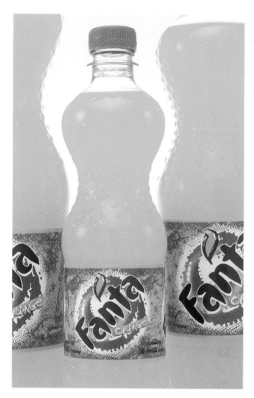

Faced with designing a preexisting label graphic, Z+Co. designers were challenged to create a new bottle shape for Fanta, a shape that would make it distinctive in the wash of soft drinks available today.

That's because Fanta, like any carbonated drink, contains carbon dioxide gas that wants to escape the solution it has been injected into during manufacturing. This gas, in combination with atmospheric pressure and temperature, can cause a plastic bottle to deform, look half full, or even burst.

Elia, principal of Z+Co., a London-based design firm, recalls an early meeting with Coca-Cola (the owner of the Fanta brand) engineers. He and his team were presenting preliminary sketches that suggested very clear brand signals in the form of bottle shapes.

"For some ideas they said OK, But for most they said, 'You are dreaming. This will never work.' It was frustrating, but we knew that every design could not just be looked at from its aesthetic merits alone. It also had to be able to keep its shape," he says.

Fanta asked Z+Co. designers to apply an existing label graphic to a new bottle shape that would be Fanta's alone. The project's brief specified that the new bottle should somehow express the fruitiness and fun of the drink—something sassy and fun—while also providing "natural" cues. But one of the biggest challenges the designers faced was designing a three-dimensional object that echoes the graphics of the two-dimensional label.

Although there are hundreds and hundreds of stock bottles already available on the market, Elia's client felt that a proprietary bottle was essential to elevating the brand.

"A proprietary container is one of the chief means for constructing a brand properly," he says. "Because as you consume a product, you are forming a relationship with it—how you hold it, how you enjoy it, how you fantasize around it. This is not the place to save money: A proprietary package is an investment in the future dreams of the product."

A stock container, he adds, may have some aspects of a brand, and it may actually turn out to be an appropriate match. But over time, it's value becomes negligible because everyone else can own it, too. Elia cites the example of the aluminum can: Because anyone and everyone can use them—for soft drinks, hard drinks, motor oil, bath products, and even candy—the can is really only able to perform as a billboard onto which graphics are posted. As a three-dimensional object, its potential to become a strong component of the brand is wasted and becomes the expression of a certain category of products rather than the expression of the brand.

"The object is devalued, yet the package is the most important part of forming the relationship with the customer," he notes.

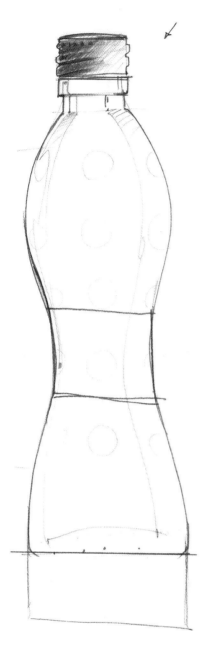

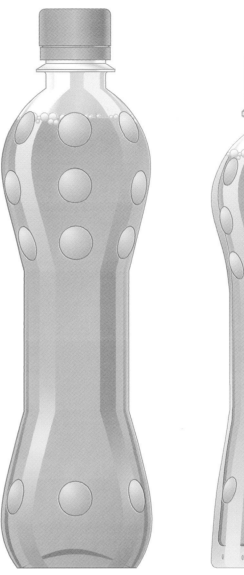

◈ Searching for the perfect proprietary bottle shape, principal Zaki Elia and his team began by experimenting with an hourglass-like shape they called the "splash" design. It was easy to hold onto and also suggested a slim body profile, which would appeal to the young audience they were after.

◈ These are plastic (left) and glass (right) designs developed from the original sketch. The bubbles in the bottles graphically suggest the fizz and bubble of the drink.

When Z+Co. began work on this project, Fanta wanted to reinforce its unique relationship with its consumers. The client asked the designers to address the younger generation and make Fanta a drink that teens and young adults would want to drink and so differentiate themselves from their parents or younger siblings. Give them something they can own, the client requested.

"Images on TV or a billboard would not be enough to do this. The object of the package would have to be the message that addressed individual fantasies—think of the Coke bottle or the Perrier

bottle. You can influence these fantasies through advertising, but they only become tangible through the physical experience with the package," he says.

After that early meeting with engineers, where structurally unsound designs were eliminated, Z+Co. designers created several designs that addressed specific aspects of the brand. One trial had an hourglass shape that was ergonomic—it was easy for the hand to hold—and had a tactile element: bumps, which were meant to graphically express the fizz and bubble of the drink.

This experiment was called the "swirl" design. It was also easy to hold, but it did not test as well as the first, perhaps because it did not mimic the body shape of a person and therefore did not have as much personality.

The plastic (left) and glass (right) designs developed from the "swirl" design.

"It is also suggestive of a body shape, which gives the object more personality because it is more like a person," Elia notes.

A second design was called "the swirl." It had multiple waves in its profile and was also easy to grip. But it didn't test as well. "People wanted to fiddle with the other one more. This one just didn't have the body profile most people prefer," the designer adds.

So the first design was refined even more. Bumps were placed in various patterns at the top of these trial designs, sometimes in combination with lines or tilde-shaped marks to suggest "splash." The label was placed very low on the container, which Elia feels is appropriate so as to allow a balanced interplay between the printed brand mark and the branded shape.

"The bigger the label," Elia says, "the less visible the bottle is, and the more noisy it becomes. Promotional activities on large labels, although necessary, if not kept in check can cannibalize the brand mark and reduce the perception of the brand quality. Large labels tend to reduce the object it envelopes to a billboard, hardly an object of desire. Because the physical experience of drinking is intimately linked to the object, it has to be given the importance it deserves."

Other ideas, including a leaf-shaped belt clip for the plastic bottles—a natural cue—and a branded round cap with a bubble pattern on it were studied, but for cost or production reasons, they were not practical. Elia believes that, as three-dimensional objects, they would have been even more voices speaking out for the brand.

⬡ Here, the designers start to combine attributes from the swirl and splash designs. Note the introduction of the proprietary, bubble-shaped cap.

⬡ This shape held a lot of appeal, so the design team tried different patterns of bubbles on the bottles. The labels are kept low to allow as much of the proprietary brand shape to show as possible.

The aspect of the Planet Krunch packaging that Bruce Crocker of Crocker, Inc., likes best is that its art embodies the notion that adventure, imagination, and discovery are interrelated.

⊘ Planet Krunch is not only a healthy snack for children on the go but also a destination for their ever-roving imagination. Designed by Crocker, Inc., the packages contain many landscapes for children to explore.

But it was the realization that the product's nature and its package design could be aligned in a spirit of youthful adventure that got his design team excited.

The products were conceived as a healthy alternative to the overwhelming abundance of sugar-based kids' snacks that overpopulate supermarket aisles and convenience stores. By being called into the product-positioning process early on, Crocker, Inc., could make marketing contributions that would help formulate the criteria for defining the Planet Krunch brand attributes.

The art style that Crocker ultimately chose is intentionally based on simple forms that are "accessible" and easily mimicked by a child who likes to doodle and draw. In fact, the illustration style has the feeling of doodles a fourth or fifth grader might draw on the inside cover of his assignment folder.

Planet Krunch is a healthy snack developed by a parent who was frustrated by the lack of available nutritious, on-the-go foods for children. Made from dried fruit, oat flour, corn meal, natural sweeteners, and other wholesome ingredients, it is billed as "the adventure snack." It would have to compete against every other food that children nibble on—chips, candies, gum, and other products with much larger advertising budgets that Planet Krunch had.

But because it was not candy, chips, or another food product that snack-browsing shoppers might understand and see near the cash register, its new packaging had to communicate the fun qualities of a snack to a child, while at the same time speaking to the health-conscience parent. In a way, Planet Krunch is championing the idea that its OK to play with your food. The solution, Bruce Crocker and his designers decided, was to inspire a sense of imagination for this snack, which Crocker Inc. helped position as "the adventure snack."

"We hoped to create packaging that would bring a sense of curiosity, not only about this product but also about life in general with kids," Crocker says.

Color, the team reasoned, would be an excellent place to start. The product would be sold in health food venues, where so much packaging is visually subdued: earth tones, natural colors, and the like. The logic was simple, using bright colors would not only be appropriate for a kid's product but would also visually stand out in these stores. The Planet Krunch color palette uses large fields of solid process blue as its main equity color. From a production standpoint, it is clean, bright, and always consistent, regardless of whether packaging or other communication vehicles are being printed. Support colors were also specified as clean, bright colors made up of only two-process colors each whenever possible.

⌃ Clear, bright colors are a
centerpiece of the packaging.

⌃ A child's guide to the new world of land-
scapes could have been a person, an ani-
mal, or a mix between the two. Whoever
he or she turned out to be, the little guide
needed to be wide-eyed, full of wonder,
and ready to explore.

A second visual idea for the packaging would be to incorporate one or more characters whom children could identify with and embrace. "We spent a lot of time playing with different characters that had a personality and quality that kids could emulate. We weren't sure if it should be a human, an animal, or an alien, but we wanted the main character to be wide-eyed and ready to explore the world," Crocker says. "When we landed on the eclectic outer-space concept, it seemed natural that the main character would be from another planet or, more specifically, not from our Earth."

For a while, Crocker considered creating many different characters that would populate different areas of the packaging. But then it seemed smarter to change the scenes on the packaging and let the single character investigate them all, just as a child would love to do, especially via spaceship. All of these scenes would be from—where else?—Planet Krunch.

"We didn't really want to depict one specific landscape, but instead a combination of different integrated landscapes. We wanted to keep all possibilities open so pine trees, volcanoes, odd land formations, and snow-capped mountains could coexist.

The basic idea was to create a multitude of curious environments," he says.

The nature of the project and the excitement around the possibilities were inspiring. The design team developed dozens and dozens of sketches of little characters and landscapes. But when it came to the point of actually designing the packaging, the design team and client decided to edit the images and stick with one central character face that customers could identify and, therefore, remember. The important thing was that the final character have the kind of personality characteristics Planet Krunch wanted to be associated with—friendliness, quirkiness, curiosity, fun, and wholesomeness.

The other images will be used over time, on shirts, stationery, and so on, as well as on future packaging. In fact, as the brand evolves, the intention is to let the visual vocabulary grow in an organic way that will allow for the integration of many exploratory ideas that were not used to launch Planet Krunch. The eventual vocabulary may be extensive, but it will also be consistent in execution through color, artwork, and the "soul" of the imaginative adventure.

The type that the designers selected needed to be full of life as well, part of the curious environment.

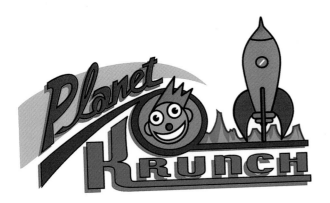
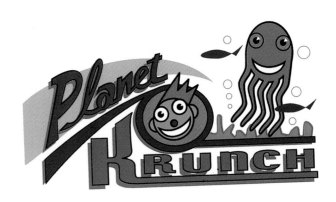

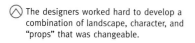
The designers worked hard to develop a combination of landscape, character, and "props" that was changeable.

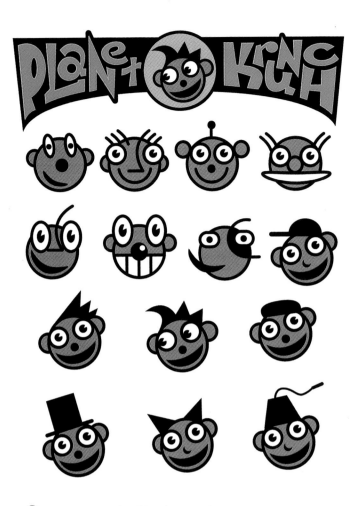

 Here the character that ultimately was used in the design is played out in dozens of iterations—as a person, an animal, and something in-between.

The Crocker designers developed many characters and scenarios for the Planet Krunch project that were initially not used. But these will eventually be used in collateral, future packaging and promotions.

The artwork was created by staff artist and illustrator Mark Fisher who has a great deal of experience doing work for educational publishers as well as clients of national public broadcasting.

When you enter the Ormonde Jayne shop at The Royal Arcade in **Mayfair's Old Bond Street in London,** you are stuck with many **sensory impressions:**

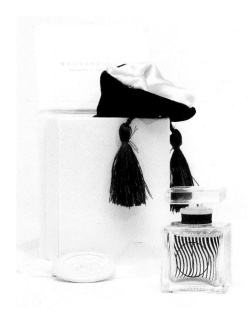

When Ormonde Jayne, a bath and body products shop, decided to create its own perfume, it needed packaging that was special. Pyott, a London-based design firm, created a multilayered design that included a dimensional bottle design, an elegant bag to hold the bottle, and a beautiful ivory, ribbon-tied box to hold everything.

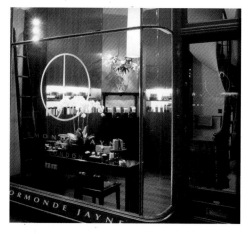

The new packaging should reflect the Ormonde Jayne shop, James Pyott concluded, with its walnut cabinets, burnt orange walls, and sense of calm and elegance.

the simplicity of the burnt orange walls and walnut cabinets, the quantity of lush products, the sense of spiritual calm, and perhaps most noticeable is the sheer abundance of smell. The place itself is actually packaging on a grand scale for the company's scented bath and body products.

In the beginning of 2002, Ormonde Jayne decided to launch a range of perfumes, developed four fragrances, and then approached Pyott, a London-based design consultancy, to create packaging for the new products. Pyott, which had already developed the brand identity, packaging, and in-store graphics for its client, was ready to build on those themes. But with a price point of £70, much higher than other products in the store, the perfume had to have a design that would work hard to help support the product's enhanced worth.

"The perfume pack had to be unique; although we would have to live with a stock bottle, and we sourced out a simple square bottle. However, because the whole experience of owning perfume is different from owning, say, a scented candle, we needed to develop something more precious, almost jewel-like in its experience," explains principal James Pyott.

The brand is a mix of Japanese and Western styles, so Pyott wanted the new design to be understated but elegant. Instead of making one large statement, he wanted to put together many small elements that together would speak of a finer experience.

A bottle alone would not be enough. A bottle in a box wouldn't be superlative enough. But a bottle in a bag in a box would have not only physical layers but textural ones as well. Pyott's sketches explored various bags, boxes, and sealing techniques.

"To draw on both Western and Eastern design, we wanted to create simple, elegant designs which used materials that made contact with peoples' emotional responses to such products. The whole process of finding the bottle was slightly seductive. It was like revealing a final prize that deliberately teased you and was always unexpected. When you finally reach your prize, the bottle is understated and not demanding. It allows the product itself to then charm you," he says.

But the bottle does have a strong nature. The Ormonde Jayne customer profile is of a strong, confident, stylish woman. The designers felt that using a Brigett Riley–inspired backdrop would add a sense of art and culture to the brand and help create an optical art piece on the dressing table.

The box also needed to be something special, so Pyott eventually decided on a Japanese box construction, made from beautiful, ribbed paper. To keep the box closed, they decided to use a long,

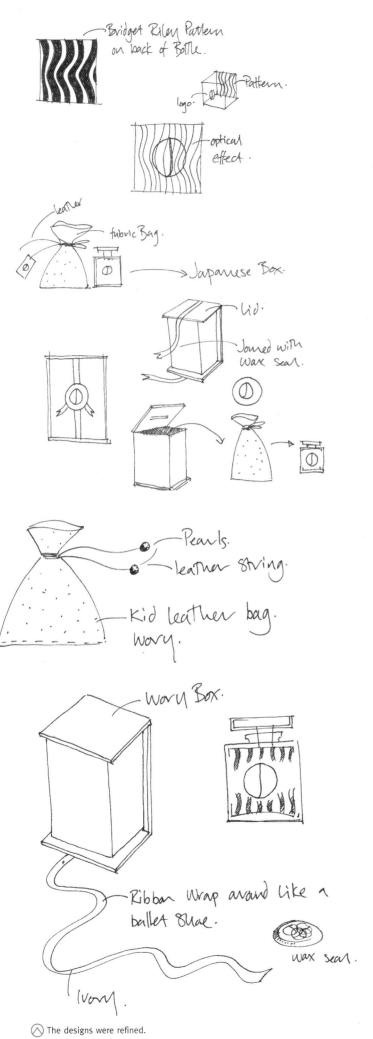

satin, ivory ribbon and wrap it around the box as a ballerina would tie up her toe shoes. A wax seal holds this very feminine closure shut.

The bag mimicked the color of the shop's cabinets. It is lined in ivory. A happy accident of the project was discovered when the designers noted that after the perfume is place in and taken out of the bag many times, the bag itself becomes infused with the scent. It becomes a subtle brand advertiser at all times.

The whole design succeeds, Pyott says, because it exudes a sense of quiet confidence: "Designing any understated packing is all about confidence. It is often the hardest type of design to create: You have to give off the right messages through a very limited number of devices. Each device becomes incredibly important—color, texture, type, layers, smell," Pyott explains. "Often these decisions are emotional and not rational, and after a time you'll find that your own point of view creates the confidence and conviction needed to pull off such pieces."

◁ Pyott sketched out different ways to incorporate the already-established Ormonde Jayne logo on the new packaging. Printing stripes on the back face of the bottle, opposite the logo, would create an intriguing dimensional effect. Boxes and bags were also studied.

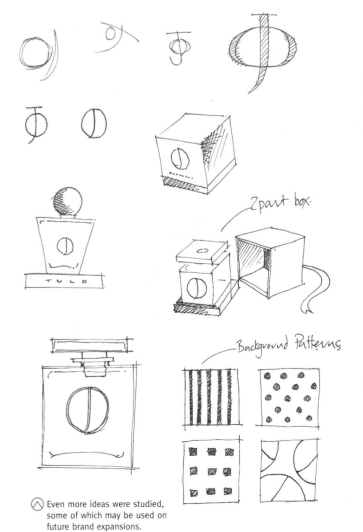

△ Even more ideas were studied, some of which may be used on future brand expansions.

△ The designs were refined.

Cars don't come wrapped in boxes. But is there any reason they couldn't? That's the **hypothetical question** designers at **Fitch Worldwide (London)** asked themselves when their client, **Nissan Europe,** asked them to package the brand in ways that

Unexpected. That's the idea at the center of this Nissan merchandising program, designed by Fitch Worldwide (London). It's unexpected that a car company would sell household products. The design of the products is unexpected. Even the design, construction, and material used in the packaging is unexpected. (Photo by Robert Howard.)

most consumers had never considered. How could the brand be extended? How could it be repackaged?

When Nissan's global director took over the company in the late 1990s, he began a revival project for the brand. Nissan, he believed, was missing the emotional link that, for example, connects the VW Bug to its vociferous fans. Capture the emotion of Nissan, he said, by creating new bonds between the brand and the consumer.

Most people are familiar with the notion of adding a company logo to T-shirts, umbrellas, tote bags, or golf balls. But the Fitch designers were charged with going much further than traditional merchandising. To inspire an emotional response, their designs would have to touch the consumer in a more personal manner and enter into his or her life in a meaningful way.

The result was a series of objects and items of clothing that were more lifestyle choices than they were beasts of burden for the brand. Each item in the new Nissan brand extension had a certain Japanese sensibility that quietly combined beauty and function: a wine glass that could be flipped on its top to become a water glass, or a jacket that rolled into itself for quick storage.

"This is a merchandising program that the consumer could react to because it was relevant to them," explains Lucy Unger, Fitch's client director for the project. "Nissan wanted to communicate the Japanese brand of design and engineering in a European way. It's a form of elegance, functionality, and simplicity that people like today."

The packaging for these products not only had to contain the products but also reflect the same practical yet beautiful principles. But the designers did not want the packaging to be a literal interpretation of what was inside. It had to be all about the parent brand, not that particular product.

Simon Mariati, Fitch design director, explains. "The packaging had to conform to the experience. Really, the package is part of the product itself, or of the experience. Many products we created were based around a certain 'Japanese-ness.' The packages did, too. The Bento box, for example, usually used to hold Japanese food, is used to hold new Nissan products. It looks simple on the outside, but it has lots of compartments inside."

"An actual Bento box is stark black, but when you open it up, you find these delightful morsels of Japanese food inside," Unger explains, noting that the Nissan packaging works in the same way.

CAPUCHINNO

ESSPRESSO

WATER

WINE

HANDLESS?

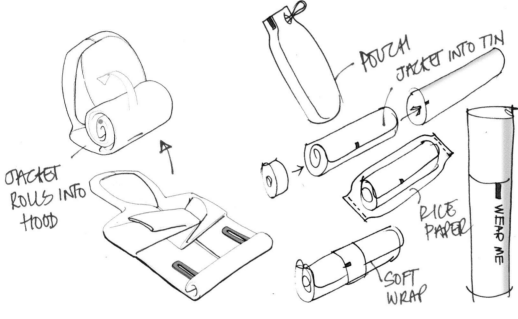

JACKET ROLLS INTO HOOD

POUCH

JACKET INTO TIN

RICE PAPER

WEAR ME

SOFT WRAP

⌃ The design of the new Nissan products was highly innovative, as these sketches reveal. The design team wanted the packaging to be an aesthetic and engineering match.

⌃ To package this unique line of consumer products, Fitch designers carefully considered innovative packaging. Can a jacket be sold in a tube? Why not?

⌄ Boxes made from wood or metal, paper sleeves, transparent bags, even packaging that turned into something else once opened were all studied.

EMERGENCY ONLY

NISSAN

NISSAN

NISSAN

"Because the box is so stark, you might expect to find something similar inside, but instead there awaits a treat."

The most successful product and package in the line is the yin-yang mug, which can be used in two ways. In one orientation, it presents an interior cavity that forms a coffee mug; flipped upside down, a smaller compartment is revealed, the perfect size for an espresso. Adding even more to its function is the air space that is trapped between the two cavities, which prevents the vessel from becoming too hot to touch. As for outer beauty, the combined cup is sleek and simple. Inside, though, it is complex.

The box design that was created to hold the cup also has a simple, outer style and a complex interior. The same analogy fits the nature of the client's original products as well: Its vehicles are simple on the outside, but very sophisticated under the hood.

White boxes hold most products in the new line, and they have a suede stock that is intriguing to the touch. "When you touch it, you get a shock: You expect to touch paper, but you feel suede.

That's one of the founding principles of this entire range of products and packaging—to be unexpected. Whether it is unexpected that the yin-yang mug has the two functions or that Nissan is selling this type of merchandise, it surprises you," Unger says.

The trademark red bar Nissan mark is the boldest adornment on the boxes, subtly shadowed by technical drawings of the product inside. More pronounced are simple commands—Drink, Eat, and so on—which further indicate the nature of the product inside.

Today, it's all about targeting individuals, Unger says. "The only thing that defines the audience is that they are all individuals. They are not slaves to brands: They will pick Nissan only if it suits their lives. Rather than just wear a Nissan T-shirt, the brand has to speak to them proactively," she adds.

The packaging and products are just the opening volley in large brands moving into unlikely product extensions, Mariati believes. "People don't expect this, which is an important reason why we are doing this."

The inside and the outside of the packaging were also thoroughly considered.

NISSAN

[LONG SLEEVED MENS T-SHIRT]

WEAR ME

私の楽しみ

DESIGNED FOR YOUR COMFORT

WEAR THIS T-SHIRT FOR EASE
& STYLE. PART OF A RANGE
OF CLOTHING ESPECIALLY
DESIGNED FOR NISSAN

PLAY

THOUGHTS

The labeling on the packages was also intended to be unusual: It simply ordered people to do something.

ること

KEEP TIME

NISSAN

AN INSPIRATIONAL RANGE OF PRODUCTS FOR YOU TO ENJOY AT YOUR LEISURE

CHOSEN FOR YOUR
WELLBEING. FILL
THIS BOOK WITH
THINGS YOU
DISCOVER AND
TREASURE

FRESH

TRAVEL

Samples of finished Nissan consumer products' packaging. The Asian influence is evident in these designs, and they are smartly European as well. ("Fresh" and "Travel" photos by John Reynolds, book photo by Robert Howard.)

VALUE PRODUCTS—DESIGN THAT DELIVERS

Perfect 10

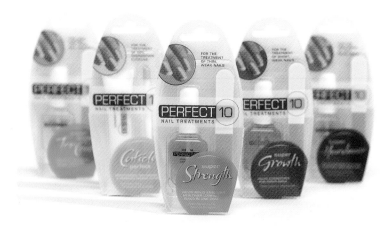

Although the Vario design team had created the unique, fingernail-shaped packaging for Perfect 10 in 2000, market competition forced the client to ask for another redesign in 2002. The new design has a more youthful appeal, communicates the benefits of the products more clearly, and fits on retailers' shelves more efficiently.

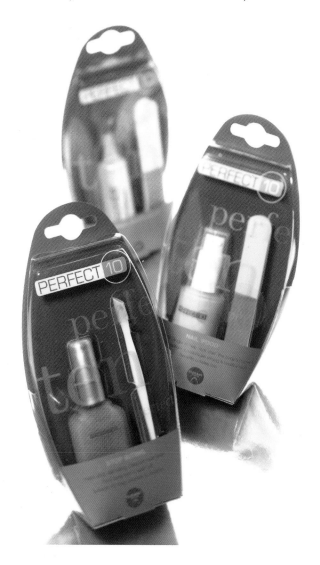

With Perfect 10, the key element in the packaging is its shape. The packs for the natural nail care products are actually shaped like fingernails, a unique statement on shelves in UK stores. Shoppers with the mindset of finding something to improve their nails can't miss it, even if they don't read a single word on the package.

"So many cosmetic products are encumbered with 100 different statements and bits of foil bursts. The ethos of the Perfect 10 packaging is that natural nails are fresh and clean, so the packaging needs to be the same. It doesn't suffer from overpackaging or 'look at me' gimmicky techniques," explains David Jones, account director at Vario, a London-based design consultancy. "This is not about false nails or even nail varnishes [polish]. This is about natural nails that look beautiful."

Vario had actually just created the product's packaging in 2000, but with changes in competition, the brand owners felt they needed to reposition again. In addition, the client wanted to appeal more to younger consumers, and it wanted to add differentiation between the various products in the line: It was difficult to distinguish one product from another with the old design scheme. The product range had grown from 6 products to 12, so differentiation had become even more important.

One of the first things the Vario designers decided to do was reduce the overall proportions of the nail-shaped package, which would permit more units to be placed on store shelves, again important with the six additions to the product line.

Next, they studied the color equity of the brand. Metallic purple and green were the predominant colors used in the previous packaging, but could the color be made brighter or be used differently in the new design? Also, to provide better differentiation between products, they wanted to consider using accent colors in bolder ways.

Their introductory explorations looked much like the original design, but these included photographic reference that alluded directly to the products' benefit—natural nails. Some designs contained the result photos in circles, whereas others vignetted the fingers across the entire package. The brand name was also made more prominent.

The package now had a premium feel. Martin Seymour, Vario creative director, says that at this point the design was becoming more open and fresh. Primary colors are not necessary to suggest "youth," he adds.

In some comps, the brand name was brought to the center of the pack, an effect that the designers liked. The oval nail shape, being wider at its middle, allowed the designers to give the name more prominence there.

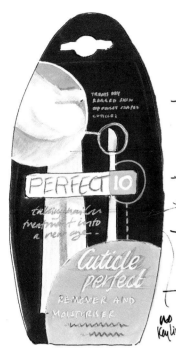

— big photographic image with product explanation

— Central branding - bigger circular keyline theme over all of pack, but

'brand statement' in silver.

— Title in rondel at bottom in a more 'approachable'

no keyline.

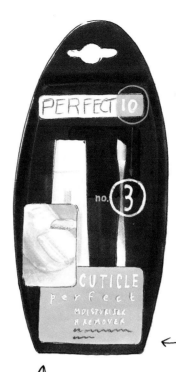

← very powerful purple

← no.3 of six, which of your regime (the no.s can be range on the back obvious link to one

← elements of in boxes, that borrow from the logo.

↑ introduction of easy to understand photography (could possibly be illustration.)

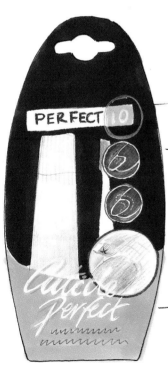

— B/G of pack in purple.

— Rondels need to be better explained & set more techy & modern.

— finger shot, not so close up.

— descriptor cleaner

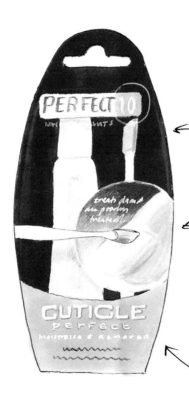

← simple purple B/G, but have duotone type image

← big picture of what the product does, explaining what the problem was.

— an element of image should always break out.

— More 'logo'ed' type, links with 'perfect 10' type

⬣ Vario designers began by reevaluating the old packaging. What was right and what could be improved?

In some designs, the actual product is almost completely exposed. But in later trials, the designers tried using a window or even obscuring the product entirely. "These designs are all about beauty and not the product. But the client had another product line in which the products were completely enclosed boxes, and people were opening them and peeking inside, which made the boxes look tattered," says Jones. "If the buyer can see the product and the end result, she is happier."

As they progressed, the designers used less and less purple in their designs until at last only the touches of it remained. Stronger colors like yellow, red, green, and blue were used in circles on the fronts of the packages to help consumers distinguish one product from another. The lighter, whiter packages definitely have a more youthful feel, and they clearly allude to the benefits of the product inside.

In the retail setting, consumers are searching for clear and easy solutions to their needs—longer, stronger nails and well-maintained cuticles. They need the right tool for the job. Showing the product, plus clearly communicating its key benefit on the front of the pack, made it very clear what each tool does. "The package tells its story and leads the buyer straight to the product," Jones explains. The colors also help the buyer remember the product when they make future purchases.

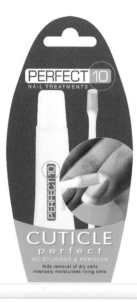

The design team examined what the brand properties were in the original design. They considered how much equity the client really had in the purple and green colors. The branding is still at the top of the package, but a photograph is now the main element and the product benefit is more prominent.

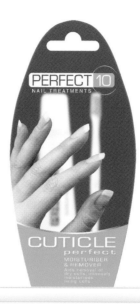

Here, the concept of beautiful nails is made more distinct through the larger photo.

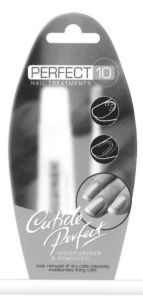

Script is introduced here to soften the package. This aspect was carried all the way through to the final design. Diagrams give the package semiscientific cues, which provide credibility to the product's claims.

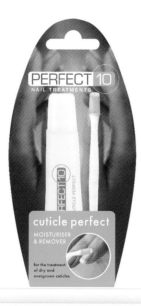

Here, two hands actually hold the product, another attempt to soften the package design.

In this trial, the colored "benefit circle" is introduced, an element that was retained on the final design. Note, too, that the brand name is now larger and run at the center of the pack, where it is at the center of attention.

A window is used as a focusing device in this design.

⊗ Here the color balance is completely rethought, and no product is showing.

⊗ Purple is back in the mix here, but much less of it.

⊗ Even less purple is used here, and the designers like the effect. This was the design that was eventually moved into the final round.

⊗ In the final comps, the designers considered how the colors of the nail products themselves worked into the mix. They scrapped the old imagery and kept the hand photos to a minimum, taking the final design down to the bare elements, the result being a clear, uncluttered package.

Mother Megs Fine Foods is a brand that nearly went under because of packaging. Its **original packaging** did not help sales. A **redesign in 1999** pushed it completely off the tracks,

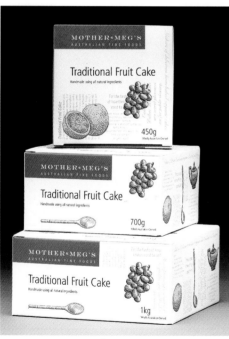

but fortunately for the small, Queensland, Australia–based business, the third try was the charm.

Founded in 1992, Mother Megs is the prototypical business-started-in-the-garage. With recipes and home-baking techniques that have been passed down through three generations, its founder turned wonderful family recipes for fruitcakes, puddings, and biscuits (cookies) into a brand that quickly gained attention for extremely high product quality.

But by the late 1990s, sales were dropping off. The company's founder also wanted to start selling her products in more cosmopolitan markets, such as Sydney and Melbourne, so she needed to quickly reinvent her brand. The product was already excellent, so she turned to her packaging for a new image.

The design firm she contracted with certainly gave her line a new look—the trouble was, it was much, much too new. The black-and-pink packaging had impact, but it didn't convey the traditional, hand-baked qualities of the Mother Megs product range. Nicki Lloyd, director with Tim Grey of Lloyd Grey Design of Brisbane, the second design firm contacted, explains.

"When she came to us, she was despondent and skeptical of design in general. Her new range had lost market share. Consumers who saw Mother Megs in specialty stores thought the packaging contained hosiery or cosmetics, not food," Lloyd says.

The situation was so bad that, after an appalling 2000 Christmas season, one major retailer told her that it would not reshelve her products unless the packaging was remade. By the time the client came to Lloyd Grey, the design team had only three weeks to perform magic: completely redesign the company's identity and packaging, and then push the packaging through printing and into the stores before Mother Megs was completely forgotten.

Lloyd's team pursued two main ideas. The first was conservative, but clever. The front of the package would show an old-fashioned, white dinner plate with a "Mm" monogram on its edge—an acronym for the brand, but also an apt comment on the contents of the package. At the center of each plate is a window that allows the consumer to see the food inside. The idea was to make the food look as if it were actually sitting on the plate.

The tablecloth behind each plate would be color-coded to help visually organize all company offerings. Lloyd says the design worked well because it looked contemporary and made the product the hero, and the monogram could easily be extended onto other elements in the identity system, such as stationery and advertising. But she also felt that perhaps the design was a bit too safe.

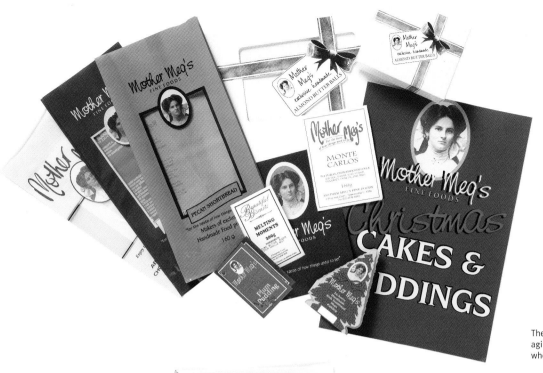

The original Mother Megs packaging, created in the early 1990s when the brand was founded.

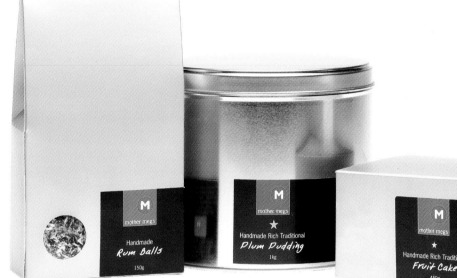

Second-generation packaging almost spelled ruin for Mother Meg's. The look was simply too modern and didn't reflect the traditional values of the brand. Sales plummeted and Mother Megs owner came to Lloyd Grey Design for help.

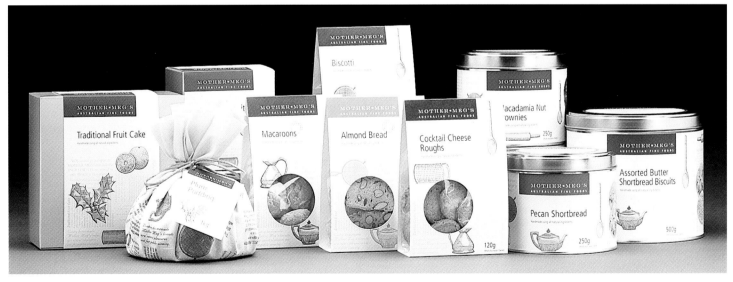

With the introduction of Mother Megs Fine Foods new packaging, redesigned by Lloyd Grey Design in 2001, sales for the company increased 113 percent.

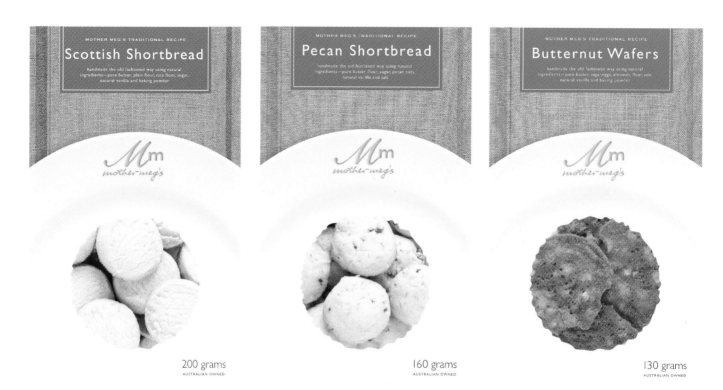

MOTHER MEG'S TRADITIONAL RECIPE

Scottish Shortbread

handmade the old fashioned way using natural ingredients—pure butter, plain flour, rice flour, sugar, natural vanilla and baking powder.

Mm
mother-meg's

200 grams
AUSTRALIAN OWNED

MOTHER MEG'S TRADITIONAL RECIPE

Pecan Shortbread

handmade the old fashioned way using natural ingredients—pure butter, flour, sugar, pecan nuts, natural vanilla and salt.

Mm
mother-meg's

160 grams
AUSTRALIAN OWNED

MOTHER MEG'S TRADITIONAL RECIPE

Butternut Wafers

handmade the old fashioned way using natural ingredients—pure butter, sugar, eggs, almonds, flour, salt, natural vanilla and baking powder.

Mm
mother-meg's

130 grams
AUSTRALIAN OWNED

◇ Lloyd Grey Design explored two options. The first used a monogrammed plate with a window at its center, allowing the product inside to show through. A tablecloth behind the plate could be color-coded to suggest flavor or variety.

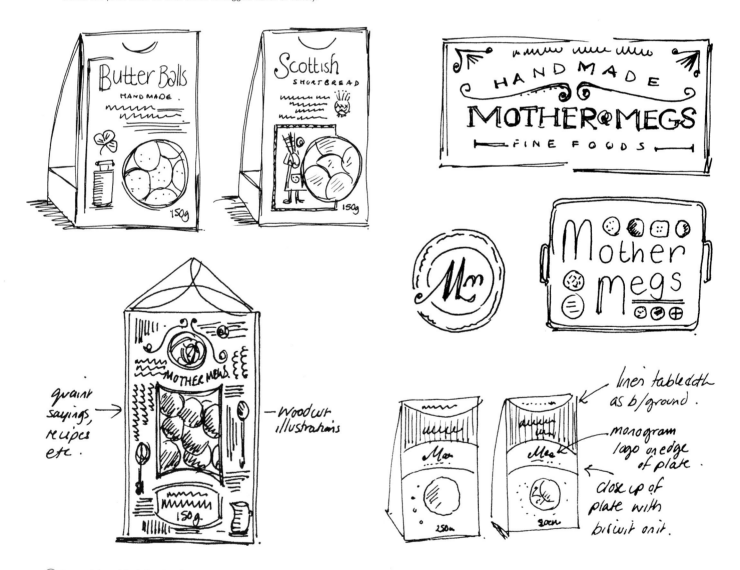

◇ Some of the original sketches that Nicki Lloyd created in her explorations for Mother Megs. The sketch at far left was taken further: Woodcut illustrations and pithy sayings from old cookbooks could be used to unify the disparate packaging in the line.

A second approach had more promise. "We researched a lot of old cooking books, which are full of quaint sayings and art. They really go back into the history of when grandmothers cooked," Lloyd says.

The designer decided to use these same sayings as well as incorporate original woodcut illustrations in the background of all packaging, an effect that would eventually tie everything in the line together.

"We set out to create packaging that contained a lot of interesting baking information and quirky statements from yesteryear. The typographic arrangement added visual interest and texture when displayed. We reproduced the actual recipe on each pack. The recipe 'secret' was preserved by positioning the diecut window through to the product over the recipe text. On packs where we didn't have a diecut window, photographs of the product were placed in strategic positions to hide a crucial part of the family recipe," Lloyd says.

A clean and contemporary color palette provided the modern touch the project needed, and a mix of modern sans serif and traditional serif type balances against each other well.

This design could also easily be extended into other elements, such as wrapping paper, stationery, hang tags, aprons, and more.

In the previous redesign, the brand name was small and ran near the bottom of the packaging, where most people couldn't read it. "We brought the product name to the top and made it bigger. We also made the hole at the center of the package larger. In the pantry pack, we left the cardboard off the sides, so people can actually see the product from the front and the side," Lloyd says.

Today, Mother Megs is again a healthy brand. The black-and-pink packaging caused a decrease in sales of 21 percent. With the introduction of the Lloyd Gray design in 2001, sales increased 113 percent in the first year. Lloyd credits this success not only to the redesign but also to the establishment of a Web site and other marketing initiatives. The designer and her client anticipate that the future will bring even greater returns as sales are expanded into the European market.

"It has been a huge success for her. It's exciting for her and for us. We feel very close to her because her business is so small," Lloyd says. The packaging provided the client with a "wow factor" and continues to open doors that would otherwise remain closed.

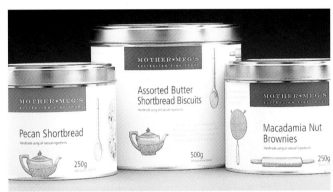

⊘ A rich color palette, combined with charming illustrations and blocks of sweet messages, produce a warm and friendly, yet polished, presentation.

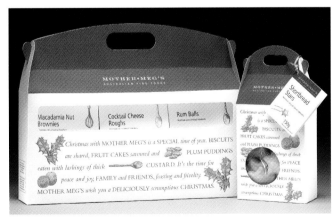

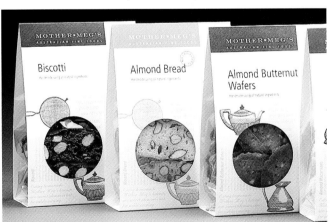

⊘ Tins, boxes, and cartons are also part of the packaging system.

⊘ Some packages are essentially sleeves that protect the bagged product inside. Consumers like this design because they can see exactly what they are buying.

When a designer **specializes in a certain category** or type of **product design,** he finds himself on a constant quest to do **something completely new and different.** But, it's tough. Realistically, **how many ways are there** to do something completely visually unique for something as ubiquitous as a CD jewel case? It's a question that **Ohio Gold Records** founder Andy Mueller has considered many times,

⬡ The success of the participatory "This is the Flow" exhibit in Holland led designer Andy Mueller to consider doing the same for the insert design of one of his favorite bands, Pinebender. Each CD was packaged with sheets of graph paper and a small pencil, plus a request to the recipient that he or she complete the unfinished work.

having designed artwork for nearly a hundred jewel-case inserts for various recording companies, including his own, Ohio Gold Records, an offshoot of his design firm, Ohio Girl.

"When you do the same thing over and over, you get trapped. Sometimes I don't know where to go next," says Mueller, who also designs snowboard and skateboard graphics. "It once got to the point where I had to completely tear apart the idea of what a CD case is and disassemble its parts."

His turning point came while he was creating an insert for a Pinebender CD. Pinebender is an independent rock band and one of Mueller's favorites—it has an "injured pop sound," he says. The recording of this CD was plain and unadorned: Composed entirely of outtakes and demos, "the glamour has been pounded out of it," he says. "It has no special production values. An unpolished, highly personal design would be the truest one."

Earlier that year, he had participated in an art show of skateboard graphics in a gallery in the Netherlands. Each artist in the show was given a specific amount of space to do with it whatever he or she wanted. Mueller came up with many different ideas, from using traditional photography to some truly offbeat concepts, including allowing show visitors to create the visuals for his area.

This last idea held real appeal for him because it seemed to be a fresh way to approach a design and art show. Mueller thought it would be interesting to see what would be created from unknown variables: What would the viewers' take on the show and on skateboard graphics in general be? He also wondered how the gallery setting, the audience's varying levels of art skills, and attendance might affect the end results of his piece.

His part of the show consisted of two skateboard decks, a two-sided hanging banner, and a double-sided easel, complete with small paper pads printed with replicas of the two skateboard graphics. On one side of the easel was a question-and-answer test that mocked an "Are you an artist?" test. On the other, he asked for the viewer to create his own board graphics on top of his designed template. Attendees were also invited to sign their names and display their works.

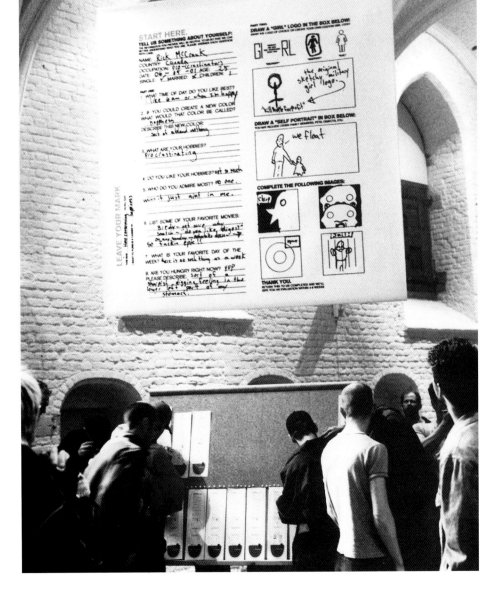

The "This is the Flow" show—that exhibited the work of the California-based snowboard company Andy Mueller designs for—encouraged visitors to take an art quiz and create their own board designs. At a work station that was part of the exhibit, patrons created their own art, which in turn became part of the exhibit. This exhibit was the inspiration for the do-it-yourself CD insert for the band Pinebender.

"Usually, when we create graphics, they are completely untouchable. The work is done. The viewer just looks at it, and that's all. So it was really fun to see what the viewer could come up with in terms of art," Mueller recalls.

This participatory concept is actually quite allied to the designer's skateboard graphics work: Riders often customize their own boards covering his designs with stickers, paint, or just plain hard use. Scratches, dents, and other abuse marks every board with personal statements of the user. To see what riders do with his designs is a full-circle, encompassing experience, he says.

With the Pinebender project, Mueller felt that a similar idea might be interesting and appropriate. The designer wanted to see if this "do-it-yourself" concept would create different results because of the different audience demographics and the nongallery setting. Mueller also thought that it would be interesting to explore the idea of audio-to-visual interpretation: How would the listener react visually to what he hears?

After a short period of sketching, Mueller zeroed in on a simple concept: He would replace the traditional CD booklet with a pad of graph paper and a small pencil. An insert was also included inside the jewel case that contained instructions the recipient should complete and submit for the cover. He would let the listener have free reign, personalizing the CD according to his or her own experience with the music.

"It plays with the same notion of inviting the consumer to modify and customize the piece. It plays with the relationship between product, consumer, and designer," he says. "Visually, this fits with what the band is all about—raw and low fidelity. Even using pencil on paper, which can get smudges and such, felt right."

So the do-it-yourself CD design was released in spring 2002, and Mueller has been pleased with its inspirational pull. More than 100 buyers of the 1,500 run have sent their designs to him from all over the world. Some are facile; some are show-offy pieces; but many are genuine pieces of art that directly address the music, his concept, or both, says Mueller. They are as random in idea and appearance as he could possibly have hoped for. But what pleases him most is that instead of him producing art for the consumer, the consumer is creating art for him.

"Some people reacted to the music, and some people were just reacting to the instructions. Some people did whatever art they wanted, and some showcased their own illustration," Mueller says of the submissions, which were still coming in at the time of this writing.

Mueller is proud of this project. He felt it was a perfect fit for the band because it allowed the listener to interpret sound on an individual level and turn the interpretation into personalized visuals—which is what audio is all about, he points out. The success of this package has allowed Mueller to start thinking in more conceptual terms: He plans on using this approach again on a variety of projects.

To see more submissions from Pinebender listeners, go to the OhioGold Records section of www.ohiogirl.com.

At the time of this writing, the CD had been in circulation for only a few months, but buyers from around the world are sending back their takes on the design. Some people react to the music, Mueller says, some to the band, some to the concept of the do-it-yourself piece, and some simply to the invitation to create art.

pinebender too good to be true

pinebender too good to be true

pinebender too good to be true

pinebender too good to be true

pinebender too good to be true

pinebender too good to be true

polaroid by rob lowe

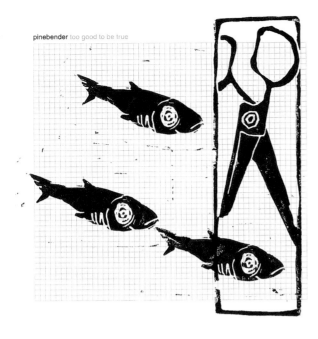

Balance. It was was at the core **of the Aqualibra redesign** project, as well as **at the center** of the work done by Blackburn's, the London design consultancy that **reworked the beverage's packaging** not once, but twice.

The current Aqualibra packaging has been redesigned twice in two years.

The original design for Aqualibra was completed in 1985, when the drink was first released onto the market. It was an adult soft drink, and so was packaged to distance it from children's fruit drinks. The brand was an enormous success, but throughout the 1990s sales declined and the brand was viewed as old-fashioned. Compounding problems was the growing popularity of bottled water as well as the introduction of competing fruit drinks to the market.

A radical redesign was needed, and Orchid Drinks, owner of the Aqualibra brand, called in Blackburn's to turn the brand around.

"Clearly, the overall look of the package needed consideration. No amount of cosmetic styling would significantly change the brand's fortunes," says the design consultancy's principal, John Blackburn. "We needed to get to the heart of what Aqualibra was and what it had to offer consumers that other drinks didn't."

Hidden away on the original packaging was an intriguing proposition: "Aqualibra helps maintain your body's natural alkaline balance." This was certainly a claim that no other drink could make. Balance was certainly a consumer benefit, and it could be expressed visually.

A logo was created that literally expressed balance: An "A" filled with fruit was set down solidly as a fulcrum, and the name "Aqualibra" was set in a strong block of color and balanced on the fulcrum's point. The logo was easily adaptable to accommodate new flavor lines, and indeed, two new flavors were added to the product mix at that time.

A beautiful, sloped, proprietary bottle was also part of the redesign.

"Our consultancy does a lot of beverages, and we feel that the container should look good enough to remain out on the dining room table. The old Aqualibra bottle was fat and stubby when the brand needed to be tall, thin, and elegant, which is what most consumers want to be. The new bottle resembles an 'A'—very subliminal," Blackburn says. The consultancy also designed 330-ml bottles for single serving, which the designers call "terribly cute."

Everyone was happy with the new design until 2002, when the soft drink giant Britvic purchased Orchid Drinks and wanted to put its mark on the Aqualibra brand. Was there another way to say balance, the new client asked?

Blackburn put a new team on the project. "We needed to find a new way to say the same thing. We could use scales, but we had already been down that path with the fulcrum and bar. Fairly quickly we came up with the idea of balancing the fruit itself," he

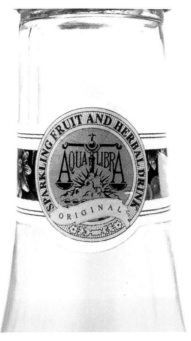

The one-time famous Aqualibra brand, originally launched in 1985, was in decline in the mid-1990s. It was seen as dated and old-fashioned.

Hidden in the neck label of the original design was the concept that drove the redesign: balance as conveyed through a scale.

The designers also explored an evolutionary development of the original design and bottle, just to see what might be salvaged. This design did not yet focus on the balance concept.

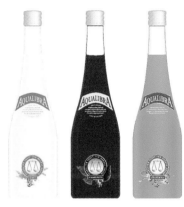

This abstract sketch was the start of explorations of the notion of balance.

As they sketched, the design team happened upon the idea of using the "A" from Aqualibra as a fruit-filled fulcrum.

Balancing the Aqualibra name in a bar on top of the fulcrum completed the picture of balance.

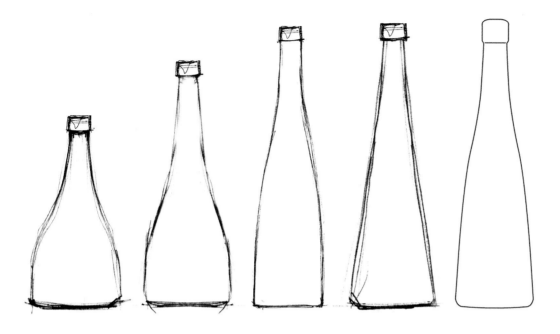

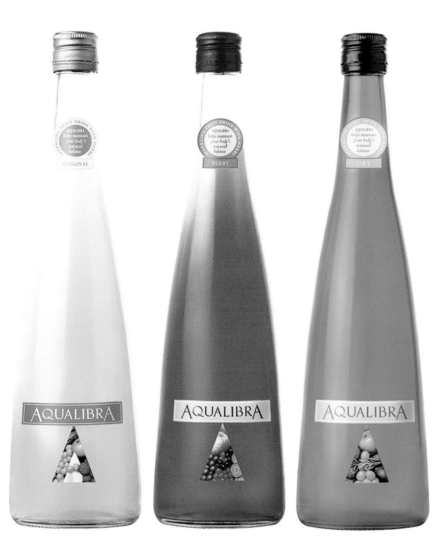

The shape of the bottle was also researched at this time. The original bottle was static and chubby—not a good match for a drink that was trying to convey health and fitness.

The taller, redesigned bottles better support the healthy, slimming theme, and the new shape also echoes the "A" of Aqualibra.

One of the most positive outcomes of the re-design was that it could be worked into synergistic advertising.

says. "We showed the client the balanced fruit, and they smiled. When people smile, you know you have them."

This second approach is more whimsical than the first redesign, especially in that the balanced fruit formed a little character. The drink is still not aimed at children, but Blackburn likes the way the design appeals to the child within.

"We don't want to be too serious. This still has a lot of sophistication to it," Blackburn says. He liked the first redesign but feels this one is even better. "It is more captivating—like balancing on a trapeze. Somehow that attracts your attention more than the balance of a scale. However, the scales did play an important part in establishing the balance idea, which allowed the second design to take the role it did."

Again, the concept is flexible enough to accommodate new flavors and container sizes. The much-admired proprietary bottle shape was maintained, so a certain amount of brand equity was carried across. Released in mid-2002, the new design is improving sales, the client reports.

Is there yet another way to say "balance"? Most probably, Blackburn says. But what is important about these designs—and any that are yet to come—is the central idea behind the art: The images and type may change, but the brand's core concept will not.

The project was a success, he concludes, because he and his team were twice able to get to the heart of the brand and find a unique, relevant way of expressing it in the simplest way possible.

All was well until the Aqualibra brand owner was bought out, and the new owners wanted yet another redesign. So Blackburn's designer started again, first by reconsidering the drink's ingredients.

They also had to find new ways to express balance. The angle of acrobats or trapeze artists balancing had a dynamic nature that the design team liked.

So they combined the two concepts. Why not balance the fruit itself? A friendly, little character emerged from the mix.

If you were designing a line of grocery retail packaging that was **expressly for kids**—in this case, **Tesco Kids**—would it be naughty or nice?

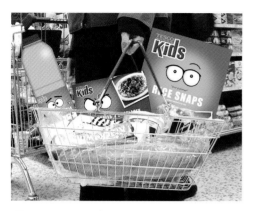

Rather than create a cartoon character that would be printed on the 200 to 300 SKUs in grocer Tesco's new Kids brand, the design consultancy Brandhouse WTS turned the packing itself into a charming, changeable character. Every SKU has a different expression and comment.

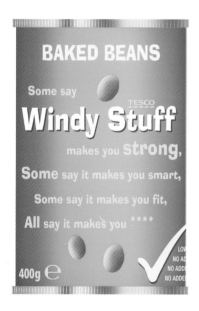

The designers considered other fun ideas for the packaging, including showing the product come to life on the label—someone sitting in a bathtub full of baked beans, for instance. Another idea was to run a short, witty poem on the front of each package (shown here). The trouble with these approaches was although some products are inherently funny, others aren't.

Would the design be more successful if it was covered with primary colors and cartoon characters, or would it have more impact if it referred to flatulence, bad breath, and other bodily disorders?

Designers at Brandhouse WTS chose the latter alternative for Tesco Kids, a new line of goods for the largest grocery retailer in the United Kingdom. With more than 150 products in the line—and the possibility of many more if the idea was a success—the design assignment could have been huge and unwieldy. Instead, designer Gary Utting found a way to make the design for the £250 million brand not only controllable but also fun.

"Tesco Kids was a new line. One of Tesco's competitor's had bought out a whole range of kids products recently and had aimed the design of the line at parents. We weren't sure that was the right way to go," says David Beard, creative director at Brandhouse WTS, a London-based consultancy. "We wanted to create an umbrella design for all of these products, and push it at mothers and kids. That was going to be difficult, because these are really opposite concerns."

For moms, the packaging design would have to speak of healthy eating for their children. But this type of design would be boring for the kids.

"Children would like something a bit more naughty and even rude," says Beard. Even more, the brand would have to feel that it belonged to the kids alone: No grownups. "If the design talked to kids through some adult voice, it would be like Bart Simpson telling them to wash behind their ears—no good," notes Utting.

The Brandhouse WTS designers explored three directions. In the first, the product contained inside the packaging was included in whimsical illustration. For instance, for a pasta label, the art might show a person climbing up long strands of spaghetti. For a can of beans, the same character might be luxuriating in a bathtub full of beans. Here, the product was hero.

In the second approach, a short, witty poem would grace the front of each package. The design team liked the approach quite a bit, but they could see themselves being painted into the corner from two directions: First, although some products were amusing—beans, for instance—others weren't quite so funny. Also, writing poems that were consistently funny for all 150-and-counting SKUs could prove to be not so amusing.

The third experiment was the preferred direction almost from the beginning. Here Utting turned the packages themselves into characters by using a different set of expressive cartoon eyes, the product name, and a cheeky remark on the front of each package. All of the "boring stuff"—the nutritional information that mothers want—is pushed to the side of the package.

trolley.
ouch!
How's my driving?

The Shelf dwellers.
Get us out of here!

eggs come from a Chickens what!

The way kids See the world.

Rotten grapes
grape juice.
Wine.

Where's the TV?

I'm full up!
Don't get carried away!

Sausages. Pigs fingers?

But fish don't have fingers!

Checkout.
See you later, Alligator.

Nectarines are Shaved Peaches?

Baked Beans Cans.
What was that! oh! Wasn't me!

Strawberry Jam, not a traffic Jam.

Toilet Paper. 4pk.
Vacant. engaged.
Vacant Store

Mind where you Put that Straw!

Tesco entrance.
kids entrance.

I'm with Stupid!

get me a Coat Ice cream.

Puppy Pet food.
Fetch!

Cereal.
Nice Pyjamas. Wakey, Wakey!

Insect Repellent.
Just Buzz off!

Fish Cake.
"funny looking Cake!"
or a Round Fish finger!

Shepherd's Pie.
Made with Real Shepherds.

Pizza.
Ciao!

Security Guard.
"Put it Back!"

Shark Bites.
ouch!

Sweet & Sour Chicken.
"No 47 please"

Bubble Bath. "Where's the Duck gone?"

Variety Packs.
eenie meanie minie
No!

Banana Milk shake. "What Monkeys drink".

Burgers! "Burger off!"

Suntan lotion. "Hello Sunshine!"

Pass me a Peg?
Cheese.

Thick Sausages 2+2 = 16. I'm a Silly Sausage.

Milk.
Cow Juice.

Brussel Sprouts. Small Cabbages.
enjoyable Shopping experience for kids.

Billy No Mates! Garlic Bread.

Toothpaste
1'2'3'4's... Hide and Seek.
Ssh! I'm Hiding from toothpaste.

⊗ The idea that really had legs—or should we say, eyes—was using pairs of expressive eyes together with a wise-guy comment to communicate what a kid might say about the product. Designer Gary Utting sketched out hundreds of thumbnails for situations as disparate as restroom doors to fish fingers.

⊘ These comps demonstrate how, within the same SKU, packages might say different things. All of the comments are slightly cheeky, and oftentimes, the packages seem to be talking to each other, even arguing, just as siblings or young friends would do.

⊘ Utting studied stock photo books, his own face, and the faces of family, friends, and coworkers for the inspiration he needed to develop a menu (more expansive than those shown here) of eyes that covered hundreds of emotions and situations.

"Many products use cartoon characters to engage children. We tried to make the character an actual part of the brand," explains Utting, who created dozens of pairs of eyes. The designer scoured stock photo books for inspiration on expressions. He even studied his own face and got himself on the apple packaging.

The designer wants every package to behave differently. Each is essentially in a different mood. Even within a single line, there might be 11 bottles arguing with each other like siblings, or a pair of boxes whispering like best friends.

"For example, the toothpaste doesn't really get along with the toothbrush, even though you might think otherwise. Or there can be big bottles looking after the small bottles, like big brothers taking care of smaller brothers," he says.

The lovely thing about this project, Utting notes, is that although designing 150 different packages seemed quite daunting at the beginning, it has turned out to be easier than he expected. By looking at the packaging by category, he can imagine all sorts of scenarios for the eyes.

About 30 to 35 related colors are used for the palette for the packaging—a broad color scheme, but one that is tied together by a gradation that emerges from the center of the front of each container. Beard says it is easy to see how the packaging works to unify products across the Tesco stores.

The eyes are making appearances elsewhere in the store, up to all kinds of wild behavior—hanging in pairs from the ceiling, looking out from the end of shopping carts and making comments about the driver, and hiding in freezer cases. The Tesco Kids brand is now being expanded to 200 to 300 SKUs, but the designers are not worried: They can see how the character would behave on everything from yo-yos to duvet covers. Essentially, he would act like a kid.

A secondary benefit to the new design is that it keeps kids entertained in the stores while moms shop. If the child does not get bored and whiny, then the parent is less likely to get angry and annoyed. Everyone is having a better experience under Tesco's roof.

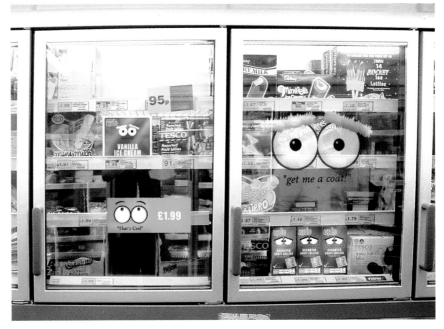

In addition to being applied to packaging, the eyes are popping up all over in the Tesco retail setting. The funny little character is even being expanded into other consumer products, such as lunch boxes, T-shirts, and toys.

In the past decade, **the category of soap** has split into two subspecies—**your standard commodity** product and your **pricey luxury item** that looks, feels, and smells wonderful, offering a personal getaway each time it is used. **Watercolours definitely falls into the latter category,** although minus the right packaging, it might not have made it there.

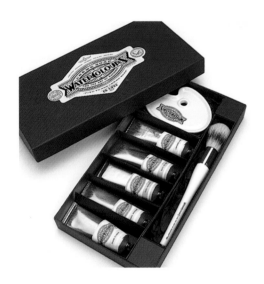

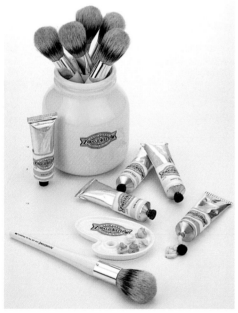

Sayles Graphic Design worked closely with client Gianna Rose to create Watercolours, a unique set of colored, scented soaps that are packaged like watercolor paints.

Watercolours is a set of five scented cream soaps, packaged in silver paint tubes, sold as a set in high-end boutiques and department stores together with a ceramic artist's palette and a paint brush. Bathers are encouraged to mix their own colors and scents for themselves or for others. It is likely to be a gift item for a child or a wedding shower gift, explains Sheree Clark, principal with John Sayles of Sayles Graphic Design, Des Moines.

"The best concepts always have a basis in reality," Clark notes. "You could package just about anything in a tube. But soap is logical and it underlines the client's original concept of paint. If this soap had been more viscous, we could have put it into a can— that may have worked, too. When you are doing something for the retail market, though, the package becomes the 'ahh!' factor, the added value that can allow the retailer to get a higher price point."

Sayles Graphic Design's client, Gianna Rose, is an ideal partner, says principal John Sayles. The owner is willing to spend plenty of time brainstorming with the designers to make her sometimes unlikely ideas—such as soap in tubes or fragrance suspended in beeswax—become a reality.

"She comes up with wild ideas and just goes with it. She just moves ahead and doesn't worry about things like focus-group testing. She has products she believes in and has faith in us. It's our job to take her ideas and improve on them or give them a new twist," he says. Too many times, Sayles points out, designers automatically view the client as the enemy, believing that his or her ideas on design aren't valid. The best designs emerge when there is mutual trust. "We can't know everything about their vision," Sayles adds.

When the client first contacted the design firm, she already had the name "Watercolours" combined with the concept of soap in her mind, but she hadn't worked out how such a product would actually be presented. She and Sayles discussed all of the ways that real watercolor paints are sold: in tins, cans, trays, and tubes. Tubes took soap to an entirely different place, and they decided to develop the idea further.

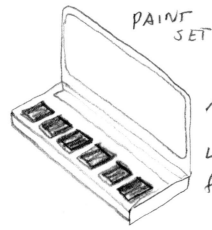

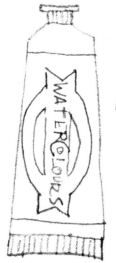

Although the client already had the name "Watercolours" and the concept of soap together in her mind when the project began, she was not sure how to package the product. John Sayles imagined all of the different ways that real watercolor paints might be packaged.

The idea of a tube was both fun and practical: The buyer would be delighted with the novelty of squeezing out and mixing her own scent and color, and the tube also protected the product in a stable container.

Other ideas that had resonance included packaging the soap with a porcelain palette for mixing and a soft brush. "In my mind, I walked up and down the aisles of the art store and considered how paints could be applied or used," Sayles says.

Although the client looked into production issues, Sayles developed the labels and box for the product. Clark notes that the design for the product could have taken many different directions considering the paint connection: kitchy with kid-like spatters of paint and a stir stick. They could have used a metal paint-roller pan to hold the products. But that pushed the design in the direction of "too casual." The product was already fun all on its own: The design of its packaging needed to be more elegant.

The client had in mind a 1940s, Art Deco feel for the labeling, Sayles says. So for the tube and box labels, he hand-rendered a mark that has a connection to the period, but with a contemporary feel. And in a product category that is typically flowery and feminine, the black 14½ x 7½-inch Watercolours box stands out in a dramatic way.

Clark says that the product and its unique packaging succeeds because, although it may have seemed like an unlikely concept at the outset, the packaging has several advantages: It makes it tidy and fun for the bather, attractive and protected for retailer display, and delightful in its overall concept.

The product is all about fun, she adds. "People aren't looking at Watercolours and asking themselves, 'Do I want Irish Spring or this?' They are essentially buying the packaging."

That being said, when a designer creates a package that is completely new and untested for a category, it is his or her responsibility to be certain that the package can deliver the client's product safely and effectively.

"You have to ask yourself the tough questions and go beyond being just a graphic designer: Will the product expand or shrink with temperature? What is its shelf life with this packaging? Can it be shoplifted too easily?" she says. "Everything has to be taken into account, not just the presentation."

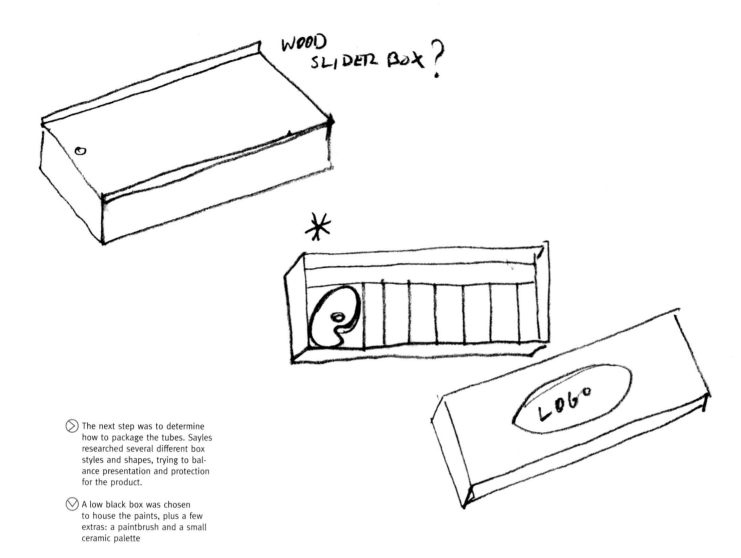

WOOD SLIDER BOX?

*

LOGO

⊘ The next step was to determine how to package the tubes. Sayles researched several different box styles and shapes, trying to balance presentation and protection for the product.

▽ A low black box was chosen to house the paints, plus a few extras: a paintbrush and a small ceramic palette

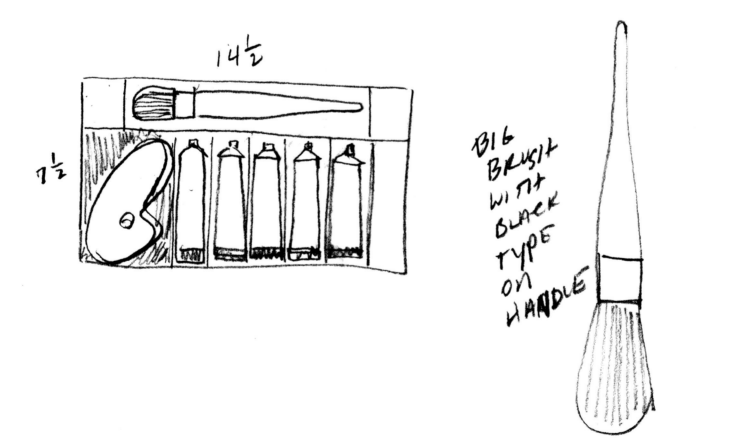

14½

7½

BIG BRUSH WITH BLACK TYPE ON HANDLE

⬠ Sayles could now begin designing a label for the box and the tubes. His client had requested an Art Deco feel for the design, but he explored other approaches that might have adapted as well.

⬠ Sayles studied and hand-rendered several different typefaces to find the right mix of the period feel and contemporary flair that the client wanted.

⬠ The final label, complete with type hand-rendered by Sayles, is very different from the flowery, fussy labels that most competitors' products use.

VALUE PRODUCTS—DESIGN THAT DELIVERS
Boots Sandwiches

The white script lettering of the Boots sign is a familiar sight throughout Great Britain: In fact, at least one retail shop can be found in every high or main street in nearly every major city. Being located in the heart of bustling business districts meant that the chemist shops served people in a hurry—on their way to work, to home, to lunch.

Over time, to better serve these busy customers, the shops began to carry more and more products besides pharmaceuticals—gift items, office supplies, food. They even offered photo developing. Although these diverse products and services were beneficial to customers and would not be withdrawn, the retailer's brand was becoming clouded. Boots made the decision to focus on the health and beauty market.

One product or service that Boots' customers had embraced was lunch. The stores offer an entire line of cold sandwiches, salads, and drinks to the consumer. Of course, local restaurants and other shops competed for this lunchtime trade, so Boots wanted to make its line of offerings stand out, not only in terms of quality and taste but also for its superior convenience.

"It was an interesting problem to address, how to make food products, namely sandwiches, work well in a pharmaceutical environment," recalls John Bateson, a director at Roundel (London). "But the design challenge involved more than just doing something that worked in that environment. We also had to give the consumer clear information—tell them that the product is fat-free or vegetarian or that it has no mayonnaise—and in a very small area on the packaging."

The existing packaging had evolved over a long period and was somewhat uncoordinated. There were three ranges of sandwiches that had been designed at different times and therefore did not tie in with each other. Research revealed that the ranges contained too much information and that consumers did not fully understand the symbols used to show the main content of the sandwich, such as the use of a blue fish to designate tuna.

Boots had completed some consumer research, which revealed that most customers were having difficulty understanding the existing system—not good for the shopper who has a limited amount of time to select a lunch and run.

Roundel designers also did their own research on-site: They studied shoppers as they came and went. What they discovered drove the entire redesign of the sandwich packaging. Some consumers would come in, clearly just want a ham and cheese or something simple, select what they wanted quickly, and go. Other buyers had a few more minutes and did not come in with a clear picture of what they wanted: They shopped a bit longer, whetting their appetites as they looked.

This design was not chosen because it did not provide enough space for product information.

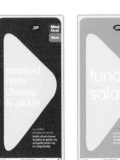

Here the graphic sandwich shapes were not big enough to hold all information that the package must carry.

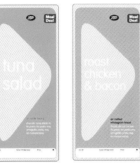

The designers liked the organic shape used here but felt it was visually confusing. It also showed the bottom of the sandwich, which might appear unattractive.

This design showed the corner of the sandwich and masked filling at its center, which was more preferable.

The designers also liked this design, but they feared that consumers may not completely understand the "enjoyment sound."

There was clearly a need to accommodate two levels of demand, but overall, the designers felt their job was to simplify the selection process for the customer. However, simplicity went further than easy-to-read type.

"This is all about honesty, clarity, and trust," Bateson says.

All sandwich-packaging designs centered on allowing shoppers to know instantly what they were looking at. Most of the trials used large type on a semitranslucent cover, which revealed the product inside.

Previously, all labels were at the top of the packaging, so the shopper had to bend down to read them. In the final design, however, all product information was moved to the bottom label and, in keeping with the "Simply" name, was kept as simple as possible. Information such as "No Mayonnaise" is presented on a separate panel so as to maintain clarity.

This simplicity also offered differentiation between the Simply line and the Special range, which appeared even more tasty and luxurious by virtue of having more ingredient information listed.

The designers realized that to make choosing a sandwich quick and easy, they needed to use color-coding. They ultimately used different colors for chicken, red meat, fish, cheese, and salad. In the Special range, they selected a photograph for each food type to help identify the differences between the ranges.

As the most luxurious sandwiches that Boots offers, those in the Special range needed to look superior. A black skillet (the plastic container the food is packaged in), combined with the photography and silver labels, made these sandwiches stand out as premium. As mentioned earlier, the more extensive list of ingredients provided on this packaging was meant to evoke a more emotional response from the customer.

Serif typefaces were specified for the Special range, to reflect the personality of such offerings as Creamy Prawn Mayonnaise, a definite step up from Tuna. In addition, more copy was used.

"We provide more description here—people are looking for something different for lunch, so reading more information makes them feel more like they are studying a menu," Bateson says.

Because these are food products, the changeover from old to new had to be instant. The new products were in the store the day after the packaging went to print. This meant that the designers had to be certain beforehand that all designs would work in-store. So mock-ups were taken into stores for testing, to ensure that the information was readable and colors stood out as the designers had intended.

The new packaging has only been in stores for a short time, and Boots reports that the redesign has had a positive effect on sales. Not only have sales increased, but some Boots staff and customers actually believe that more than the packaging has changed.

"Some people thought that the actual contents of the sandwiches had changed—that Boots was using more or different tuna, for instance. All we actually did was change the packaging," Bateson says.

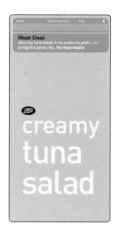

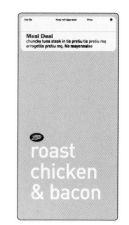

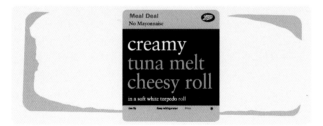

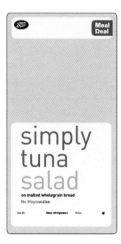

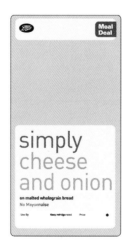

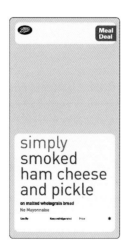

The sandwich descriptor here was deemed too small. Busy consumers needed something they could read quickly and grab and run.

The design team felt that in this design black felt "unfoody" and heavy. The other colors masked a lot of the product underneath, but they might clash with various product fillings.

This idea led to the final design. Only minor typographic and spacing tweaks were ultimately made.

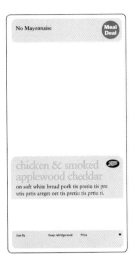

No Mayonnaise **Meal Deal**

chicken & smoked
applewood cheddar
on soft white bread pork tis pretiu tis pre
utis prtis arrget oet tis pretiu tis prtiu ti.

Use By Keep refrigerated Price

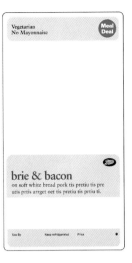

Vegetarian
No Mayonnaise **Meal Deal**

brie & bacon
on soft white bread pork tis pretiu tis pre
utis prtis arrget oet tis pretiu tis prtiu ti.

Use By Keep refrigerated Price

Vegetarian
No Mayonnaise **Meal Deal**

greek salad
on soft white bread pork tis pretiu tis pre
utis prtis arrget oet tis pretiu tis prtiu ti.

Use By Keep refrigerated Price

Meal Deal No Mayonnaise
Vegetarian

cheese
ploughmans
on soft white bread
pork tis pretiu tis pre
utis prtis arrget oet
tis pretiu tis prtiu ti.

Use By Keep refrigerated Price

No Mayonnaise
Vegetarian **Meal Deal**

green salad
on soft white bread pork tis pretiu tis pre
utis prtis arrget oet tis pretiu tis prtiu ti.

Use By Keep refrigerated Price

No Mayonnaise
Vegetarian **New** **Meal Deal**

green salad
on soft white bread pork tis pretiu tis pre
utis prtis arrget oet tis pretiu tis prtiu ti.

Use By Keep refrigerated Price

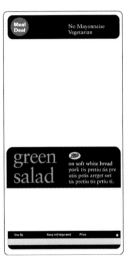

Meal Deal No Mayonnaise
Vegetarian

green
salad
on soft white bread
pork tis pretiu tis pre
utis prtis arrget oet
tis pretiu tis prtiu ti.

Use By Keep refrigerated Price

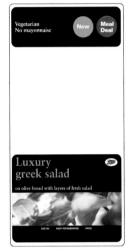

Vegetarian
No mayonnaise **New** **Meal Deal**

Luxury
greek salad
on olive bread with layers of fresh salad

USE BY KEEP REFRIGERATED PRICE

⊘ These designs experimented
with type size, weight, and
color. Here, the designers
were also beginning to con-
sider using photography.

⊘ The final design of the Simply
line.

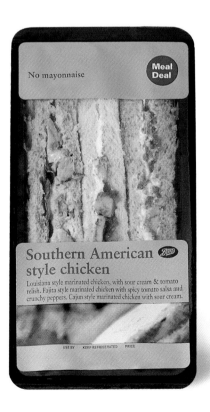

No mayonnaise **Meal Deal**

Southern American **Boots**
style chicken
Louisiana style marinated chicken, with sour cream & tomato
relish. Fajita style marinated chicken with spicy tomato salsa and
crunchy peppers. Cajun style marinated chicken with sour cream.

USE BY KEEP REFRIGERATED PRICE

Meal Deal

Simply
cheddar cheese & coleslaw
tuna, mayonnaise
& cucumber
egg mayonnaise

USE BY KEEP REFRIGERATED PRICE

Jim Lienhart says he **enjoyed his recent work** for Archibald Candy, makers of **Fanny Farmer** products, and he's definitely **satisfied with the finished results.** There was only one unpleasant outcome of his work for the **candy manufacturer: "I gained about 12 pounds** on this project," he admits.

Two projects for two subbrands of Jim Lienhart Design's client, Archibald, Inc., required different approaches: The candy product was destined for mass-market shelves, whereas the coffee would be sold only in small proprietary stores.

It would be hard not to imbibe when you have box after box of some of this country's most well-known candies, including Pixies, Meltaways, and Trinidads, all made by one of Archibald's brands, Fanny Farmer. Top that off with a new line of candy-flavored coffees, these produced by sister brand, Fannie May, and you have a temptation-laced project.

Archibald had asked Lienhart Design to handle two separate and unrelated projects, but Lienhart and senior designer Allison Fabing came up with two solutions that were coincidentally visually related—but both solutions were arrived at for different reasons.

The first project was a candy box design for Fanny Farmer. The client wanted a seasonal candy package that could be used for both Christmas and Valentine's Day. The box would be sold through larger retail stores such as Target, and it needed to have the feeling of real quality. There is no danger for this category, Lienhart says, of making a package look too rich or expensive: These candies are usually given as gifts, and the givers want their present to look pricey.

"It also insinuates that this is a good product, which it is," he says. "We definitely wanted a high-quality look to separate it from the cheap stuff."

And there is plenty of competition. The design team took on the envious task of buying every type of chocolates they could find—from budget to gourmet brands—and studying the design of the packaging. Each competitive brand had a recognizable image, such as Ghiradelli, Russell Stover, and Lindt, but their packages focused more on individual flavors than on specific gift-giving seasons.

In previous years, the Fanny Farmer packaging had been basically dark red and deep green, and it looked much more like a Christmas gift than a Valentine's Day gift.

To even out the balance between the two holidays, Lienhart was looking ahead to possible future applications: He wanted to develop a look or pattern that could be used on other Fanny Farmer products.

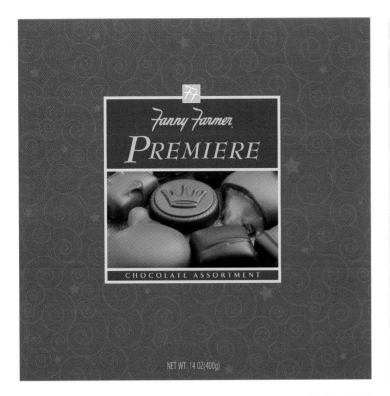

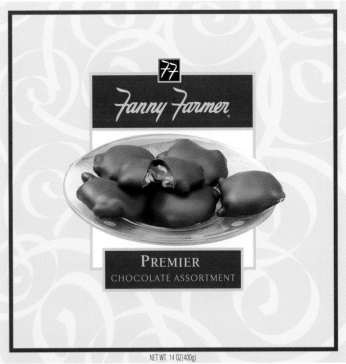

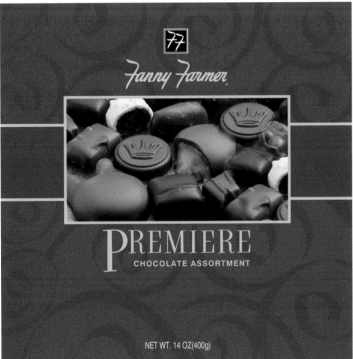

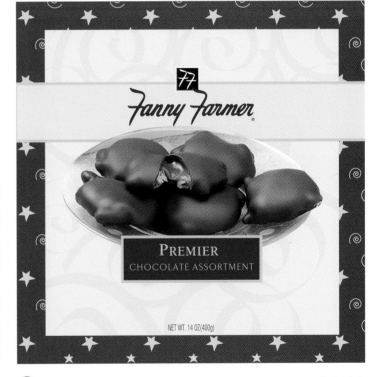

⌃ Above: Challenged with creating a gift package that could be sold for two gift-giving holidays, Christmas and Valentine's Day, the Lienhart design team explored patterning that could be used on this project as well as future ones. Swirls had energy, and they were generic enough to span the holidays.

⌃ Below: The swirls were relaxed here, and a band was added below the photo.

⌃ Above: The designers also explored a much lighter approach, but eventually decided that dark, rich colors made for a more lavish-looking package.

⌃ Below: This design combines aspects of several of the earlier designs. In the end, an all-red approach won out.

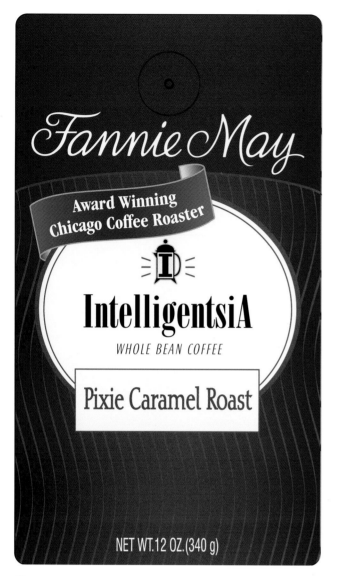

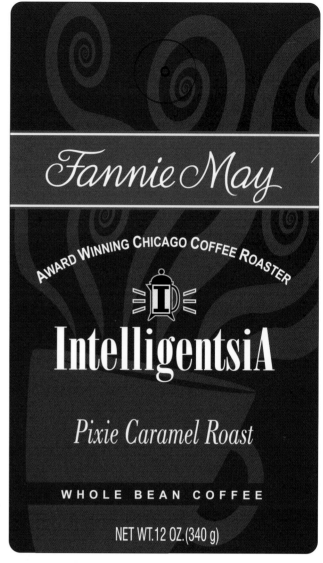

For the Fannie May coffee packaging, the designers were trying to combine and prioritize many different elements: the core brand name; the name of the cobrand, the fact that the product is a coffee, the fact that the coffee is award winning, and the fact that the coffee has the flavor of a popular Fannie May candy. But trying to incorporate all of this information proved confusing to the consumer: Is this a coffee? A candy? What is IntelligenstiA?

He and Fabing started experimenting with different patterns. They quickly happened on swirls: "It has energy, and it has the feel of holiday gift wrap, no matter what the holiday is," Lienhart explains. As the designers made the swirls larger, the pattern felt more casual, which was appropriate for this project. Tiny swirls almost made the packaging too formal, like a Godiva chocolate.

With chocolate candies of this sort, a photo of the product is usually a necessity. "You might get away without a photo for Truffles, say, but when the product is a Chocolate Mint Sparkle Meltaway, consumers may not know what that is. We will even cut a candy open in the photo to give more information," the designer says.

On the final packaging, the swirls are foil stamped and embossed, and the core brand name is foil stamped; both effects add depth and dramatic punch. The power of the all-red box with

the reflective, embossed swirls was dramatic on the shelf, offering an elegant, yet spectacular look.

The second Archibald project, this time a new coffee line for Fannie May, had a different set of objectives. The brand wanted to start marketing a private label coffee in its stores. The all-white base line packages may be perceived as not visually exciting, Lienhart says, but it is a brand identity that is well established: Consumers recognize the candy boxes immediately.

However, the client did not want the new coffee brand to be all-white. The new beverages, which were cobranded by the coffee company IntelligenstsiA, would have candy flavors borrowed from Fannie May's most famous lines—Trinidads, Mint Meltaways, and Pixies. Besides this information, the Fannie May name would have to appear on the final packaging.

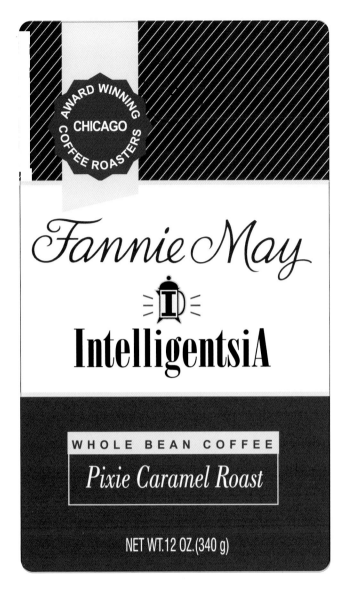

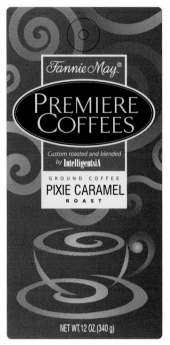

In a second round of trials, the IntelligentsiA information was moved to the side of the package, to make more room for the other information (left). This design was the one that was eventually chosen. But in a last minute try, the designers attempted, at the client's request, to bring IntelligentsiA back, plus add the word "Premiere." A quick comparison between the two designs makes it clear which is more successful.

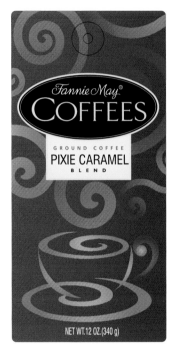

Although the Lienhart design team's trials experimented with giving each bit of information different weight, it soon became evident that what was not being communicated was that this coffee was specially flavored. "The concept just wasn't settling well into the minds of consumers," Lienhart recalls.

The next set of trials made the concept of coffee much more prominent. Swirls, representing rich aromas, were added to the background, as was a coffee cup, built from swirls and strokes. On a few comps, the designers made one last attempt to work IntelligenstiA on the front panel and even the word "Premiere," but these also moved away from a clear statement.

"The word 'Premiere' really was another cobrand, so we thought, why do it? With the Fannie May name and the well-known candy flavors, there is an automatic connection with quality," Lienhart

says. In the end, the IntelligenstiA cobrand information was moved to the side of the pack.

"The finished graphics were printed on foil, with the aroma lines wrapping around the package," he adds. The packaging is more high quality than flashy: It isn't positioned against any competition in the Fannie May stores.

The clear concept of Fannie May producing coffee in its top-selling candy flavors made it easy for the consumer to understand. The power of a rich, solid color with "aroma swirls," Lienhart says, also made this solution stand out to establish a strong brand identity.

Pol Roger is known as the **wine writers' champagne.** Wine **aficionados regard it highly,** and it has a glamorous, romantic history that **appeals even to those who know very little about fine wines.**

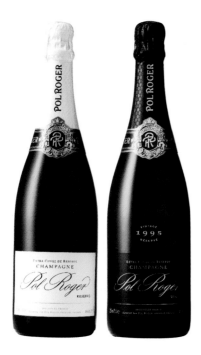

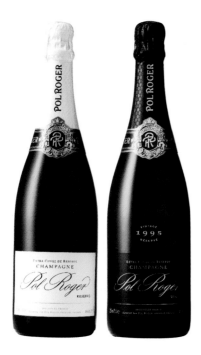 Pol Roger is a premier champagne, but its brand image had not stayed as relevant as it should have over the years. Lewis Moberly redesigned the product packaging so that it reflected the brand's history yet allowed Pol Roger to move forward.

Odette Pol Roger was a famous beauty who enchanted Winston Churchill, who drank only Pol Roger. As a result, his name is given to one of the family's most celebrated wines—Cuvée Winston Churchill. Odette was a regular guest at the British Embassy. This was a glamorous period in history, and the design of the Pol Roger brand is reminiscent of elegant formal invitations of the time, with their fine handwriting and sensual lines.

But the wine's packaging was no longer a good match for this top-of-the-line brand image and quality. The White Foil variety illustrates the challenges the brand faced. As Pol Roger's benchmark wine, White Foil is the soul of the company's five-wine portfolio, explains Mary Lewis, principal of Lewis Moberly, an accomplished design consultancy based in London and the firm challenged with realigning the brand image with its packaging and identity.

White Foil's white capsule or top neck foil is distinctive in the variety's sector. Its packaging design, as well as that of the other varieties—Chardonnay, Rosé, Vintage, and Demi Sec—had become disparate over time through inconsistent use of the house marque, different logo styles, and confused range organization.

"Brands with a heritage must be altered with care, but equally they must move forward, remaining salient with contemporary consumers and their changing appreciation of luxury," Lewis explains. "The balance of tradition and modernity is important. The Pol Roger archives were an excellent starting point to understand the brand spirit."

In the client's archives, Lewis Moberly designers found early labels that revealed sensuous, refined script, reminiscent of formal invitations. These would be an enormous help in redesigning the brand marque and script.

Today, the brand's owner describes the brand as "vivacious, pleasurable, and exciting." With knowledge of the past and the present in hand, Mary Lewis and her team could begin the redesign. They started with the house marque, which had been represented in four different ways. A single marque needed to be reestablished.

Inspired by the archive images, which are rich in detail, the team created a molded, elaborate marque that projected the Pol Roger deep blue house color, the brand name in entwined initials, the company's year of founding, and majestic lions.

The next element to examine was the brand name script. "It was important to retain the signature branding of Pol Roger, which is both distinctive and personal," Lewis explains. "In the context of global abstraction, these attributes are to be valued."

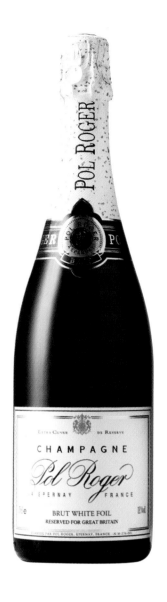

Left: The original White Foil package design.

Center: The Lewis Moberly design team found beautiful samples of Pol Roger labels from the past in the company's archives. The script in particular inspired the designers.

Above: The old house marques were rather generic and said nothing about the elegant history of the Pol Roger brand.

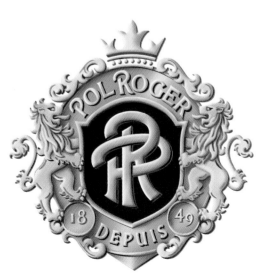

Left: A pencil sketch of the new marque showed the detail and richness that bespoke the Pol Roger brand.

Right: The new marque included the brand's deep blue house color, the company's initials, the year of the company's founding, and lions. Each element spoke of the brand's genteel heritage.

POL ROGER

ORIGINAL SCRIPT

MORE HARMONIOUS

MORE EXTENDED

FINAL SCRIPT

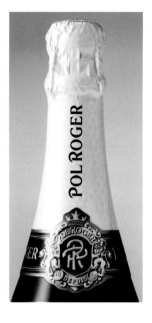

⊗ The marque lettering and the product name typography matched well: classic, yet modern.

⊘ Far right: The designers explored a number of different scripts for the main label.

⊘ Right: A detail of the new White Foil neck dressing and of the new Reserve label.

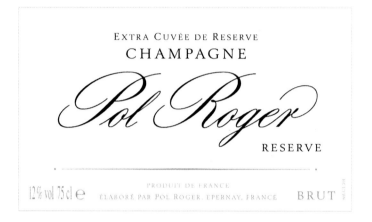

EXTRA CUVÉE DE RESERVE

CHAMPAGNE

Pol Roger

RESERVE

12% vol 75 cl e PRODUIT DE FRANCE BRUT
ÉLABORÉ PAR POL ROGER. EPERNAY, FRANCE

The designers explored several handcrafted scripts, some extended, some traditional, some more modern. They decided on a style that was eminently legible, elegant, and simple.

With these basic design elements determined, Lewis Moberly could begin the White Foil redesign. The designers began by removing the gold speckles from the packaging—a common design element among sparkling wines—and replaced them with a repeat pattern of the "PR" initials. This distinctive, ownable brand detailing on the neck foil was handled in a subtle way, by printing pure white on an oyster metallic foil: The effect is simple, yet sophisticated with the new and particular Pol Roger logo in place.

"The capsule bottle label echoes 'the party,' the vivacious, exuberant part of the design. The new body label is the 'invitation' to the party," Lewis says.

The project team decided to rename the product "Reserve," because White Foil was really an affectionate trade name used only in the United Kingdom. Furthermore, because the brand was international, "Reserve" would travel better. The reinforced name takes center stage on the new main label, surrounded by restrained, formally positioned type. The label itself is also smaller, and therefore, more precious, Lewis says.

From here, the designers moved on to the Vintage line, described as the "heart of the brand," which originally was too similar in appearance to the old White Foil line. A more revolutionary approach was needed.

Using the same basic design structure they had implemented on the new Reserve line, the designers moved the Vintage design to a gold and black palette, which immediately distinguished it. The

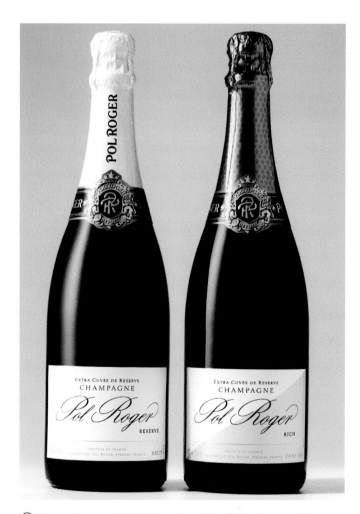

⊗ The new Reserve and Rich designs. Clear differentiation is now made between the two varieties, and each now has its specific flavor attributes communicated through subtle visual cues.

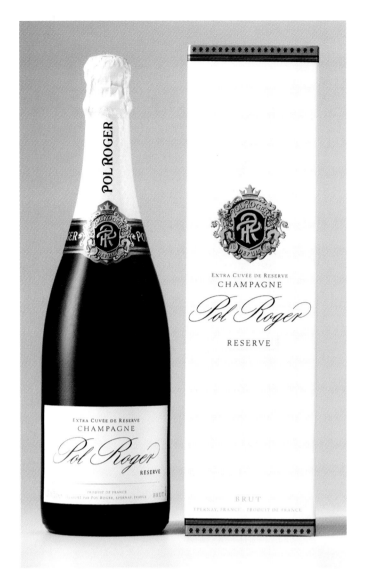
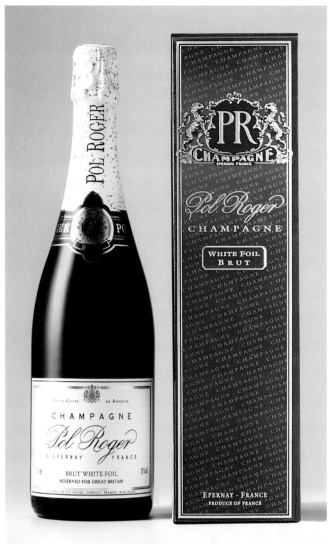

The product's boxes also needed to be addressed. A comparison of new (left) and old (right) designs shows a clear upgrade in elegance. Although the brand identity was also heightened, the design remained classic and simple.

neck foil retained the subtle detailing of the repeat PR branding, but in black, through a tactile surface change of a mix of gloss and matte inks.

The original design for the Chardonnay—the brand's "spirit"—and Rosé—its "body"—lines was too shiny and overstated. The Chardonnay labeling was gold and the Rosé labeling metallic dark pink. The color choices communicated the correct values for the champagnes, Lewis explains, but they needed to be tempered in both hue and finish to fit in with the more sophisticated brand image.

So the Chardonnay went back to a pale satin gold finish, and Rosé adopted a pale satin, desaturated pink. These refined colors involved several print trials before they were mastered, Lewis reports. Again, the PR initials repeat was used on the capsule foils.

The final member of the portfolio, Demi Sec, suffered from a lack of differentiation from the old White Foil line: It is richer than Reserve, but closely related. This product needed both connection to

and differentiation from the Reserve, so the project team renamed the product "Rich." In addition, placing a metallic, deep oyster diagonal in the label as well as using a dark gold capsule foil communicated a more intense image for the new Rich variety.

Mary Lewis is pleased with the completed design. "Our focus was to ensure that the new design reflected Pol Roger as the pinnacle of champagne—you taste what you see. Visual expectation now met product quality head on. This contemporary, elegant design is rooted in the rich history of the brand. This brand is talking the same language across the portfolio, exuding the brand's personality," she says.

Lewis takes two lessons away from the project, lessons that she has witnessed and learned from in many other projects. First, she says, to successfully move a brand forward, a designer must first completely understand its past. Second, as many designers know, it is best to have a direct line of contact with the brand owners and the people who make the decisions. Both factors were in place for Pol Roger.

There was no question that, when client Sun-Rype presented its new **Fruit & Veggie Bar** to karacters design group, based in Vancouver, B.C., for a packaging design, the new snack was a little off-putting. **What exactly is a fruit and vegetable bar?**

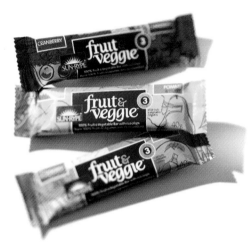

An unlikely product—a healthy snack bar made from dried fruits and vegetables—required an intelligent packaging solution by karacters design group. The rotogravure-printed foil packages looked like small art prints, and their bright colors and illustration style heightened the taste appeal.

What do dried vegetables actually taste like?

In truth, says Matthew Clark, associate creative director at karacters, the product tastes wonderful and has since proved to be one of Sun-Rype's most valuable product launches. Although the individually wrapped bars have no veggie flavor at all, they deliver two government-sanctioned servings of fruit and one serving of vegetables in each bar. But getting these benefits past the wrinkled noses of most consumers was a challenge in the beginning.

The karacters design team began by suggesting alternative names to the client. "We were convinced at the start that including the word 'vegetable' would be a mistake. We suggested things like 'Basics,' even 'Vega,' but these were all rejected in focus groups, whose participants made it clear they did not want to be snowed," Clark says. "They said, 'Just call it a fruit and vegetable bar.' We did end up changing to 'veggie,' just to make it more colloquial and approachable."

The focus groups also liked the concept of the bar, a healthy, convenient way to get those hard-to-manage vegetables into their diets. And when they tasted the actual product, they were sold.

Even with this clear vote of acceptance, the designers felt that showing photos of vegetables on the packaging would scare off buyers. Illustration would be a more palatable presentation for parsnips and peas. The designers also knew that the new package design had to be aligned with the client's popular, preexisting juice lines, which are marketed as being mainly for kids and families. But this new product was definitely targeted to adults, not children.

"The packaging had to be distinctly Sun-Rype, but instinctually adult," Clark says. "It had to stand for the principles of the established brand—wholesome, family, taste, and purity."

Another consideration was the printing process that would be used to produce the packaging. Rotogravure printing on foil has its own eccentricities and limitations. It can handle good detail—much more so than flexography—but it is much less able than lithography to print accurate four-color process photography. And the registration on a rotogravure press can be a bit loose, so it lends itself to a design in which colors overprint each other.

The first round of designs studied the actual style of the label. One design spoke of simple, cleaner life of wholesome goodness. It was hand lettered and slightly naïve, but it was a bit too "hippie" to align well with the Sun-Rype brand. Another design was quite a bit more sophisticated and fashionable; it addressed the

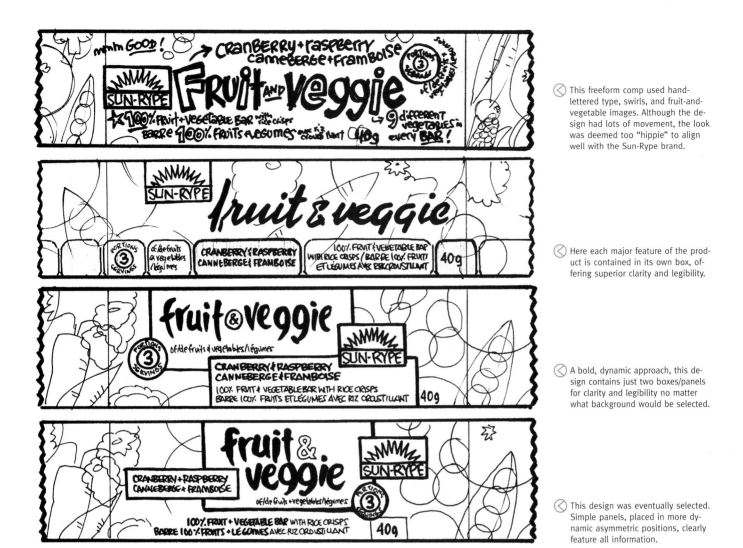

This freeform comp used hand-lettered type, swirls, and fruit-and-vegetable images. Although the design had lots of movement, the look was deemed too "hippie" to align well with the Sun-Rype brand.

Here each major feature of the product is contained in its own box, offering superior clarity and legibility.

A bold, dynamic approach, this design contains just two boxes/panels for clarity and legibility no matter what background would be selected.

This design was eventually selected. Simple panels, placed in more dynamic asymmetric positions, clearly feature all information.

premium nature of the ingredients. But this went too far into the direction of affectation, again, not a good match to the brand.

A third style fell into the middle ground. It was dynamic and bold, stated the product information clearly, left plenty of open space for enticing illustrations to show through, and was asymmetrical enough to provide visual interest. This design was the one that was eventually selected for the final design.

Next, the designers searched for an appropriate illustration style. The right art would be crucial in communicating the flavor, quality, and progressiveness of the product. Anything too modern would not have the friendliness of the Sun-Rype brand, whereas anything old-fashioned might send the message that "This is good for you, which is not necessarily a product attribute that consumers flock to," Clark explains.

One illustration style, for example, used a wallpaper display effect to show different fruits and vegetables. The client deemed it too old-fashioned, although its bright, hot colors were preferred. Some of the more modern styles they experimented with did not feel personal enough. A mix between the two styles might work, they thought, and so illustrator Adam Rogers was called in for the final illustrations.

"Adam is an illustrator who doesn't normally do line art. He is an illustrator who works in two distinct styles: One is a graphic, textural painting style, and another on the computer that has a chic, 'wallpaper' look. We challenged him to take his painterly style,

apply this aesthetic to a more gestural line art, and then bring it onto the computer to clean up the lines," Clark explains.

The resulting illustrations are sensual, with a slightly nostalgic feel, as if they came from the 1960s. But with their fresh colors and minimal line style, they feel very much like modern art prints.

Clark blocked in the background colors on several trial designs to simulate the three main color schemes: green for apple-pear, red for cranberry-raspberry, and orange for blueberry citrus. "I was trying to figure out a priority of information here," the designer says.

Sun-Rype has historically used its trademark blue as the main background on all packaging, but a recent redesign to the entire juice line allowed Sun-Rype to see that its blue could be used as a panel over a background of fruit. For the new bar's design, blue panels float over the illustrated background. The information was organized to highlight the product name, the Sun-Rype brand, the flavors, and then the details such as the three-servings-a-day icon. The flavor name emphasizes the "fruit" in "Fruit & Veggie," and the center panel is flanked by the two fruits, because this is the predominant taste, but vegetable illustrations make up the majority of the background pattern.

The project was a success, Matthew Clark says, because it stayed true to the brand equity in an intelligent manner by expanding on what the brand is, rather than just copying the core juice line packaging. It has the proper aesthetic and used the correct printing processes to achieve it. The information hierarchy is clear.

⬡ The karacters design team experimented with many different illustration styles, including this traditional wallpaper style. This style tied into references of heritage and goodness but was not used because it had an old-fashioned feel to it.

⬡ Although this illustration trial was simple and stylized, the ingredients were still recognizable.

⬡ The illustration and color blocking explorations were continued, but here the blue core brand panel was introduced.

⬡ Here the idea of overlapping transparent colors began to emerge. This more abstract approach would have relied more heavily on the printed information on the label's front panels.

⬡ The idea of stylized fruit and vegetables was joined here with intersecting shapes. Both ideas were carried through to the final design.

⌃ The final illustration selection was combined with color blocking.

⌄ These fresh illustrations with their minimal line style were chosen as the final art for all packages.

⌄ The designers first placed the color blocks in the final comps without illustrations complicating the effect.

⌃ Color drawdowns for the final palettes show the effect of transparent ink colors.

VALUE PRODUCTS—DESIGN THAT DELIVERS
CVS Pharmacy

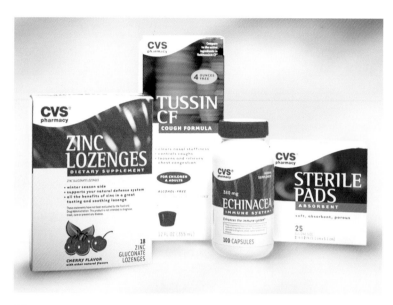

⊘ MLR Design devised a way for CVS Pharmacy "house" products to stand out on the shelves, even when set against better publicized national brands.

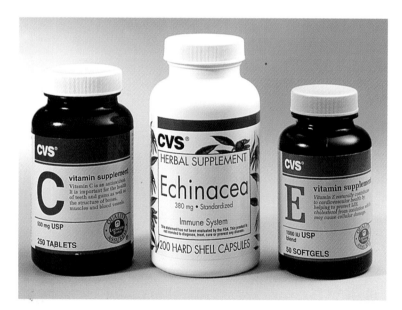

⊘ The original CVS Pharmacy branding was a melange of different styles: Different categories of products were borrowing different color and design cues from national brands. In sub-categories, such as those found in the vitamin line, the styles diverged even further.

By definition, a pharmacy is a place where medicines are dispensed. Medicine, by definition, is something that is used to treat illness. So a pharmacy's express purpose is to help sick people, right?

Up until recently, that defined the retail category fairly well—that is, until CVS Pharmacy, a private label brand, decided that not only was this picture negative it also did not define its company philosophy. Progressive management at CVS made the commitment to completely transform the packaging design of its over-the-counter offerings so that they delivered a different message: CVS products should promote "health," not "sickness."

This change in perspective might seem like so much window dressing until one learns that CVS's target customer base is 25- to 45-year-old women—a young, health-conscious demographic. The company's primary customer focused on health, so it must do the same.

"CVS, as a point of differentiation, has made a commitment to really pay attention to women," says Christy Russell, director of business development for MLR Design (Chicago), the design firm that was invited to tackle the unbelievable task of redesigning 750 SKUs in 12 product segments, almost all of which presented the additional challenge of having brand-name equivalents that enjoyed better package or name recognition.

MLR creative director Amy Shannon led a team that began the project by conducting an extensive retail audit of what competitors, such as Eckert's and Walgreen's, were offering in the over-the-counter category. Their findings basically confirmed their suspicions: No one was doing anything particularly special, especially when it came to addressing women. Most packaging, in categories ranging from vitamins to cold treatments to feminine products, had a clinical, medicinal look.

The reason no one had attempted to revamp the trade dress for such extensive lines of goods as CVS and its competitors offer is perhaps understandable: Any new look had to work not only for a general product category but also for a category's subsets. For example, in the vitamin category, CVS offered herbal, natural, and synthetic varieties.

"From a 'shopability' standpoint, this was a very involved system," Russell says.

CVS's original system lacked consistency, even within subcategories. Color cues were often borrowed from the competing national brand, a common practice among smaller, private brands with advertising budgets that could never compete with leading brands. So CVS's brand stance, even though it was inconsistent, was wholly appropriate for positioning in the current retail environment.

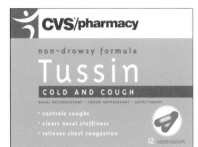

This stage-one concept, created by MLR Design creative director Amy Shannon, introduces a wave, which cradles and highlights the CVS brand mark, while providing a home for the product name. With some fine-tuning, this is the idea that eventually emerges as the winning design.

A "health and wellness" icon was created as a unifying element for this set of experiments. This design is far more graphic than the others and places the brand name in a strict bar at the top of the label each time.

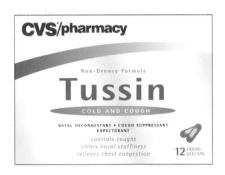

Here the designers chose to use color as a unifying device. The silver color in this contemporary proposal would be recognizable throughout the store.

This design is similar to the previous one, but it uses photo backgrounds as visual ties between the many product SKUs. The designers felt this was a positive approach, but focus groups studying it felt that it looked like an X-ray—a far more medicinal attitude than the designers wanted to inspire.

With this set of comps, the designers were trying to strike a balance between clinical and lively. Whether or not to show the product on the package design was determined (indirectly, that is) by the national competing brand: If it did, the CVS brand would also show the product so that consumers could compare apples to apples, so to speak.

This selection of products, all of which would be found together on the CVS Pharmacy shelf, shows how the CVS products stand out in their visual unity.

CVS's research with consumers revealed that the existing design system was not conveying the quality of national brands. To send an equal-to-national-brand-quality message and to design some visual distinction for their client, MLR would have to create a new look that completely departed from the norm established by private label marketers. It could not borrow design element cues and mimic national brands. It had to be a distinctively CVS trade dress system. For a pharmacy brand, it really was revolutionary thinking.

"This was unnerving for CVS," Russell explains. "The leaders in this category weren't doing this—why should they try it? It was a real shift in thinking to stop doing what the competition was doing."

Design experimentation went in a number of different directions. One trial suggested a label that had an almost entirely silver background: a single color unified the entire system. This was a modern look, very different from many of the other, rather staid brands on the shelf.

Another set of comps worked hard to balance clinical and lively sensibilities. For these, more color was used. In yet another group of trials, the designers created a health and wellness icon, a lively, leaping, abstract character who could serve as a sort of mascot to unify all of the packaging.

But the very first set of trials the design team created actually formed the impetus for the final solution. A gradual wave emerged from the left side of the label and crested near the top right. The wave was a practical solution as well as an attractive and recognizable one: The CVS Pharmacy brand name could sit in the lap of the wave, so to speak.

"The final design system works well for a number of reasons," Russell says. First, it has a strong shelf presence: The soft, feminine curve of the wave rang true with CVS's target audience. The wave also made it easy for the client and the designers to manage the brand name no matter what shape of container it appeared on. In addition, the design team specified royalty-free photography for inside the curve area to keep costs down.

Russell points out the advantages of the typography in the new system. "The type really balances clinical with health and wellness. It's organized, clean, and effective, but with more style. And from a tactical standpoint, it is very flexible," she says.

"Taking a leadership role in a retail category and doing something really innovative like CVS has is tough," Russell points out. The momentum has to start at the top of the organization.

"The SVP of marketing endorsed the overall direction and the effort was spearheaded by Maurice McCord, director of marketing," she says, adding that from start to finish of the enormous job, only 12 months elapsed. There was no time to battle resistance or hurdle obstacles. All new packaging was rolled out in late 2002. "We know the new system has already had an impact on their sales. The whole goal of transforming the CVS over-the-counter category from being about sickness to being about radiant health was successful."

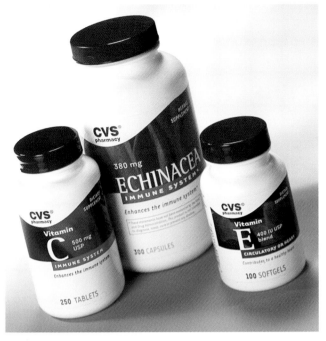

Compare this shot to the visual of the original vitamin packaging. The transformation from three disparate and uncoordinated products to a successful team of products is remarkable. Note, too, how the original designs (on page 200, bottom) feel medicinal, whereas the new designs have an uplifted, aspirational sense.

When business is good, as it was with **Koppers,** clients tend not to pay attention to such onerous issues as **rethinking packaging:** If things aren't broke, **why put yourself through the agony?**

Koppers Chocolates wanted to expand its customer base, but needed a new packaging system to increase its shelf appeal. Its previous system used clear boxes and bags—the product was clearly visible, but the packaging did nothing to reinforce the brand. Designer Nicky Lindeman devised a flexible, eye-catching suite of packages that captured immediate acclaim.

But a new manager of family-owned Koppers, the oldest candy maker on New York's Hudson River, had bigger ideas for the company that she just inherited. Business was good, but it could be better, she felt. Koppers, which specializes in chocolate-coating nuts, fruits, candies, and other items—in fact, it will coat just about anything customers bring in, including roses—is also well known for its kosher candies. The confectioner sells its goods to a mostly adult audience in quality retail settings such as Sak's and in smaller specialty shops.

Kopper's original packaging program hadn't been addressed in many years. For the most part, it consisted of clear bags and boxes. Because candy is commonly given as a gift, and because of the confectioner's largely adult audience, this generic approach was missing the mark. In addition, Koppers wanted to expand its business beyond its regular buyers.

"You just don't give an adult a plastic bag of candy as a gift," notes Mirko Ilić, of Mirko Ilić Corp., whose spouse, Nicky Lindeman, undertook the Kopper's redesign project.

One of the first things Lindeman examined was the client's logo, which was extremely narrow and used a candy-colored palette of pink, purple, yellow, and green. She convinced the client to consider a more open design, one that clearly stated the company name but with less color, and graciously left space for the candy name or variety.

The client was committed to a metal container for her goods, but because she still wanted shoppers to be able to see her candies, she selected a container with a clear window in its lid. However, because the containers are normally stacked on store shelves, most of the windows would be covered up.

So Lindeman began searching for an additional way to convey the canisters' contents. "Koppers has many different kinds of chocolates, so this needed to be a design that worked on anything. That's when I thought of the wallpaper background. I could use patterns of fruits, coffee beans, or whatever was inside," she explains. Some of the same colors used in the company's original identity were still used, but were toned back.

There were two other challenges to be faced: The client had asked for a great deal of copy to be included on the new packaging—too much, in fact, for the new design to accommodate. Another hurdle was overcoming advice that had been given to the client by a previous vendor. For example, the printer for the original packaging had advised Kopper's that nothing could be printed under the UPC code.

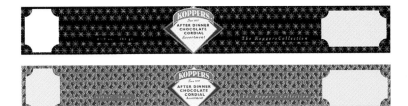

An early wallpaper design for the chocolate cordial assortment used star bursts, but the client requested that the pattern be changed to bottles.

The original Kopper's logo was tall and narrow. Lindeman convinced her client to extend the mark so that the brand name could be larger and longer.

Other early label designs. Other than minor color adjustments, these comps are similar to the final designs.

The client liked the fact that her original packaging revealed the product inside. So Lindeman wanted to capture the same effect in the new design. A wallpaper effect that showed the main ingredient of the candy was both flexible and graphic.

The final printed labels. The wallpaper patterning provides subtle yet clear distinction between varieties. If the client chooses to, she can easily expand the visual to package new products later.

Lindeman says that by actually showing the client other printed samples of UPCs and by giving the client a concrete word count, both obstacles were overcome. It was simply a matter of education and cooperation, the designer says: After all, it had been many years since the client had been through the redesign process, and plenty had changed in the interim.

Immediately after the redesign was finished, in early 2003, the client took the new packaging to a candy fair, and reactions were extremely positive. There is talk now of redesigning the company's Web site, stationery, and so on.

"This was a successful project because the client is happy—she got a new, fresh look for her product," Lindeman says. "We felt it was an improvement on the previous packaging. Also, the canisters are something that people might keep even after the candy is eaten."

designer directory

AdamsMorioka
8484 Wilshire Blvd., Ste. 600
Beverly Hills, CA 90211 USA
323-966-5990
www.adamsmorioka.com

Addis
2515 Ninth St.
Berkeley, CA 94710 USA
510-704-7500
www.addis.com

Bill Chiaravalle
484 W. Washington Ave., Ste. A
P.O. Box 446
Sisters, OR 97759 USA
541-549-4425
www.officeofbc.com

Blackburn's Design Consultants
16 Carlisle St.
London W1D 3BT England
44 20 7734 7646
www.blackburnsdesign.com

Blue Q
103 Hawthorne Ave.
Pittsfield, MA 01201 USA
413-442-1600
www.blueq.com

Brandhouse WTS
10A Frederick Close
London W2 2HD England
44 20 7262 1707
www.brandhousewts.com

Chase Design Group
2255 Bancroft Ave.
Los Angeles, CA 90039 USA
323-668-1055
www.chasedesigngroup.com

Crocker, Inc.
17 Station St.
Brookline, MA 02445 USA
617-738-7884
www.crockerinc.com

Design Bridge Ltd.
18 Clerkenwell Close
London ECIR OQN England
44 20 7814 9922
www.designbridge.co.uk

Design Edge
316 N. Lamar Blvd.
Austin, TX 78703 USA
512-477-5491
www.designedge.com

Design Guys
119 N. 4th St., Suite 400
Minneapolis, MN 55401 USA
612-338-4462
www.designguys.com

Dossier Creative
305.611 Alexander St.
Vancouver, BC, V6A 1E1 Canada
604-255-2077
www.dossiercreative.com

Dragon Rouge
32, rue Pages BP 83
F-92153 Suresnes cedex.
Paris, France
www.dragonrouge.com

88 Phases
8444 Wilshire Blvd., 5th Fl.
Beverly Hills, CA 90211 USA
323-655-6944
www.88phases.com

Fitch Worldwide (London)
10 Lindsey St.
Smithfield Market
London EC1A 9ZZ England
44 20 7509 5000
www.fitchworldwide.com

Harcus Design
118 Commonwealth St.
Surry Hills NSW 2010 Australia
61 2 9212 2755

IKD Design Solutions Pty Ltd.
173 Fullarton Rd.
Dulwich 5065 South Australia
+61 8 8332 0000
www.ikdesign.com.au

Alexander Isley, Inc.
9 Brookside Pl.
Redding, CT 06896 USA
203-544-9692
www.alexanderisley.com

Jones Knowles Ritchie
128 Albert St.
London NW1 7NE England
44 20 7428 8000
www.jkr.co.uk

The Jupiter Drawing Room
6rd Floor, The Terraces
Fir St., Observatory, 7925
Cape Town, South Africa
27 21 442 7000

karacters design group
1500-777 Hornby St.
Vancouver, BC V6A 1B2 Canada
604-609-9546
www.pjddb.com

David Lancashire Design
17 William St.
Richmond 3121 Victoria
Austrialia
61 39421 4509

Lewis Moberly
33 Greese St.
London W1P 2LP England
44 20 7580 9252
www.lewismoberly.com

Lipson Alport Glass & Assoc.
747 Third Ave., 35th Fl.
New York, NY 10017 USA
212-486-3090
www.nyc@laga.com

Lloyd Grey Design
1023 Ann St.
Fortitude Valley
Queensland 4006 Australia
61 7 3852 5023

MLR Design
325 W. Huron, Suite 315
Chicago, IL 60610 USA
312-943-5995
www.mlrdesign.com

Mirko Ilić Corp.
207 East 32rd St.
New York, NY 10016 USA

Motiv Design
6 George St., Stepney
Adelaide, South Australia SA5069
61 8 8363 3833
www.motivdesign.com

Ohio Girl Design
4602 Los Feliz Blvd. #204
Los Angeles, CA 90027 USA
310-663-5080
www.ohiogirl.com

Parham Santana
7 W. 18th St.
New York, NY 10011 USA
212-645-7501
www.parhamsantana.com

Primo Angeli: Fitch
101 15th St.
San Francisco, CA 94103 USA
415-551-1900
www.fitchworldwide.com

Pyott Design Consultants
Unit 3, 170 Katherine Mews
Whytleafe, Surrey, England
44 20 8668 5558
www.pyott.co.uk

R Design
Studio 3 Church Studios
Camden Park Road
London NW1 9AY England
44 20 7284 5840
www.r-website.co.uk

Roundel
7 Rosehart Mews
Westbourne Grove
London W11 3TY England
44 20 7221 1951
www.roundel.com

Sandstrom Design
808 SW Third, No.610
Portland, OR 97204 USA
503-248-9466
www.sandstromdesign.com

Sayles Graphic Design
3701 Beaver Ave.
Des Moines, IA 50310 USA
515-279-2922
www.saylesdesign.com

Smart Design
137 Varick St.
New York, NY 10013 USA
212-807-8150
www.smartnyc.com

Stratton Windett
6 Rossetti Studios
72 Flood St.
London SW3 5TF England
44 20 7352 6089

Trickett & Webb Ltd.
The Factory
84 Marchmont St.
London WC1N 1AG England
44 20 7387 4287
www.trickettandwebb.co.uk

Tucker Design
The Church St.
Stepney, 5069 South Australia
61 8 362 4000
www.tuckerdesign.com.au

Vario
The Business Village
3 Broomhill Road
London SW18 4JQ England
44 20 8875 6990
www.planetvario.com

Willoughby Design
602 Westport Road
Kansas City, MO 64111 USA
816-561-4189
www.willoughbydesign.com

Z+Co. Design Consultants
Unit 4.1
2-6 Northburgh St.
London EC1V 0AY England
44 20 7336 7808

about the author

Catharine Fishel has written about and worked with designers and illustrators for more than 20 years. She is the editor of LogoLounge.com, writes for leading design magazines such as *PRINT*, *ID*, and *STEPinside Design*, and is the author of many books on design-related topics, including *Paper Graphics*, *Minimal Graphics*, *Designing for Children*, *The Power of Paper in Graphic Design*, *Redesigning Identity*, *The Perfect Package*, *LogoLounge* (all Rockport Publishers), and *Inside the Business of Graphic Design* (Allworth Press).